Dearest Gary,

Wishing you a very Happy 30th Birthday,
with all my love and best wishes,

Liz.
x x x x

DALI

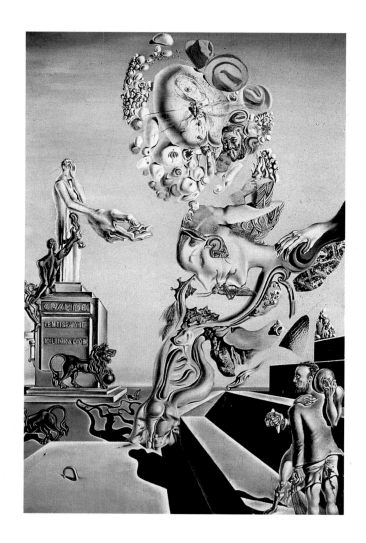

MAGNA BOOKS

DALI
Paul Moorhouse

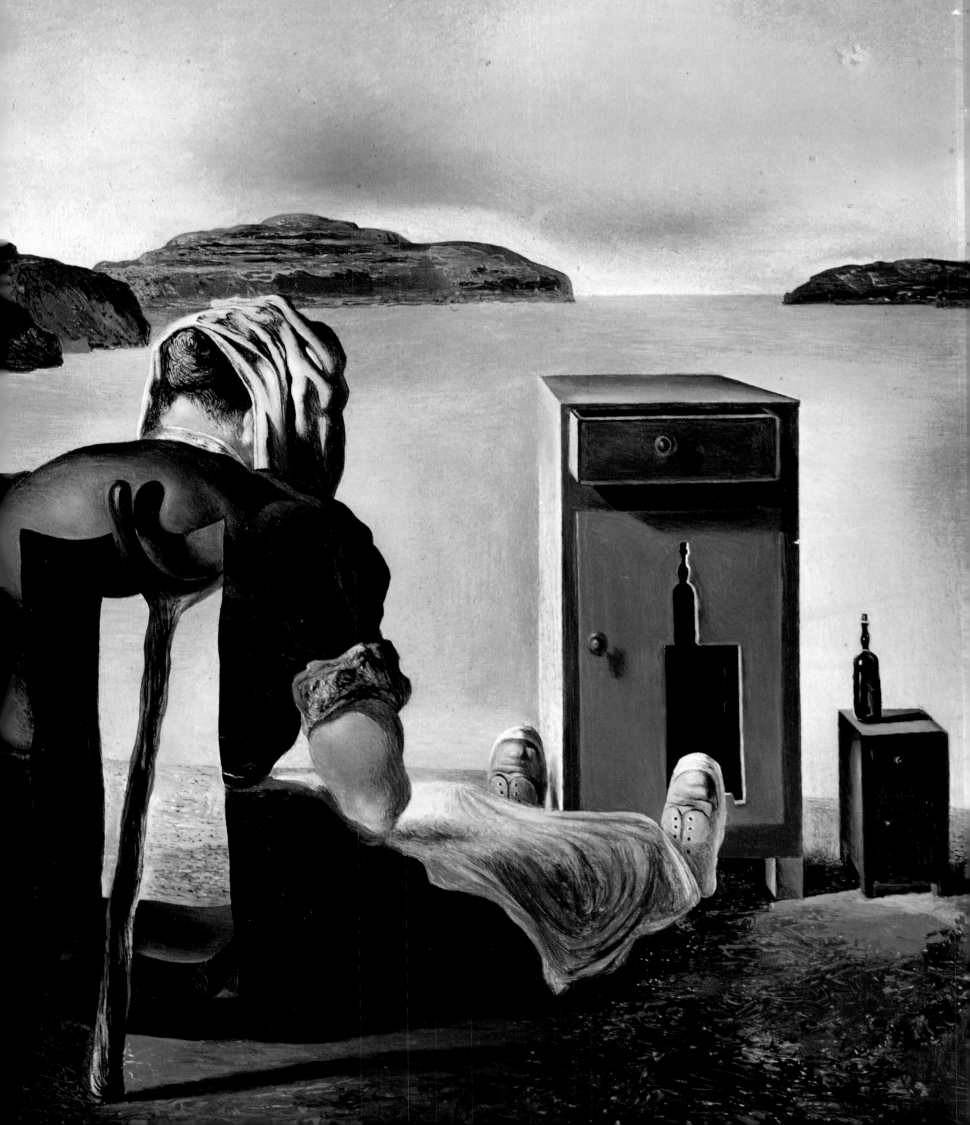

Published by Magna Books
Magna Road
Wigston
Leicester LE8 2ZH

Produced by Bison Books Ltd
Kimbolton House
117A Fulham Road
London SW3 6RL

ISBN 1-85422-105-1

Printed in Hong Kong

Reprinted 1993

Page 1: *The Lugubrious Game (Dismal Sport)*, 1929, Private Collection

Page 2/3: *The Weaning of Furniture-Nutrition*, 1934, Collection of Mr and Mrs A Reynolds Morse, on loan to Salvador Dali Museum, St Petersburg, Florida

Contents and List of Plates

Introduction

'I AM SURREALISM' – THE LIFE OF SALVADOR DALI

'I cannot understand', Dali once observed, 'why man should be capable of so little fantasy'. For Dali, fantasy was only the beginning. He joined the Surrealist group in 1929 because he recognized an affinity between their aims and his own nature. Five years earlier the leader of the Surrealists, André Breton, had announced their campaign for the liberation of the unconscious. Already an abnormally introspective and hypersensitive individual, Dali implemented this aim literally and without qualification. However, in his case probing the recesses of his psyche meant cultivating latent hysteria and what he regarded as a paranoiac sensibility. This resulted in behaviour and imagery which even the Surrealists found shocking. Where they held back Dali pressed on, contemptuous of their timidity: 'The difference between the Surrealists and me is that I am a Surrealist', he declared. The evidence for this assertion is manifest in Dali's life and art; a journey through a reality dominated by fantastic and irrational forces. In Dali's universe, desire, phobia and obsession are the terrorists of truth.

At 8.45 on the morning of May 11 1904, the most significant event in Salvador Dali's life occurred; he claimed that he suffered 'the horrible traumatism of birth'. Dali's belief that he could remem-

ber his prenatal experiences either attests to or explains the prominence of fantasy in his life. In the case of the latter, this conviction led Dali to regard reality as the opposite of the 'paradisial state' and to invest his imagination with the role of reconstituting an ideal world. Three years before Dali's birth, his parents had lost their first child, a seven-year-old boy also called Salvador. The over-protective love which they bestowed on their second-born encouraged the development of a temperamental and selfish child; his bouts of attention-seeking and whims were humored. He wet the bed until aged eight 'for the sheer fun of it', kicked his sister in the head, and pushed another child off a fifteen-foot high bridge. But his nose bleeds and angina were a cause for concern and his parents presented him with a king's costume – he was 'the absolute monarch of the house' and he knew it.

At the same time, Dali's character was marked by an abnormal sensitivity and a craving for solitude. When he was five years old he was given a bat with a damaged wing. Retreating to the washhouse where he could be alone, he placed the bat in an empty pail and put a glowworm beside it so as to create a kind of shrine. This evoked a deep love for the bat and he kissed it tenderly on the head; he was distraught when he later discovered the bat being eaten alive by ants. When he grew older Dali was allowed to set up a studio in an old laundry room at the top

of the house. This contained a large cement basin which Dali would fill with water. He would then sit in the basin for long periods, absorbed in the workings of his imagination and sustained by his developing narcissism.

Outside this womb-like space, the young Dali's mania for solitude manifested itself as total withdrawal. At school his teachers despaired of teaching him anything. He would spend hours staring at the stains on the classroom ceiling; these drew images from his imagination which he saw as clearly as if they had been cast by a motion picture projector. It was at secondary school that Dali began to display the bizarre and audacious exhibitionism which later became synonymous with his name. He extracted money from his parents and sold it to his fellow pupils for half its value. His outbursts of aggression became more frequent and vicious, attacks being perpetrated on any pupil who looked sufficiently incapable of resistance. He grew his hair long and wore make-up. By the age of 16 he had discovered the attention which he could command by flinging himself down flights of stairs. As a result of this behavior questions often to be repeated were heard for the first time: Is he mad? Is he not mad? Is he half-mad?

While sitting in the laundry basin, Dali passed hours contemplating the art books given to him by his father. These inspired him to paint his first two oil paintings at

the age of eight. Soon after, Dali's parents sent him to stay with some friends of theirs, the Pitchots, who owned a country property called 'The Tower Mill' about two hours from the Dalis' home at Figueras. The Pitchots were a cultured family and their taste in art and musical talents made a deep impression on the young Dali, but it was the work of the Paris-based Impressionist painter Ramon Pitchot which made the greatest impact. His richly colored canvases adorned the Pitchots' dining room and filled their young guest's eyes with wonder. Instilled with the desire to paint, Dali's precocious talent soon revealed itself. Employing three colors only, which he squeezed direct from the tube, Dali painted a pile of cherries using a worm-eaten door as a support. Reality and illusion then cross-migrated. He planted the stems of the real cherries, which he was using as a model, in the wet paint then, using a hairpin, he picked the worms out of the door and transplanted them to the holes made in the real cherries. When Señor Pitchot saw this he muttered 'That shows genius'; with the Pitchots' encouragement Dali was launched on his life's work. Señor Pitchot persuaded Dali's father to enrol his son in evening classes to teach him drawing. Simultaneously Dali immersed himself in painting. By the time he reached the age of 17 Dali had produced a number of works, mostly views of the local landscape and portraits, in Impressionist and Post-Impressionist styles. Moved by his son's growing artistic ability and also by his lack of academic success – Dali was expelled from his secondary school – Dali's father agreed to his enrolment at the School of Fine Arts in Madrid in 1921.

Installed in the student's residence, Dali was at first a model student. The timidity which his outlandish behavior masked prevailed for the moment and he avoided the other students, but this reticence was not reflected in his appearance, which was calculated to draw attention. Nevertheless, he led an ascetic existence, attending courses at the Academy or visiting the Prado, then returning to his room where he studied and devoted himself to his painting. It was at this time that he read Freud's *The Interpretation of Dreams*, a work which deepened his introspective nature by plunging him into self-analysis. He also developed a knowledge of avant-garde art movements, gained through reading various art magazines, particularly *L'Esprit Nouveau*. As a result he reacted against the influences of Pointillism, the Fauves and Bonnard, apparent in his work when he first moved to Madrid, and

Left: Dali and Gala at Port Lligat.
Right: Salvador Dali pictured during his lengthy stay in the United States.

began to experiment with a range of avant-garde styles. Between 1921 and 1924 he employed techniques reflecting the lessons of Cubism, Futurism and Purism, as well as producing sporadic essays in a more conventional atmospheric realism.

He soon grew contemptuous of his teachers at the Academy; they were still absorbing the lessons of French Impressionism and could impart no useful technical knowledge. Dali felt that they could teach him nothing. At the same time he was 'discovered' by one of the more avant-garde student groups which included Luis Buñuel and Garcia Lorca. They were dazzled by Dali's intellect and his unconventional personality and he quickly assumed a prominent position within their ranks. He in turn underwent a transformation as a result of their ideas.

He shed his fantastic garb, had his long hair trimmed and sideburns shaved off, and re-emerged in the dandified image of his peers which, typically, he took to an extreme. No longer inhibited by his isolation, his bizarre behavior surfaced once more and he acquired the reputation for being 'crazy as a goat!' His asceticism was replaced by excess. Following the lead of Lorca and Buñuel he was introduced to the nightlife of Madrid. They initiated him into eating expensively, drinking copiously and staying out into the early hours.

This extravagant existence was cut short in October 1923. His teachers had identified him as a rebel; a student protest against a staff appointment was blamed on Dali and he was suspended for a year. More trouble followed upon his return to

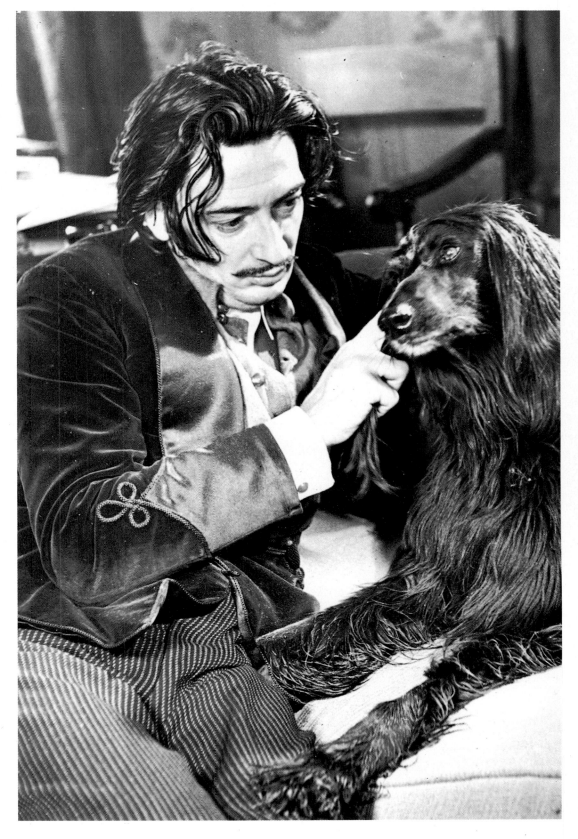

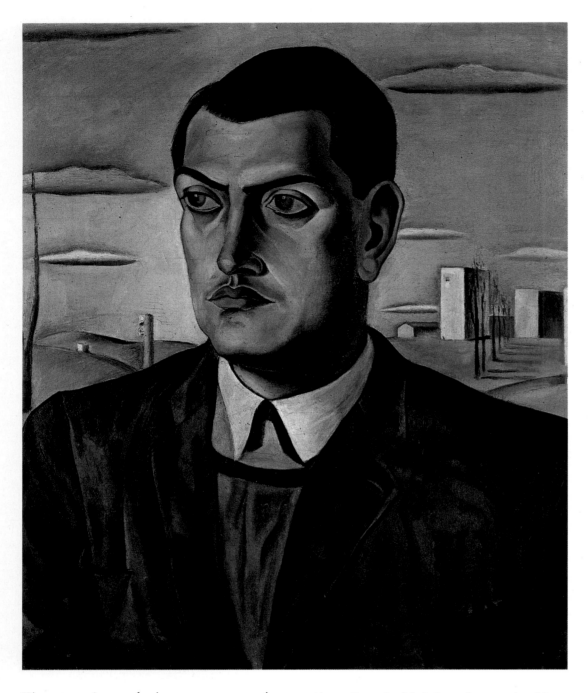

and threw himself into preparations for his second one-man show. This was held between December 1926 and January 1927 in Barcelona and was widely praised by the press. Dali spent the following nine months doing his compulsory military service and painted virtually nothing during this time, but the respite appears to have given him the opportunity to consider his artistic future. The paintings he began to make at the end of the year were like nothing he had done before. Paintings such as *Apparatus and Hand*, 1927, (page 32) and *Bather*, 1928, (page 34) demonstrate his adoption of Surrealist ideas, gleaned from discussions as a student and from articles in reviews. He found that this new idiom provided an outlet for the nervous excitability, fantasy and introspection which continued to provoke the bizarre excesses of his behavior. At the end of 1928 he was visited in Figueras by Buñuel and together they wrote the scenario for *Un Chien Andalou*, the film which was to make Dali's reputation. Miro and his dealer Pierre Loeb also visited Dali and encouraged him to visit Paris. Miro confided to Dali's father: 'I am convinced that your son's future will be brilliant!'

At the end of 1928 Dali traveled to Paris to collaborate with Buñuel on the shooting of *Un Chien Andalou*. During this visit Miro acted as his guide and, having suggested that Dali acquire a dinner jacket, launched him on a round of society dinners. Miro was also responsible for introducing Dali to the Surrealist group. Although Dali was to suffer a relapse of timidity he made an impression. When he showed Robert Desnos his painting *The First Days of Spring* (page 36), the Surrealist poet observed 'It's like

Figueras. A revolutionary upsurge in Catalonia had just been crushed and Dali's reputation as an anarchist again incriminated him. The Civil Guard imprisoned him for 35 days. Dali reveled in the notoriety which surrounded him when he returned to the Academy but his days as a student were numbered. He continued to experiment with a variety of styles, often using completely opposite techniques in different paintings simultaneously. During the next two years he passed through Cubism and 'Neocubism' – a kind of figuration with simplified planes and forms demonstrating Picasso's influence – as well as painting portraits, landscapes and still-lifes in a realistic idiom. Although as yet undefined, Dali's confidence in his artistic ability was growing. In 1925 he had his first one-man show in Barcelona, which attracted the attention of Picasso and Miro. In April of the following year he visited Picasso in Paris and showed the Master one of his recent paintings. Six months later Dali was expeled from the Academy, having announced his refusal to be examined by his professors on the grounds of their incompetence.

Undismayed, Dali returned to Figueras

Above: Portrait of Luis Buñuel 1924, painted by Dali while they were both students at the School of Fine Arts in Madrid.
Below: Still from the opening sequence of *Un Chien Andalou*.

nothing that is being done in Paris'. Left to his own devices, Dali prowled the brothels and boulevards of Paris looking for a woman who might be persuaded to act out his erotic fantasies. Since adolescence Dali's sexuality had shown signs of aberration; although erotic fantasies obsessed him, the physicality of sexual union repeled him and his sexual practices then and in later life seem to have centred on auto-eroticism and voyeurism. *Unsatisfied Desires*, a painting executed at this time, reflects Dali's lack of success in finding an appropriate partner. The strain of the visit soon began to tell; Dali became depressed and succumbed to a bout of angina which confined him. When he returned to Figueras his state of nervous exhaustion threatened to plunge him into madness. He became prey to delirious fantasies and suffered a full hallucination. Bouts of hysterical laughter gripped him, rendering him incapable of speech or movement. Despite this he threw himself into painting and attempted to transcribe the images which flashed before his mind. *The Lugubrious Game* (page 38), a key work of this period, conveys forcefully the irrationality to which Dali surrendered.

During the summer of 1929, Dali was visited by the Belgian Surrealist René Magritte and his wife, the Paris art dealer Camille Goemans, and the Surrealist poet Paul Eluard and his Russian wife Gala. They were intrigued by Dali's work but his mental condition was a cause for concern. The scatological elements in *The Lugubrious Game* became a focus for controversy. As an image it fulfilled the Surrealist ethos of uncensored thought, yet it also seemed to point to pathological thought processes. Gala was initially repulsed then intrigued by Dali. His manic and intense personality alarmed her, yet she sensed a boyish helplessness beneath the surface. One day she took Dali by the hand and silenced his fanatical laughter for a moment. Dali saw a way out of the abyss and fell at her feet. Gala became his muse and the object of his intense passion; she later became his wife and companion for life. From this moment they were rarely to be separated for long. During the course of that summer Dali gradually conquered his hysteria; Gala remained with him for a short period after the departure of the other visitors. After she left Dali shut himself away in his studio for two months and painted two of his most important works, *The Enigma of Desire* (page 44) and *The Great Masturbator* (page 42). He then rejoined Gala in Paris for the first showing of *Un Chien Andalou* but left two days before the opening of his first exhibition in the art capital of the world for a 'voyage of love' with Gala which took them to Barcelona. Nevertheless both events

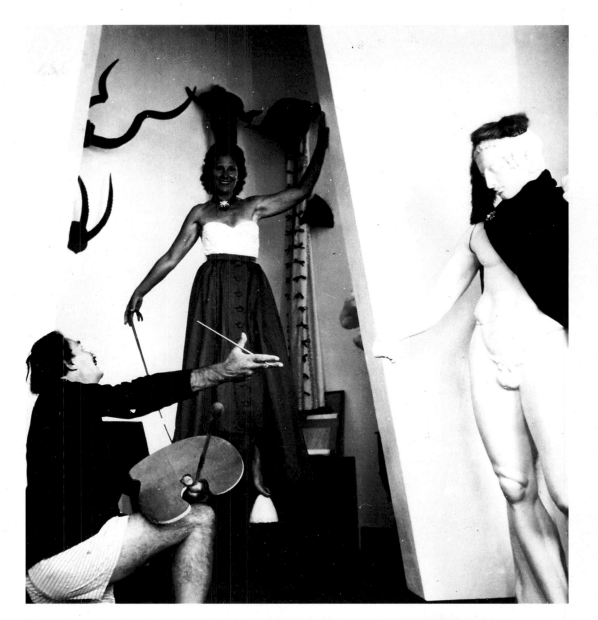

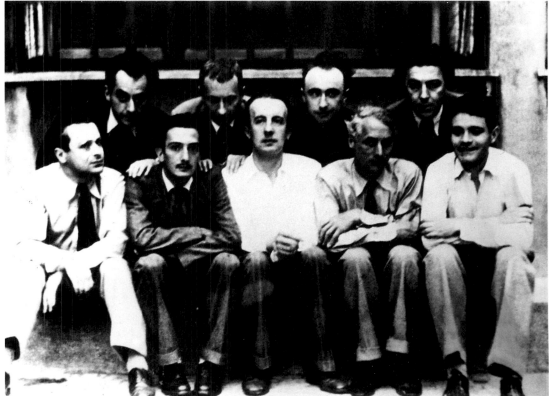

caused an instant sensation and consecrated Dali's reputation within the Surrealist group.

When Dali joined the Surrealists he found the group split by internal dissension and in need of a renewed sense of purpose. The question of their affiliation with the Communist party had alienated a number of Surrealists and had led to expulsions. The initial revolutionary spirit

Top: Dali plays the showman with Gala at Port Lligat.
Above: 1929/30 photograph of the Surrealist group showing Dali (second left, seated) with, among others, Paul Eluard, Max Ernst, Man Ray and André Breton.

which had been sustained by the Surrealists' experiments with dream transcription and automatic writing had flagged. Dali immediately invigorated the

Surrealists with his originality, daring and natural ability to shock. At the cutting edge of this activity was his development of the paranoiac-critical method, which he outlined in a number of publications between 1930 and 1935. Dali defined it as a 'spontaneous method of irrational knowledge based on the interpretive-critical association of delirious phenomenona'. Unlike dreams and automatism, which depend on passive states in order to gain access to the unconscious, the paranoiac-critical method became, in Dali's hands, a way of unleashing irrationality at will, by subjecting his thought processes and the external world to the irresistible force of paranoiac interpretation and association. During the next decade Dali poured out a sequence of paintings in which he used the method to give vent to his fantasies, phobias and obsessions. Nothing was censored and his subject matter ran the gamut from masturbation, coprophilia, oedipal desire and fellatio to Hitler, Lenin, skulls, pianos, soft watches and crutches. Dali's aim was, he announced, 'the Conquest of the Irrational'.

The potential of the method was obvious but few of the Surrealists, if any, followed Dali's lead in applying it to painting. However, Dali's invention of the Surrealist object, a three-dimensional collage of fetishistic elements, caused a rash of activity within the group. Dali's notoriety grew inexorably. A second successful show in Paris in 1932 was followed the next year by his first exhibition in

New York. In 1934 he had no less than six one-man shows in New York, Paris, Barcelona and London. Breton watched with disapproval; success for Dali, it seemed, bred excess. His behavior and pronouncements became increasingly provocative, and his fascination with Hitler in particular irked Breton. Finally he summoned Dali to his apartment and demanded he explained himself before an assembly of the Surrealist group. Dali stated that his obsession with Hitler was strictly paranoid and essentially apolitical. The crisis passed and Dali continued to exhibit with the Surrealists but relations deteriorated thereafter, although his reputation as the arch-Surrealist spread. In 1936 he delivered a lecture in London dressed in a diving suit. Later in the year he appeared on the cover of *Time* magazine on the occasion of his second New York exhibition. Against Breton's wishes he exhibited his *Rainy Taxi* at the International Exhibition of Surrealism at the Beaux-Arts Gallery in Paris in 1938. This comprised a real taxi, its interior saturated by sprays of water. Inside sat a mannequin covered in snails and lichens.

With the coming of Civil War in Spain Dali embarked on a period of extensive travel. He visited Italy, where he fed his admiration for Raphael and the Renaissance; in London he met Freud who pronounced him a 'fanatic'; and he visited America on several occasions, finally settling there while the Second World War

raged in Europe. On his arrival in New York he declared 'I am Surrealism' and in so doing alienated himself from the Surrealists from that point onward.

Dali sealed the rift the following year. In the catalogue of a large exhibition of his work at the Julien Levy Gallery, New York, in 1941 he declared 'Finished, finished, finished, a thousand times finished – the experimental epoch'. His destiny was, he announced, 'TO BECOME CLASSIC!'. Despite this Dali hesitated, as if uncertain as to what form this destiny would take. His output of paintings slowed but, apart from a growing academicism noticeable in his technique, they continued to provide an outlet for his fantasies. *One Second Before Awakening from a Dream Caused by the Flight of a Bee Around a Pomegranate*, 1944 (page 22), is a key example of Surrealist dream transcription and interpretation. His activity in other fields was frenetic. Resolving to become 'the greatest courtesan' of his time, a decision undertaken in a 'paranoiac rage', Dali threw himself into the social and commercial maelstrom of American life. During their eight years of exile, when Dali and Gala divided their time between California, New York and Pebble Beach, Dali designed jewelry, painted portraits of society personalities and decorated their apartments, wrote his autobiography *The Secret Life* and a novel *Hidden Faces*, created advertisements, collaborated with Schiaparelli on the marketing of a new perfume, designed the scenery and costumes for three ballets, and worked with Alfred Hitchcock in Hollywood on the dream sequence in the film *Spellbound*. The wealth which he began to amass inspired Breton's famous anagram on his name, 'Avida Dollars'. Swept along on the tide of his own celebrity, it seemed that Dali had lost direction. His sense of spiritual aridity at this time is conveyed in the disgust he expressed for 'the surrealist banquet which we had allowed to grow cold' and in his declaration at the end of *The Secret Life*: 'At this moment I do not yet have faith, and I fear I shall die without heaven'.

In 1945, the cataclysm of the atomic bomb lit up the direction Dali would take. Destruction on this scale implied that Dali's Conquest of the Irrational now lay in the world of phenomenal reality rather than in the depths of his own mind. He declared, 'After the First World War it was Psychology. After the Second World War, it shall be Physics'. Fascinated by the discoveries of atomic theory, he embarked upon a new creative phase which he dubbed 'nuclear painting'. In *Disintegration of the Persistence of Memory*, 1952-4, for example, he returned to one of his most famous images, reinterpreting it in terms of the atomic

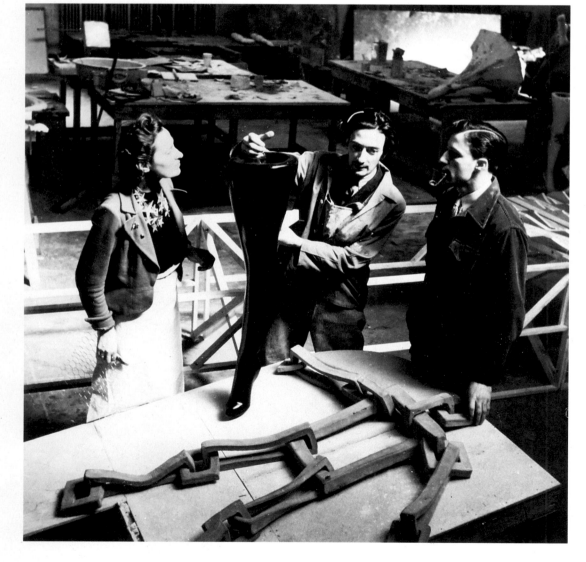

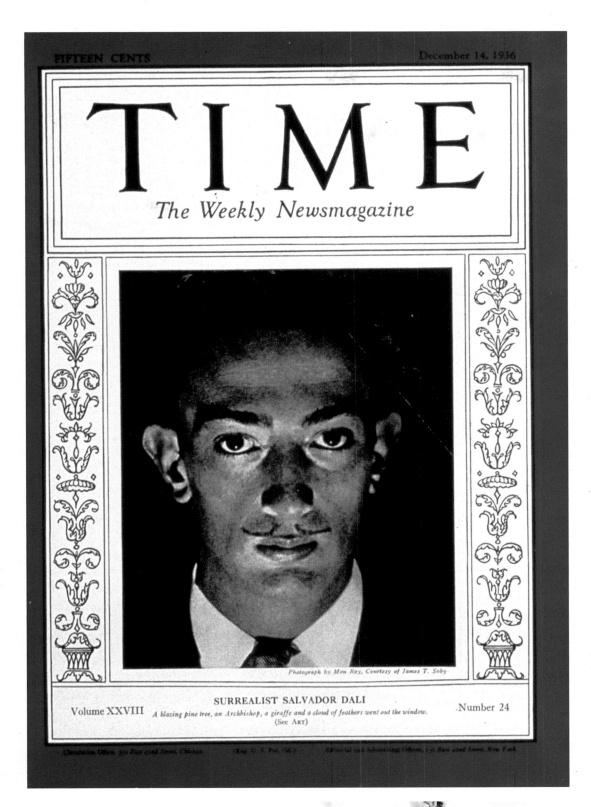

FIFTEEN CENTS December 14, 1936

TIME
The Weekly Newsmagazine

Photograph by Man Ray, Courtesy of James T. Soby

SURREALIST SALVADOR DALI

Volume XXVIII *A blazing pine tree, an Archbishop, a giraffe and a cloud of feathers went out the window.* Number 24
(See Art)

techniques of the Old Masters. 'It was necessary', he explained, 'to turn to the silver oxide and olive green dignity of Velásquez and Zurbarán, to the realism and mysticism that we were to discover were alike and consubstantial'. The transcendent reality which Dali sought in the fusion of physics, metaphysics and Renaissance beauty was, as ever, subjected to paranoiac interpretation. In 1955 Dali gave a lecture at the Sorbonne entitled 'Phenomenological Aspects of the Paranoiac-Critical Method'. In this he identified the logarythmic spiral of the rhinocerous horn, which he discovered in sunflowers, as being the embodiment of absolute formal perfection. Dali brought all these ideas together in his painting *Raphaelesque Head Exploding*, 1951 (page 100). His inquisition of reality was extended subsequently by experiments with optical theory undertaken toward the end of the 1950s, by his linking of religious ideas with the discovery of DNA during the next decade, and in the 1970s by his annexation of holography and stereoscopy as means of expression. As usual, Dali was able to forge a synthesis and a paradox to describe his work. This late period he called 'Metaphysical Hyperrealism'.

Dali died on January 23 1989. He courted irrationality until the end of his life, and in so doing he raised a question which may never be answered: was the Conquest of the Irrational *by* Dali or *over* Dali? In 1974 Customs officials seized 40000 sheets of blank paper bearing Dali's signature. It seems these were destined to have been used in the production of prints which should have been limited in number. Dali's assistants reported that he had signed as many as 1800 sheets in an hour, while Dali claimed that he had been betrayed by those around him.

Left: Dali and Gala prepare his exhibit *The Dream of Venus* for the 1939 World's Fair in New York.
Above: Time magazine cover featuring Man Ray's 1933 photograph of Dali.
Right: A meal of sea urchins for Dali and Gala.

structure of the material world. Its elements are held in a state of suspended disintegration, referring metaphorically to the divisibility of matter. But this was only a preliminary stage in Dali's new development. Previously he had sought to go beyond reality by diving into the depths of his unconscious; he now moved in the opposite direction. He observed, 'Transcendent reality had to be integrated into some fortuitous part of pure reality ... But this already presupposed the uncontested presence of God, who is the only supreme reality'. From 1949 onward, Dali began to harness his nuclear painting to religious subject matter. The resulting images were rendered with a meticulous realism reminiscent of the

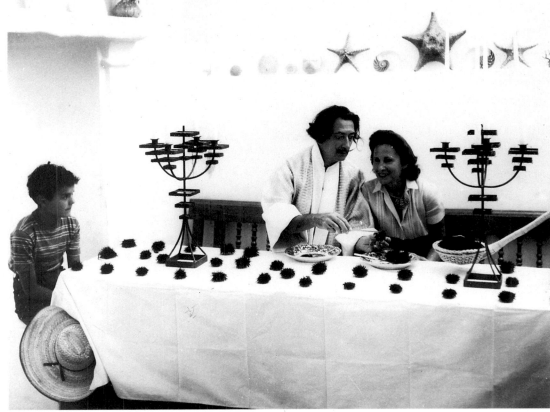

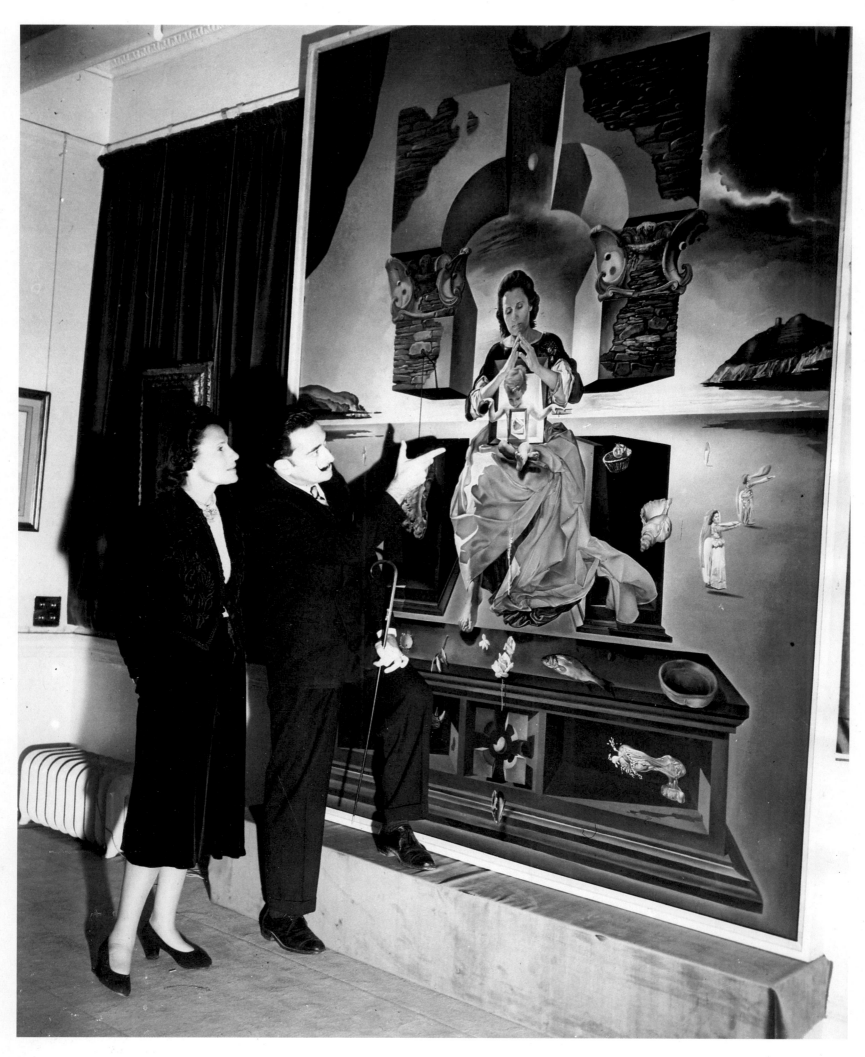

In 1982 Gala died; Dali was devastated and he withdrew into her medieval castle at Pubol, closing the windows on the world, but controversy continued to rage outside. In 1983 a young Catalan painter claimed that since 1975 he had been responsible for a number of works believed to have been painted by Dali. Other fakes then also emerged. It appeared that, in

addition to forged prints with genuine signatures, also circulating were genuine prints with forged signatures. Dali's solution was typically Surrealist in its logic. He proposed to produce 'authorized' prints which would be recognizable because they would not carry *any* signature, he being too enfeebled by age and illness to sign them.

In 1984 Dali emerged from his isolation after being badly burnt when his bed caught fire. The world was shocked by his appearance. Apparently on the verge of insanity, he believed himself unable either to stand or swallow and was suffering from severe malnutrition; he weighed only 100 pounds. Nevertheless he recovered and moved to the tower of the

museum he had created at Figueras. As in his childhood days, when he sat by himself in the laundry room at the top of this father's house, Dali's last days were passed alone, absorbed in his thoughts, in one small room inside the tower. Much of the time he spent looking out of the window, contemplating the weathered stones in the ancient wall opposite. Occasionally he received a single visitor, Antonio Pitchot, the nephew of the man who first inspired Dali. One day Dali confided to his visitor 'Do you know? Each day I see new things in the shape of the stones . . .'

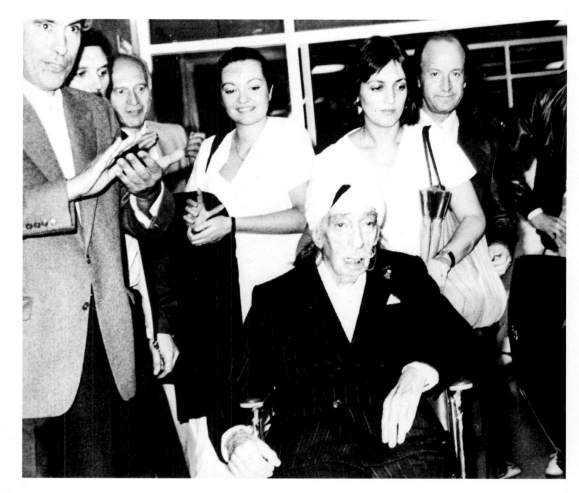

Left: Dali, in London in 1951, explains *The Madonna of Port Lligat*, 1949 (page 99) to Gala, model for the picture.
Right: An undernourished and decrepit Dali in 1984 after the fire at his home.
Below: Preliminary study (1935) for *Soft Construction with Boiled Beans*, 1936 (page 82), which expresses Dali's horror at the prospect of civil war in Spain.

THE PARANOIAC-CRITICAL METHOD

In his autobiography, *The Secret Life of Salvador Dali* (1942), Dali describes how as a child he would stare at the great vaulted ceiling of his school classroom and see a succession of images in the large brown moisture stains which covered it. He discovered that he was able to repeat these hallucinations at will and described these early experiences as 'the keystone of my future aesthetic'. Implicit in them was the ability to recover images from the unconscious *voluntarily* and this is the essence of what Dali later called the paranoiac-critical method. Dali expounded its theory during the course of his association with Surrealism in the 1930s and its practice lies at the heart of his art during that period. André Breton, the leader of the Surrealist Movement, recognized its importance when in 1934 he stated:

Dali has endowed Surrealism with an instrument of primary importance, specifically the paranoiac-critical method, which has immediately shown itself capable of being applied with equal success to painting, poetry, the cinema; to the construction of typical Surrealist objects, to fashions, to sculpture and even, if necessary, to all manner of exegesis.

Dali's break with Surrealism at the end of the 1930s heralded a shift away from the exploration of internal experience and a growing fascination with the workings of the physical world. In the post-war period the paranoiac-critical method was no longer primarily employed by Dali as a means of probing his own psyche, but it remained an important weapon in the arsenal of his artistic practices. As Dali

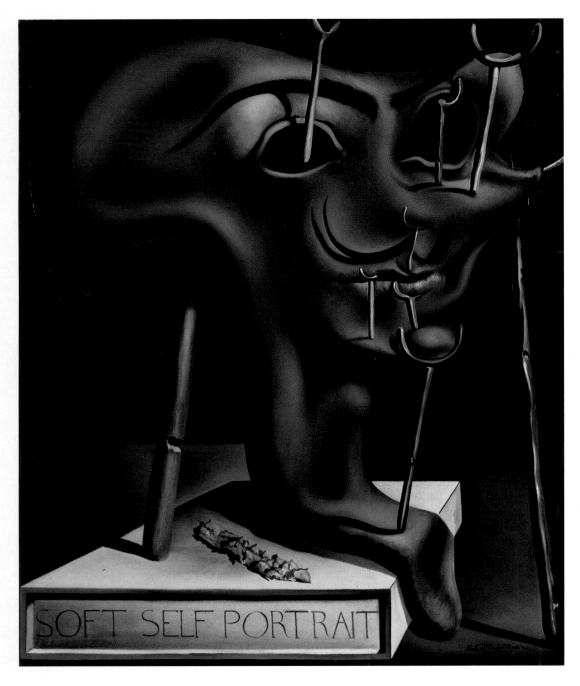

In other words, paranoia is marked by delirium. The nature of this delirium reflects the second characteristic of paranoia. Jaspers has indicated how:

Many things which take place in the immediate surroundings of these sick persons attract their attention and arouse unpleasant, barely comprehensible reactions in them . . . Sometimes, everything seems 'too much' to them . . . even a very ordinary noise or happening is enough to irritate them. They always have the impression that someone is deliberately doing this to them.

This demonstrates the way paranoiacs *interpret* both their hallucinations and their experiences in general by establishing associations and causal connections between disparate phenomena. Different ideas and experiences become linked in the paranoiac's mind, giving rise to feelings of persecution. These associations have no rational basis and yet to the paranoiac appear perfectly logical and coherent. Paranoia thus develops as a pattern of active and systematic delusion in which the sufferer interprets and structures his experiences of the world according to the irrational associations which he imposes upon it. Although paranoiac-critical activity is aimed at revealing associations of a paranoiac nature it is not designed to induce paranoia *per se*. This is reflected in Dali's statement: 'The only difference between a madman and me is that I am not mad.' Dali claimed to have a paranoiac sensitivity which produced a reservoir of unconscious images and irrational associations, but he explained that, unlike the true paranoiac, this material was bought to the surface of the mind by 'critical intervention', that is, by lucid and objective processes. As a result, no consistent pattern of delusional psychosis could develop. Dali's statement may thus be understood to reflect his conviction that

explained: 'I applied my paranoiac-critical method to exploring the world. I want to see and understand the forces and hidden laws of things, obviously so as to master them'. Although the paranoiac-critical method permeated Dali's art as a whole, it received its fullest theoretical exposition and most rigorous application in the pre-war period.

In *Conquest of the Irrational* (1935), Dali defined paranoiac-critical activity as a 'spontaneous method of irrational knowledge based upon the interpretive-critical association of delirious phenomena'. Essentially this is an experimental method in which 'paranoiac phenomena' are revealed by 'critical intervention'. Paranoia is a severe mental disorder and the nature of paranoiac phenomena is determined by its two dominant and interconnected symptoms. The first of these has been described by the philosopher Karl Jaspers as follows:

The sick persons (paranoiacs) are no longer in control of the progression of their mental images . . . all kinds of sensory illusions (frequent hearing of voices, visual pseudo illusions, synesthetic sensations) complete the picture.

Above: Soft Self-Portrait with a Rasher of Grilled Bacon, 1941.
Below: Bathers of the Costa Brava, 1923, reflects the pointillist style which Dali adopted around 1922-23.
Right: Dali as a young man in romantic pose, photographed in Connecticut in 1939.

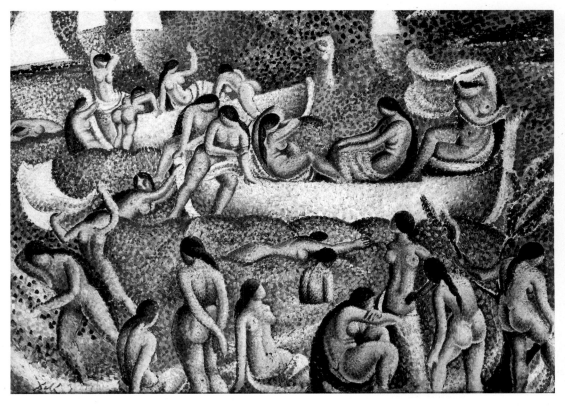

he could think like a madman without actually being mad.

The theory of paranoiac-critical activity was outlined by Dali in a number of publications between 1929 and 1935. The first, a manifesto entitled *The Putrescent Donkey*, was published in the first issue of *Surrealism in the Service of the Revolution* and discusses the use of paranoia. This was followed in 1930 by Dali's first book, *The Visible Woman*, in which he announced his purpose. 'I believe', he wrote, 'the moment is at hand when by a paranoiac and active advance of the mind, it will be possible. . . to systematize confusion and thus to help discredit completely the world of reality.' His 1933 essay *Paranoiac-Critical Interpretation of the Obsessive Image of Millet's Angelus* was followed a year later by his preface to an exhibition of his illustrations for the Comte de Lautréamont's book *Les Chants de Maldoror*. This nineteenth-century poet was a precursor of the Surrealist spirit. In Dali's preface, Jean François Millet's painting *The Angelus* (1859) became, by a process of paranoiac thought, associated with, and interpreted in terms of, Lautréamont's simile: 'As beautiful as the chance encounter on a dissecting table of a sewing machine and an umbrella'. Ideas contained in *Latest Fashions of Intellectual Excitement for the Summer of 1934*, published that year, were elaborated in Dali's definitive statement on paranoiac-critical activity, *Conquest of the Irrational* (1935).

The theoretical framework for the paranoiac-critical method which Dali developed during the course of these publications suggests a conscious alignment with the principles of Surrealism, as defined in Breton's writings. It also reflects a desire to place the method at the forefront of Surrealist activity. The founding principle of Surrealism was that, as the result of a civilization which operates only according to rationalist principles, Man had become alienated from a vital part of his being, the imagination, and those 'strange forces' contained in the depths of the mind and revealed in dreams. The aim of Surrealism was to liberate the mind in order to bring about 'the future resolution of these two states, dream and reality. . . into a kind of absolute reality, a surreality'. Dali's aim, as defined in *Conquest of the Irrational*, was couched in similar terms:

My whole ambition in the pictorial domain is to materialize the images of concrete irrationality. . . In order that the world of the imagination and of concrete irrationality may be as objectively evident, of the same consistency, of the same durability, of the same persuasive, cognoscitive and communicable thickness as that of the exterior world of phenomenal reality.

Breton originally identified automatism as the means of liberating the unconscious mind, by aiming at 'thought's dictation, in the absence of all control exercized by the reason and outside all aesthetic or moral preoccupations'. However, its almost complete absence in the second *Manifesto of Surrealism* (1929) demonstrates that Breton was beginning to recognize that automatism was more an ideal than a practical reality. Consequently the way was open for alternative methods.

In *Conquest of the Irrational* Dali's criticism of automatism represents an attempt to clear the way prior to its replacement by the paranoiac-critical method. Dali identified 'two grave inconveniences' afflicting automatism. Firstly images produced in this way 'cease to be unknown images' because, in being susceptible to psychoanalysis, they are reducible to 'ordinary logical language' thus shedding their marvelous nature. Since, according to Breton, 'only the marvelous is beautiful' the exercise is rendered fruitless. Conversely, Dali claimed that 'the images of concrete irrationality' – those produced by the paranoiac-critical method – 'are . . . authentically unknown

images' (although in practice there is no reason why paranoiac images are any less susceptible to psychoanalysis that those produced by automatism). Dali's second criticism cited the 'virtual and chimeric' character of automatically produced images and instead he posited 'the physical facts of "objective" irrationality, with which one can . . . wound oneself'. His damning repudiation seems aimed at so-called 'automatist' painters such as Masson: 'I believe that the period of inaccessible mutilations, of unrealizable sanguinary osmosis, of loose visceral torn holes. . . is experimentally closed'.

Dali advanced the cause of paranoiac-critical activity by exposing the weaknesses of existing methods but also by showing his own method capable of accommodating the aims of Surrealism. In his essay *Surrealism and Painting* (1928) Breton had argued that the nature of external reality is suspect because it lies beyond our direct apprehension. We perceive it via our senses but our perceptions are a construct of internal forces, such as memory, learning and desire, as well as exterior causes. He had concluded that, because the external world is suspect, the painter must 'refer to a purely internal

model'; he must be an eye observing the landscape of the mind. In this, Breton was following the lead of Arthur Rimbaud, another nineteenth-century poet whom the Surrealists revered. In his *Lettre du Voyant*, Rimbaud had identified the poet as one who 'makes himself a seer', achieving this by 'a long, immense and reasoned disordering of all the senses'. The importance which Breton attached to this principle is clear in his definition of the aim of Surrealism as being 'the attempt to liberate once and for all the imagination by the "long, immense, reasoned derangement of the senses"'. It also shows that Breton is willing to admit the use of reason, previously excluded by his definition of automatism, into the process of mental liberation. The notion of delirium used in conjunction with conscious processes is central to the paranoiac-critical method.

Dali argued that:

Critical activity intervenes solely as a liquid revealer of images, associations and systematic coherences and *finesses* already existing at the moment when delirious instantaneousness is produced...

What Dali is suggesting here is that paranoiac images, based on the irrational association of different ideas and found in the unconscious mind, already possess a fully formed systematic structure. The notion of a 'critical' faculty appears in *The Interpretation of Dreams* (1900) by Sigmund Freud, meaning the capacity of the mind to take notice of its own thoughts. According to Dali, critical activity was responsible for bringing unconscious ideas to the surface of the mind and then transcribing them onto canvas or paper. This was a voluntary process, in contrast to the passive states of automatism. Dali claimed that these unconscious images, because they already existed, were unchanged by their critical apprehension, even when this was sudden and instantaneous. His use of preliminary sketches, however, and the organization of elements within his paintings suggest that, to some degree, he also used conscious processes to manipulate images mined from the imagination and to invent others. Consciously formed images would thus be used in conjunction with images proceeding from the unconscious. Nevertheless, in theory at least, the concept of a mechanism for *revealing* unconscious images without changing them permitted paranoiac-critical activity to make a virtue out of the main problem confronting automatism: the inevitable intervention of the conscious mind in getting at material in the unconscious.

Breton recognized the value of the paranoiac-critical method as part of the Surrealists' campaign for transforming the nature of reality. Central to this campaign was their conviction that perception constitutes our sense of reality and, because perception can be molded by the liberation of unconscious forces, the real can be modified accordingly. The potential of a controled method of simulated paranoia – a condition which imposed irrational mental structures upon the real world – was clear. Breton wrote:

The paranoiac . . . [regards] the very images of the external world as unstable and transitory, if not as suspect, and it is, disturbingly, in his power to impose the reality of his impression on others. . . We find ourselves in the presence of a new assertion, with formal proofs in support of the *omnipotence of desire* which has remained since the beginning Surrealism's only act of faith . . .

The degree of congruity between the aims
of paranoiac-critical activity and those of
Surrealism is clear from comparing Bre-
ton's statement that 'One can work
systematically, safe from any delirium, at
making the distinction between subjec-
tive and objective lose its necessity and
value' with Dali's parallel assertion that
'Paranoiac-critical activity organizes and
objectivizes in an exclusivist manner the
limitless and unknown possibilities of the
systematic association of subjective and
objective phenomena'. The theory of
paranoiac-critical activity thus evolved
within the wider conceptual framework
of Surrealism's aims and principles. This
provides a context for the development of
the method but it does not account for its
particular nature. In this respect it was
consistent with tendencies apparent in
Dali's work from the beginning of his
association with the Surrealist group.

The central characteristic of Dali's
earliest Surrealist works is their conjunc-
tion of images relating to a range of
abnormal psychological conditions with
autobiographical material. This included
the use of free association, which Dali
subsequently defined as paranoiac in
nature. The key works of this period, in-
cluding *The Lugubrious Game, Illu-
mined Pleasures, The Great Masturbator*,
and *Accommodations of Desire*, all
painted in 1929, demonstrate a familiarity
with and use of the major textbooks of
psychoanalysis. Notable among these
were Freud's *Interpretation of Dreams*
(1900) and also Krafft-Ebing's *Psycho-
pathia Sexualis* (1899), a major study of
sexual perversion. For this reason, in his
book *The History of Surrealist Painting*
(1959), Marcel Jean described these paint-
ings as 'illustrations of a kind for a still un-
written manual of psychoanalysis'. While
this view is true to an extent it overlooks
the way Dali used imagery of a purely
personal nature, in combination with the
vocabulary of psychoanalysis. Reflecting
the importance which Freud attached to
childhood experiences in psychoanalysis,
many of the autobiographical elements in
Dali's paintings have their source in child-
hood memories. However, Dali
employed the techniques and case histo-
ries of psychoanalysis as a means of iden-
tifying and embellishing personal obses-
sions and neuroses, rather than as a way of
understanding and explaining such phe-
nomena.

All of the paintings identified above,
for example, explore, among other things,
various aspects of sexual anxiety. When
Dali met Gala in 1929 he had never ex-
perienced sexual intercourse, and he

appears to have been torn between sexual
desire and a neurotic fear of the sex act. As
his relationship with Gala proceeded and
the prospect of its consummation arose,
this conflict deepened and expressed itself
as an obsessive fixation with masturba-
tion. *The Lugubrious Game* (page 38)
and, more overtly, *The Great Masturba-
tor* (page 42) are concerned with this prac-
tice and a number of neuroses which Dali
associated with it. The lugubrious game in
question is suggested, in the painting of
that name, by the hand of the statue,
which is enlarged due to its masturbatory
function (this element is the central motif
in *The Hand: Remorse* (page 46), which
focuses on the same theme). The atten-
dant feelings of guilt are represented by
the statue, possibly intended to reflect
Dali himself, which hides its face in shame
and turns away from the phallus-shaped
object held up by the figure beneath. The
feared consequences of auto-eroticism are
suggested by other elements in the paint-
ing. A bearded figure representing paren-
tal authority holds a bloodstained hand-
kerchief, alluding to castration, while the
flaccid candle at the foot of the stairs sug-
gests another consequence – impotence.

The enlarged head in profile at the
centre of *The Lugubrious Game* is a re-
current image in Dali's iconography and
is a self-portrait. It features, for example,
in *Portrait of Paul Eluard, Illumined
Pleasures* (page 39), and *The Persistence of
Memory* (page 48), while in *The Great
Masturbator* it is the main subject. In
many instances the face is represented
with a grasshopper clinging to its mouth.
This is typical of Dali's use of an obses-
sional idea, stemming from a childhood
experience, expressed in a vivid pictorial
motif. It relates to Dali's discovery as a
child that a slimy and repellent fish which
he had been inspecting had the same face
as a grasshopper, an insect he had pre-
viously liked. As a result he sponta-
neously associated his repugnance for the
fish with the grasshopper's face. This
phobia is dramatized in the image of the
grasshopper clinging to his own face. The
sense of horror which invests this image is
associated in *The Great Masturbator* with
Dali's anxiety about sexual intercourse,
hence his self-personification in this way.

Another recurrent image in the early
Surrealist works is the lion's head. In *The
Interpretation of Dreams* Freud had iden-

tified animals in dreams as symbols of genitalia, and wild beasts in particular as symbolizing passionate drives which the dreamer is unable to acknowledge. The title of *Accommodations of Desire* (page 40), a painting in which the motif of a lion's head occurs six times in various forms, suggests that Dali used the symbol according to its Freudian connotations. The lion's head is a key element in *Illumined Pleasures*, where it is attached to a female face, depicted in a Freudian way as a jug and hence as a receptacle, transforming this image into a symbol of sexual desire. This in turn spawns a plethora of associated anxieties represented by other motifs in the picture. Hands struggle with a bloody knife, again suggesting fear of castration. The figure of a youth turns away in shame. A shadow falls across the foreground and, by reference to an identical shadow in *The Lugubrious Game*, we know that this is cast by a castrating father supporting a mutilated son. In *The Enigma of Desire* (page 44), the lion's head is connected to a huge amorphous shape growing from the self-portrait motif. Dali often used forms growing from the heads of figures in his paintings to suggest their thoughts; in *The Enigma of Desire* the subject of Dali's thoughts is his mother, indicated by the repeated phrase '*ma mère*'. This is linked to feelings of passion represented by the lion's head symbol, and so the picture symbolizes oedipal desire. While *The Great Masturbator* expresses the feelings of horror inspired by sexual intercourse, *The Enigma of Desire* accounts for that anxiety. Dali stated, 'It is to my mother that I owe my terror of the sexual act. . . It is specifically a matter of a memory, or a "false memory", of my mother sucking, devouring my penis. . .' In Dali's mind, false memories occupied the point at which 'it becomes impossible for me to know where reality begins and the imaginary ends'. As real and vivid as actual experiences, a false memory could be identified as being a fabrication only when it could not be accommodated within the wider pattern of experience. As a result of this particular false memory, the sex act became linked in Dali's mind with feelings of guilt and fear of physical threat.

In the second *Surrealist Manifesto* Breton connected 'the reasoned derangement of the senses' with poetic inspiration, and thus identified psychosis as a fertile source of inspiration. This was a direction in which Dali was already moving. In September 1929, Dali's first Paris exhibition included *The Lugubrious Game, Accommodations of Desire* and *Illumined Pleasures*. Referring to these works in his preface to the catalogue, Breton wrote: 'With the coming of Dali, it is perhaps the first time that the mental windows have been opened really wide'. Breton employed the theories of Freud and of F. W. Myers, an English writer on the paranormal, to support the Surrealists' investigations into the depths of the mind. His accolade also gave the seal of approval to an approach which employed psychoana-

lytical theory specifically as it applied to *abnormal* psychological states. The ideas which Dali had begun to formulate on the use of paranoia were published in *The Putrescent Donkey* in July 1930. Shortly after, and independent of Dali, the results of Dr Jacques Lacan's research into paranoia were published. Lacan's ideas, contained in *On Paranoiac Psychosis in its Relation with the Personality*, concurred with Dali's proposals in identifying paranoia as a systematic and coherent, although completely irrational, phenomenon. Dali's adoption of paranoia may thus be seen as implementing Breton's ideas. At the same time it was also completely consistent with his own artistic development, in that it represented a focusing of his preoccupations within the field of abnormal psychology.

As Breton pointed out, the paranoiac-critical method was capable of being applied to 'all manner of exegesis'. Its use, for example, is apparent in *Un Chien Andalou*, the film on which Dali collaborated with Luis Buñuel in 1929. As the scenario reveals, the opening scene is a classic example of a paranoiac visual association:

Indoors, a man is whetting his razor. He looks through the window at the sky and sees. . .
A fleecy cloud drawing near to the full moon.
Then a young girl's head with staring eyes. A razor-blade approaches one of the eyes.
Now the fleecy cloud passes over the moon.
And the razor-blade passes through the girl's eye, slicing it in two.

The film's subsequent momentum is generated to a large extent by other associations:

None of the ants falls off the hand.
Dissolving into the armpit of a girl stretched on the sand of a sunny beach. Dissolving into a sea-urchin whose sharp spines wave slightly. Dissolving into the head of another girl. . .

The many Surrealist objects which Dali made, notably the *Surrealist Object* (1931), incorporating a glass of milk inside a woman's shoe, and the *Retrospective Bust of a Woman* (1933), also make use of the method and this underlies their fundamental difference from traditional sculpture. The elements which comprise them are not selected for their formal values and are not related according to aesthetic considerations; instead these objects are three-dimensional collages whose parts are fetishistic in nature – their components are irrationally associated with some other object or idea. As Dali stated in *Conquest of the Irrational*, 'The means of pictorial expression are placed at the service of this subject', and it is in Dali's painting that the paranoiac-critical

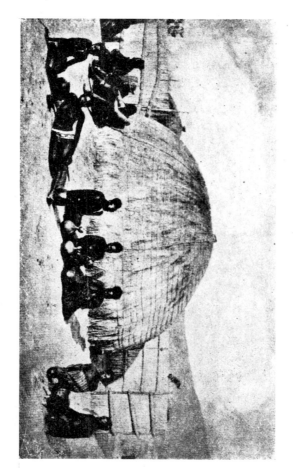
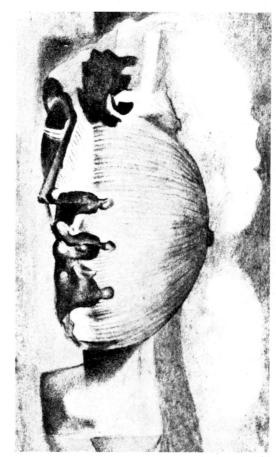
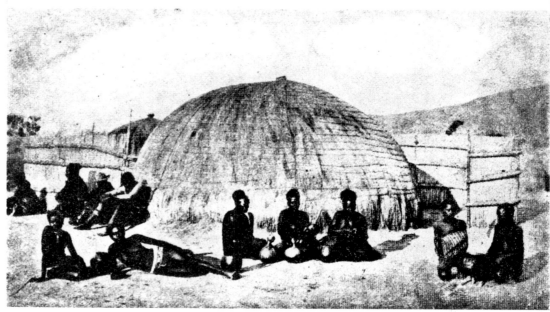

method received its fullest exploration and widest application.

In *Dada and Surrealist Art* (1969), William Rubin observed that 'visually the "paranoiac-critical method" referred to the hallucinatory power to look at any object and "see" another'. This follows Dali's own definition: 'Paranoiac phenomena: common images having a double figuration'. The double image is, of course, nothing new in art. Leonardo da Vinci's *Treatise on Painting*, collected from notes made throughout his life (1452-1519) contains the following advice:

Look at certain walls dirtied with various stains or with a mixture of different kinds of stones. . . you will be able to see in them a resemblance to various landscapes adorned with mountains, rivers, rocks, trees, plains, wide valleys and hills. You will also be able to see various battles and figures in quick movements, and strange expressions on faces, and

Above: Paranoiac Face from *Le Surréalisme au Service de la Révolution* 3, December 1931, showing an early use of the double image; Dali identified a Picasso-style face in this photograph while shuffling through a pile of papers.

costumes, and an infinite number of things. . .

In the sixteenth century Giuseppe Arcimboldo (1537-93) explored the use of the double image in his paintings of fantastic heads formed from leaves and twigs or fruit. Dali's fellow Surrealist Max Ernst also utilized the notion in his frottages. These rely on the use of rubbings, taken from irregular surfaces, to intensify 'the irritabilities of the faculties of the mind'. Put more simply, they permitted the artist to 'read' abstract patterns figuratively by a process of suggestion.

The double and multiple images produced by the paranoiac-critical method have a superficial affinity with these other processes. But an essential difference lies

in the way that Dali specifically linked the recognition of double images with the ability of the hypersensitive paranoid mind to perceive hidden significances in reality by a mechanism of irrational association. Dali also argued that, in the absence of external stimuli in the form of, for example, stains on walls, the formation of these images drew on associations which already existed in the unconscious mind as a result of delirious obsession. Moreover, the visual manifestations of paranoiac-critical activity were not limited to the phenomenon of simultaneous representation but appeared in a variety of forms. One of its earliest applications took the form of a chain of irrationally associated images proceeding from an initial image. This is evident in *The Lugubrious Game* where a plethora of images – a grasshopper, Dali's own face, a rabbit's head, a hand, hats, stones, breasts, a finger, an anus, a vagina – spirals out of the first image: a pair of truncated legs and buttocks. The many other ways in which images became irrationally connected, by formal allusion, by fusion resulting in distortion and composite forms, by the linking of objects with unfamiliar qualities, by repetition of outline and form, is examined in detail below.

Firstly, however, it is necessary to look at Dali's use of the paranoiac-critical method as a means of 'psychic-interpretive illustration', which relates to the way paranoiacs 'interpret' reality, perceiving hidden significances in events and objects by the irrational associations of *ideas* as well as images. This is evident in Dali's treatment of the legend of William Tell and of Millet's painting *The Angelus*. Between 1930 and 1933 Dali painted a number of pictures in which the legend of William Tell became associated with and subjected to an obsessional idea. The paintings include *William Tell* (page 50), *The Old Age of William Tell* (1931), and *The Enigma of William Tell* (page 54). In these works the story of the Swiss bowman, sentenced to shoot an arrow at an apple placed on his son's head because of an act of patriotic rebellion, became bound up with the hiatus which had occurred between Dali and his father. One cause of this was Dali's affair with Eluard's wife, Gala. As a result, Dali saw the story as signifying paternal threat and he reinterpreted the legend as a castration myth. In *William Tell* for example, the hero has become a bearded father figure wielding a pair of scissors, his intent made apparent by the obsessive repetition of phallic references in the painting. His own penis and that of the horse are fully exposed and are echoed in the egg-cup motif on the plinth and the eggs in the nest. The youth's genitals are concealed by a leaf, so that it is unclear whether castration is impending or has happened.

The water gushing from the hole in the wall is, however, suggestive of mutilation. Other pictures in the series are even further removed from the legend's source. In *The Old Age of William Tell* the father figure is engaged in some undisclosed sexual act, suggested by the shadow of the lion denoting passion. In *The Enigma of William Tell*, the father figure is represented as Lenin holding the baby Dali in his arms.

In his book *The Tragic Myth of Millet's Angelus*, written in 1938 but not published until 1963, Dali applied a paranoiac-critical process of interpretation to Millet's painting, 'analyzing' the picture in terms of the personal, irrational and obsessive associations produced by its individual elements. In this way he divined a web of hidden significances. The predatory nature of the father, which Dali perceived in the William Tell legend, is restated in his interpretation of *The Angelus*. He saw this as 'the maternal variant of the immense and atrocious myth of Saturn, of Abraham, of the Eternal Father with Jesus Christ and of William Tell himself devouring their own sons', and identified an underlying sexual tension in *The Angelus*. This interpretation is also apparent in the preface to the exhibition of his illustrations for Lautréamont's *Les Chants de Maldoror*, where he established an equivalence between Millet's painting and Lautréamont's phrase 'as beautiful as the chance encounter on a dissecting table of a sewing machine and an umbrella'. The setting of *The Angelus* is analogous to the dissecting table. The fork thrust into the earth, 'sinking ... with ... purposeful greed for fertility', signifies sexual penetration but, by further association, is also connected with a surgeon's scalpel used for dissecting corpses. Thus, by the irrational processes of paranoia, sex and death become connected.

Dali sees the postures of the peasant couple as consistent with this interpretation. The male figure, he explains 'is trying to hide his state of erection... by the shameful and compromising position of his own hat'. The pose of the female peasant is identified with the 'superfree perforation of the praying mantis', an allusion to the female insect's habit of devouring the male after copulation. The handles of the wheelbarrow behind the woman echo the 'praying' attitude of the mantis. *The Angelus* appears in a number

of Dali's paintings between 1932 and 1935, including *Meditation on the Harp* (page 58), *Gala and the Angelus of Millet before the Imminent Arrival of the Conical Anamorphoses* (page 61), *The Architectural Angelus of Millet* (page 62), *Archaeological Reminiscence of Millet's Angelus* (page 64), *Atavistic Vestiges After the Rain* (page 66), *The Atavism of Dusk* (page 63) and *Portrait of Gala* (page 74). Dali's reinterpretation of *The Angelus* is evident in these works; in *The Atavism of Dusk* the male peasant has been transformed into a skeleton as a result of his

Left: Winter by Giuseppe Arcimboldo, 1563, making early use of the double image.
Above: Max Ernst's *Evening Song*, 1938, uses *frottage* to create a double image.
Below: The Angelus, 1857-59, by Jean-Francois Millet became a fertile source of paranoiac interpretation during the 1930s.

fatal sexual encounter, and in *Portrait of Gala* Dali's future wife has become involved with the relation of the peasants through her double depiction.

The various manifestations of the paranoiac association of 'objective phenomena', as opposed to the 'psychic-interpretative' associations discussed above, are more subtle and diverse than is generally conceded. In *The Visible Woman* (1930), Dali wrote that:

It is by a specifically paranoiac process that it is possible to obtain a double image: that is the image of an object which, without the least figurative or anatomical modification can at the same time represent another, absolutely different object. . .

However, he also made clear that paranoiac associations are not necessarily limited to double figurations but:

The double image may be extended, continuing the paranoiac advance, and then the presence of another dominant idea is enough to make a third image appear. . . and so on, until there is a number of images limited only to the mind's degree of paranoiac capacity.

Hallucinatory images produced by the paranoiac-critical method are thus capable of indefinite multiplication. Although the paintings record the delirious images obtained by the artist during paranoiac-critical activity, the exact nature of the corresponding hallucination which they evoke in the observer is rendered ambiguous by these statements. Dali's first statement implies the co-existence of two images which interrelate *simultaneously*, so that it is impossible to look at one without also being aware of the other. The mind of the observer thus hovers between two perceptual alternatives. In contrast, his second statement implies that two or more images co-exist and are experienced *sequentially*. In this way the observer experiences a hallucination which corresponds to the passage

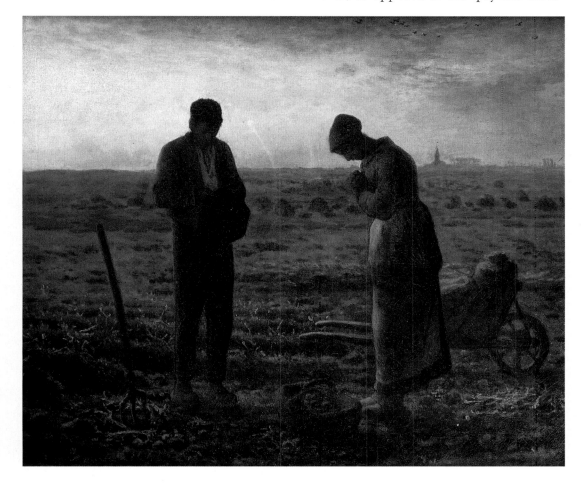

21

of the mind from one perceptual alternative to another. This is a fine distinction which relates directly to the degree of exclusivity with which alternative images are rendered or, in Dali's terminology, the extent to which they have undergone 'figurative or anatomical modification'. In practice, Dali's early attempts at double and multiple figuration involved a high degree of modification of the various alternatives so that different readings are not entirely visually exclusive, and so the observer tends to experience them simultaneously. As Dali's technique became more sophisticated he was able to make independent exclusive readings possible without a high degree of modification of the constituent elements. This enabled the observer to experience alternative images separately and sequentially. The process of multiple figuration was thus subject to considerable development throughout the course of the application of the paranoiac-critical process to painting.

Two paintings which represent Dali's earliest attempts at double and multiple figuration, are *The Invisible Man* (1929-33) and *Invisible Sleeping Woman, Horse, Lion* (1930, page 54). Both demonstrate the difficulty involved in entirely excluding figurative or anatomical modification from the process. In *The Invisible Man* we are aware of the figure and the architectural setting simultaneously, completely independent and exclusive readings being precluded by the degree of transformation which various elements have undergone. The figure's right arm, for example, has undergone a complete anatomical modification and is fully described as the torso of a woman, but can

only be read as an arm because of its strategic placing. In other parts of the painting, alternative readings are not held quite in balance; the left hand is painted in a literal way and the head is easier to read than the corresponding architectural elements, so that the effect is one of transparency rather than hallucination. *Invisible Sleeping Woman, Horse, Lion* is a more ambitious subject and is Dali's first attempt at a multiple image, but is also not completely resolved. The artist described it as follows:

The double image (the example of which may be that of the image of the horse above which is at the same time the image of a woman) can be prolonged continuing the paranoiac process, the existence of another obscure idea being then sufficient to make a third image appear (the image of a lion, for example)...

In one of the three versions that he painted there are two further elements, unnamed by Dali: a group of fellateurs in the foreground and a pair of boats with figures. In this image the metamorphosis of the various component elements is

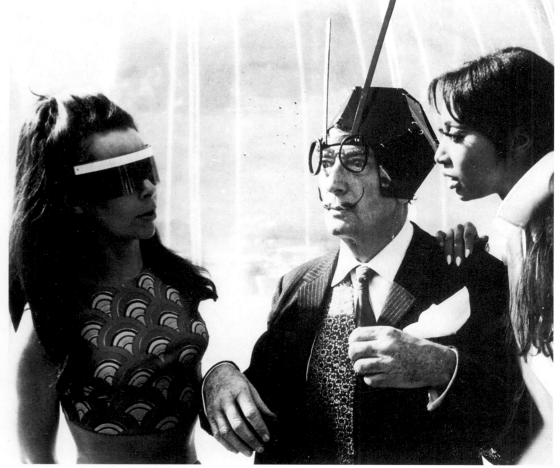

even more marked, so that mutually exclusive readings are not possible and some elements do not cohere independently at all. The difficulty of holding so many elements in balance means that, overall, the image is confusing and we are aware of a number of similar forms competing simultaneously for our attention.

In contrast to these early non-exclusive, simultaneous images are later paintings in which Dali mastered the technique of making two images interrelate, so that completely alternative and exclusive readings are possible. There is a minimum of formal modification and the observer experiences either image fully independently and sequentially; the image is not so much a composite form as one which seems to 'switch' in the mind's eye from one form to another. This was achieved through simplification of the constituent elements, as is evident in one of the first fully successful works of this type, *The Phantom Cart* (1933, page 60). In this painting the observer experiences the illusion of a cart, which is being driven toward a distant town, suddenly appearing empty, the driver having vanished. Instead, a distant tower is seen through the covering on the cart. This hallucination rests on the simple formal association of the figure with the tower but the effect is potent in its power to disorientate. An insoluble question is posed and we are forced to question the veracity of our senses. It is, as Dali stated, part of his effort to 'systematize confusion and contribute to the total discrediting of the world of reality'.

The success of paranoiac-critical associations of this type resides principally in the ability of the artist to undermine the observer's assumptions about reality, but also in Dali's capacity to impose a subjective idea upon the real world. As *Paranoiac Face*, published in *Surrealism in the Service of the Revolution*, No. 3 December 1931, demonstrates, the origin of such ideas can be as much a matter of recognition as of invention. In this example, two completely independent images, an African sculpted head and a group of African natives seated in front of a hut, coexist within a single configuration. The artist's intervention is minimal, since the image is an original photograph which Dali accidentally happened upon. The hallucinatory association which he recognized is forced upon the observer by the simple expedient of changing the format of the photograph; upright it depicts the

head, lengthways it shows the group of natives. This manifests Dali's conviction that paranoiac sensitivity is a matter of the ability to recognize hidden meanings and significances in the commonplace. This particular hallucination was subsequently developed as a painting, *The Great Paranoiac* (1936, page 79), in which figures in a landscape change in to a gigantic head.

Dali perfected the technique of double figuration during the middle of the 1930s. In *Impressions of Africa* (1938, page 90), the double images cluster at the peripheries, so that the edges of vision seem to shift and transmute as in a dream. A remarkable metamorphosis in this work is the switch which Dali forces from the image of a priest to the head of a donkey. In *Slave Market with the Disappearing Bust of Voltaire* (1940, page 96), two women in seventeenth-century Spanish

costume disappear and are replaced by an apparition of Houdon's bust of the French philosopher. Quite different is the type of hallucination in *Swans Reflecting Elephants* (1937, page 86). In this painting double images abut, rather than overlapping, so that the reflections cast by the swans appear as elephants. The difference between this type of double image and those discussed so far is that instead of two images co-existing within a single configuration, the configuration is repeated in another part of the painting with a different visual significance. In this way, the viewer is made aware of an association between two different facets of reality, not by experiencing a transformation from one to another, but by being compelled to sense a connection between elements which are physically separate. Dali painted a number of works which

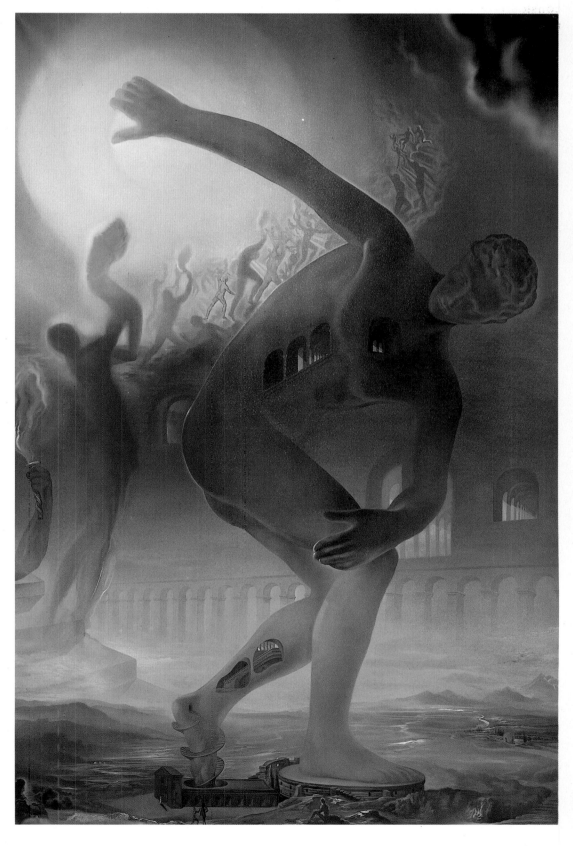

Left above: Dali's *One Second Before Awakening from a Dream Caused by the Flight of a Bee Around a Pomegranate*, 1944, a key example of Surrealist dream transcription.
Left: Dali photographed in Barcelona in 1966.
Right: The Cosmic Athlete reflects Dali's synthesis of Renaissance art, physics and metaphysics in the 1950s and 1960s.

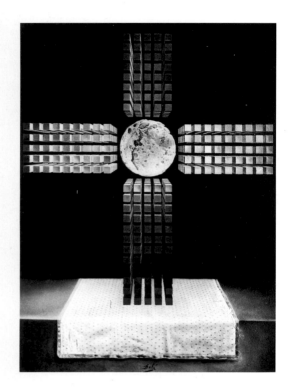

feature this phenomenon. In *Suburbs of a Paranoiac-Critical Town; Afternoon on the Outskirts of European History* (1936, page 80), a network of associations connects the bunch of grapes held by Gala with the skull on the table and with the hindquarters of the equestrian statue; the girl skipping, with the bell in the distant tower; the figures on the arcaded building at left, with the chesspieces on the dressing-table; and the keyhole in the cabinet at the right of the picture with the distant figure framed by the doorway beyond. In *Metamorphosis of Narcissus* (1937, page 88), the repetition of a configuration is the central feature of the work and carries a temporal significance; Narcissus is shown regarding his reflection, while at his side the hand holding an egg depicts the nature of his subsequent transformation. In *The Weaning of Furniture-Nutrition* (1934, page 68), three elements are linked by virtue of their related outlines: the cupboard seems to have been formed from the back of the nurse and, in turn, seems to have formed the smaller cabinet with the wine bottle. Outline as the basis of repetition is also evident in *Paranoiac-Critical Solitude* (1935, page 76), an arresting and sophisticated image reminiscent of Magritte. The car seems three-dimensional in its lower half because the wheels cast a shadow on the ground, while a hole driven through the rocks behind also cuts through the top half of the car, suggesting that the rock and car are somehow consubstantial. This confusion is heightened by the repetition of the outline of the car and hole in the rock wall. The implication is that the car is really a two-dimensional relief which has been removed and shifted; reality and appearance are thus meshed in an insoluble conundrum.

The relation of different levels of reality is also explored by the repetition of images in *Portrait of Gala* (1935). Gala is portrayed seated on a wheelbarrow, a position which echoes that of the peasant in the picture behind, a variation on Millet's *The Angelus*. In this way the reality of the picture on the wall is extended into the space which Gala occupies. At the same time, the dual depiction of Gala, front and back, connects with the composition of the figures in the Millet variation. The back view also suggests a surrogate for the viewer in the real world looking into the picture. Three different levels of reality are thus invoked and connected by a chain of association.

On occasion, the paranoiac-critical method was used to create associations between disparate objects, or between objects and qualities which are normally distinct. This resulted, not in double images, but in distortion or fantastic forms. In *Average Atmospherocephalic Bureaucrat in the Act of Milking a Cranial Harp* (page 65), a huge soft skull is draped over a crutch and is supported by a human figure. The skull sags like the udder of a cow and also assumes the position of a harp. Both interpretations are accommodated by the gesture of the bureaucrat, who seems both to be milking a cow and playing a harp. In *The Persistence of Memory* (page 48), the quality of softness characteristic of camambert cheese is associated with watches, which become soft and runny. In other works, the association of images is allusive rather than resulting in distortion. In *Anthropomorphic Bread* (page 56), the French loaf is invested with phallic significance while retaining its own identity. The rigidity of the bread seems artificially sustained by being roped, which conveys an anxiety about impotence.

A particular form of paranoiac association which invests a number of Dali's

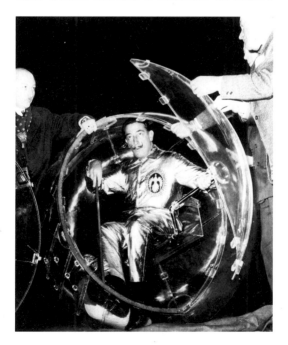

Top: Dali's *Nuclear Cross*, 1952; in the 1950s Dali began to harness his nuclear painting to religious subject-matter.
Above: Dali in his pedal-powered ovocipede, 1959.
Right: This 1940s society portrait typifies the commercialism attacked by Breton.

works is the relation established between animate and inanimate elements. Living things tend to putrescence while objects possess the ability to come alive. In *Ghost of Vermeer of Delft Which can be Used as a Table* (page 71), the leg of the apparition has assumed a purely functional role. In *Skull with its Lyric Appendage Leaning on a Night Table which should have the Temperature of a Cardinal Bird's Nest* (page 72), a remnant of human life and a manufactured object are connected by the linking of teeth with piano keys; in *Atmospheric Skull Sodomizing a Grand Piano* (page 73) they indulge in an erotic act. In this way the systematic confusion and discrediting of reality is effected by linking elements belonging to different categories of being. Often the grounds for the association of different images and the forms taken by particular paranoiac visions are completely inexplicable. The connection, for example, between a piano keyboard and the head of Lenin in *Composition – Evocation of Lenin* (1931) remain enigmatic.

Toward the end of the 1930s Dali painted a number of pictures which demonstrate an increasing technical sophistication in the rendering of multiple images, but also a corresponding decline in hallucinatory force. The pictures are ingenious rather than truly delirious. In *Apparition of Face and Fruit Dish on a Beach* (page 92), the multiplication of associations has produced a complex of images. A dog appears from a mountainous landscape, its body forming a fruit dish; in turn the fruit dish dissolves to reveal a face which is also, in part, formed from a seated woman shown from behind. Various other incidentals – a tabletop, figures in the landscape, a length of rope – support the illusion. In *The Endless Enigma* (page 93) the interlocking forms include a beach scene depicting a woman mending the sail of a boat, a reclining philosopher, a hideous face, a greyhound, a mandolin and a fruit dish on a tabletop, and a mythological beast. Breton's opinion was that: 'By wanting to be punctilious in his paranoiac method, it can be observed that he is beginning to fall prey to a diversion of the order of a crossword puzzle'. The implication is clear: the means were taking precedence over the subject-matter, which is characterized by a growing banality.

The development of the paranoiac-critical method in this direction meant that its usefulness to Surrealism was compromised. For Breton, the central tenet of Surrealism was the 'resolution of all the principal problems of life'. When any method became valued for its own sake it had to be abandoned. In Dali's case it was apparent that 'pictorial expression' was no longer 'at the service of this subject': it had become the subject. A more funda-

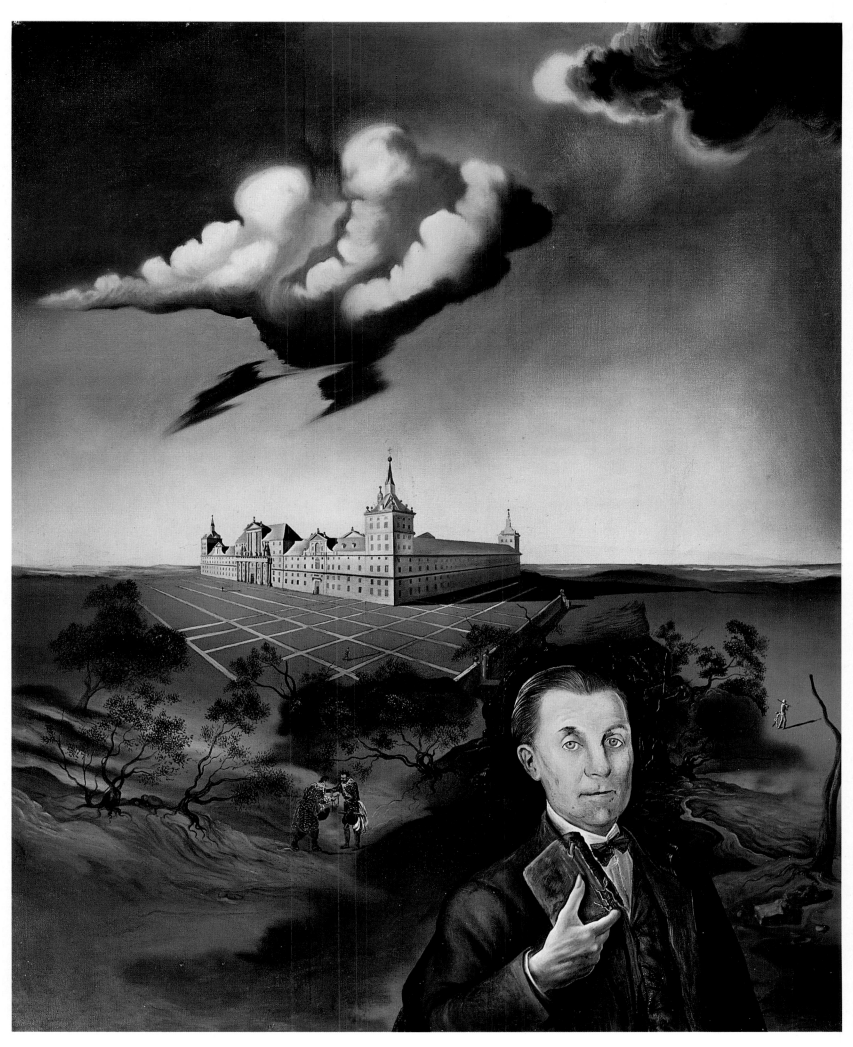

mental problem was the ideological distance which had grown between Dali and Surrealism. Breton had advocated the reasoned derangement of the senses, but only prior to the final unification of personality and 'the future resolution of these two states, dream and reality'. In contrast, Dali'a aim was to 'systematize confusion and contribute to the total discrediting of the world of reality'. Although he wanted to invest concrete irrationality with 'the same consistency . . . as phenomenal reality', these two states were not to be resolved, and irrationality was cultivated and prized for its own sake. In view of this difference, Breton's fear in 1929 that 'the admirable voice which is Dali's will not break' was prophetic of the hiatus which occurred between Dali and Surrealism at the end of the 1930s. In the post-war period Dali turned his attention to resolving another pair of opposites: physics and metaphysics. And in this the paranoiac-critical method still had a part to play because his ethos remained unchanged: 'Madness . . . constitutes the common base of the human spirit'.

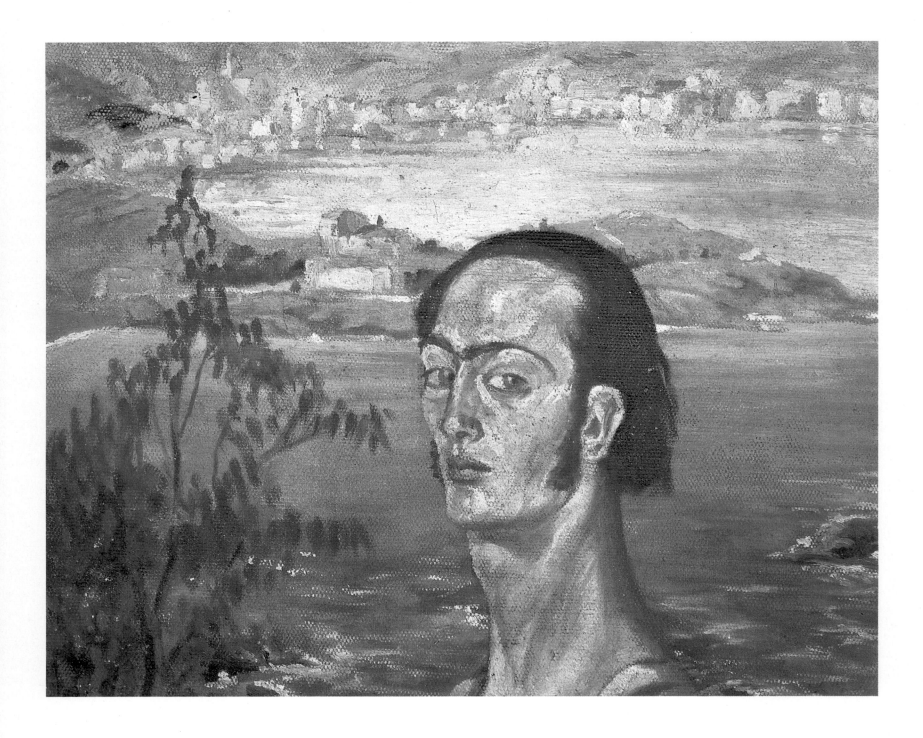

Self-Portrait with the Neck of Raphael, 1921

Oil on canvas
21¼×22½ inches (60×57 cm)
Spanish State Patrimony

This self-portrait is one of several which Dali executed during 1921, a critical year in his personal and artistic development. On February 6, 1921 his mother died. Dali had worshiped her and he described this event as 'the greatest blow I had experienced in my life'. The following September he left the family home at Figueras and entered the School of Fine Arts at Madrid. Throughout his childhood and early teenage years Dali used to spend his summer vacations at Cadaqués on the Costa Brava, where his parents had a holiday home. The cove of Seboya which is connected by road to Cadaqués can be seen in the background of this painting.

As it was probably painted during the summer, this portrait must therefore have been completed in the aftermath of loss and in anticipation of commencing an independent life to develop the artistic talent evident in this work.

In style it reflects Dali's movement away from the Impressionist palette which had characterized his paintings hitherto, and his adoption of what he called 'exuberant colors' which reflects the influence of Fauvism. The composition is dramatic. Dali depicts himself against the wide expanse of the bay yet his own image dominates the painting. The light reflected from the water below

illuminates his face as he turns away momentarily to look out of the painting. As in his other self-portraits at this time, Dali takes the opportunity to show off his long sideburns of which he was particularly proud. This affectation earned him the nickname 'Señor Patillas'. He fixes the viewer with a stare bordering on contempt, his expression grave yet sensitive. The impression evoked is that of the visionary and the aesthete surveying himself, his world and his future; and the confident tilt of the head suggests the vision which Dali recorded in his autobiography, *The Secret Life:* 'I would go my way with head held high, full of pride'.

26

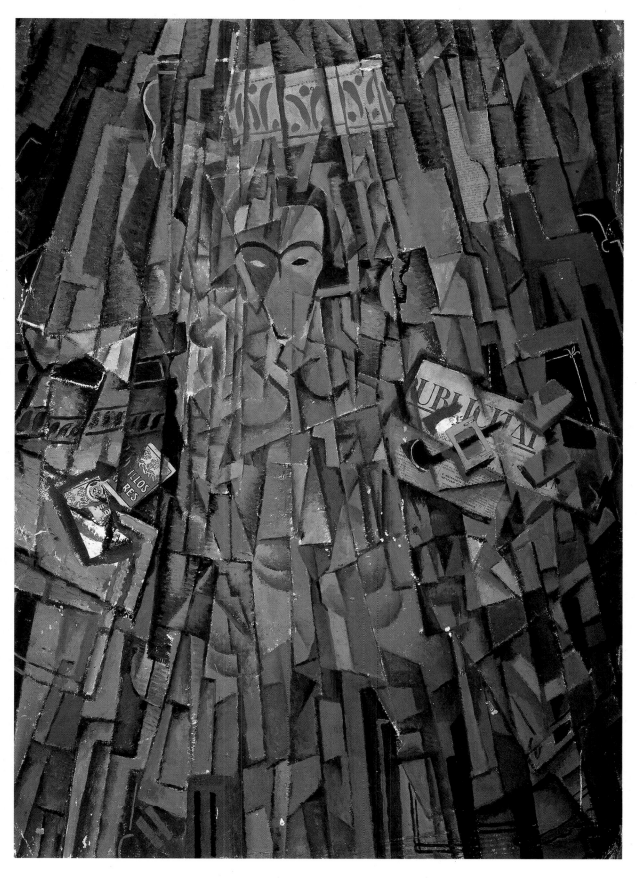

Cubist Self-Portrait, c. 1922-23

Gouache and collage on cardboard
41¼×29¼ inches (104.7×74.3 cm)
Spanish State Patrimony

The paintings which Dali produced as a student in Madrid reveal a lively and rapid experimentation with a range of avant-garde styles, although he also continued to paint using a more conventional realist technique throughout the period. Soon after entering the Academy, his Post-Impressionist and Fauvist inspired essays gave way to the influence of Picasso, Braque and Gris. Leading an ascetic and solitary existence, he spent hours in his room reading and painting his first Cubist paintings. 'These', Dali observed, 'were

almost monochromes. As a reaction against my previous colorist and Impressionist periods, the only colors in my palette were white, black, sienna and olive green'.

This particular work reveals an unsophisticated grasp of the essential stylistic traits of Cubism. The fragmentation of forms into flat shapes arranged parallel to the picture plane shows the influence of the analytical phase of Cubism and, in particular, works such as Picasso's *Man with a Pipe,* 1911. But Dali has also incorporated fragments of collage – the newspaper, for instance – a device which belongs to a later phase of Cubism. Also, the planar fragmentation is decorative rather than truly analytical in its treatment of form. Despite this, the effect of

these works on Dali's fellow students was dramatic. They identified Dali as an independent spirit and as an intellectual alive to new ideas. Overnight he ceased to be the butt of their derision and was accepted as a leading figure in one of the more avant-garde student groups.

Traces of figurative elements reveal Dali's fantastic appearance at this time: the long hair stuck out on either side of his head like a mane; the pipe, which hung unlit from the corner of his mouth; and, in the pyramidal arrangement of the shapes sweeping down the canvas, the waterproof cape, covering a pair of shorts and puttees, which reached to the ground. Thus attired an inner voice repeated to him: 'Dali, Dali! You must do something phenomenal'.

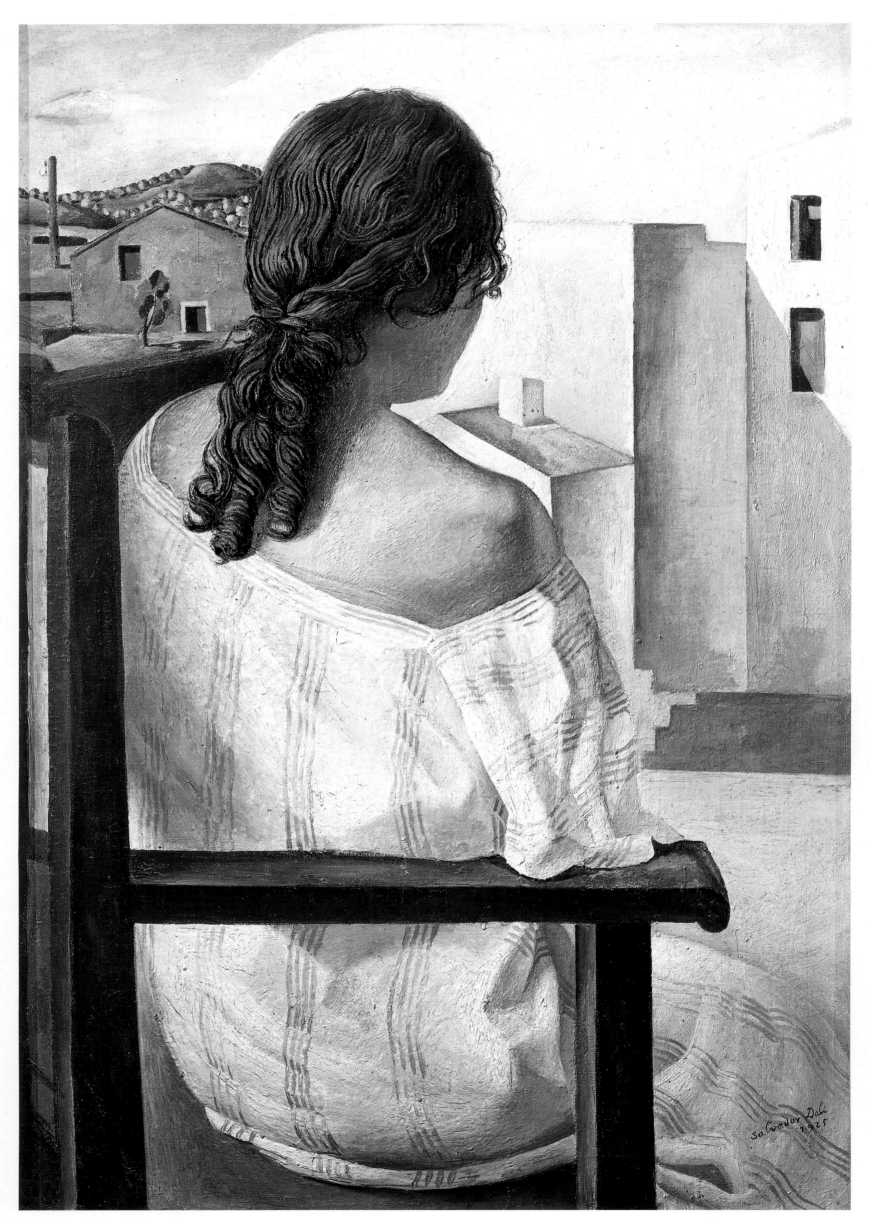

Seated Girl, Seen From the Back (The Artist's Sister), 1925

Oil on canvas
42½×30¼ inches (108×76.8 cm)
Museum of Contemporary Art, Madrid

Throughout the early 1920s, and concurrent with his experiments in Divisionism, Cubism and Purism, Dali continued to paint in a realistic vein. During the summer of 1925, which he spent at Cadaqués, he concentrated on this style and brought it to a new level of technical accomplishment. *Seated Girl, Seen From the Back* is the largest of several portraits of his sister Ana Maria, which he painted at this time. All were included in Dali's first one-man exhibition, held at the Dalmau Gallery, Barcelona, November 14-27 1925.

Seated Girl, Seen From the Back is an unusual portrait in that the face of the subject is hidden, eliminating any psychological interest. Instead, the work arrests the attention because of the cool objectivity with which it has been rendered; in this respect the influence of Ingres is evident. The inspiration for depicting the subject from behind would also seem to derive from the central nude in Ingres's *Le Bain Turc* (1863). The peculiar force of Dali's realism is generated by its marriage of simplification and subtle stylization. This can be seen in the picture's composition and also in the treatment of individual detail. An even light pervades the scene and Dali draws an effective contrast between the graceful form and soft flesh tones of the subject and the angular planes of the surrounding objects. The chair is described as a simple vertical and horizontal structure. The buildings beyond are expressed as a pattern of abutting planes. Amid this network of geometric shapes, a sinuous line describes Ana Maria's outline and is echoed in the pattern of her robe. Her hair, the focus of interest in the picture, exercises a fascination in the way the coiling tresses are simply yet precisely suggested by a cluster of arabesque-shaped strokes.

The exhibition at the Dalmau Gallery also included works in Purist and Cubist styles. Despite this stylistic incoherence it was generally well received by local critics and, more importantly, it was seen and admired by Miró and Picasso. The latter was particularly enthusiastic about *Seated Girl Seen From the Back*. It was at this time that Dalmau brought a copy of the review *La Révolution Surréaliste* to Dali's attention. The exhibition thus provided a platform for Dali's exposure to the Parisian avant-garde, and encouraged him to develop the intensity of observation revealed in this picture.

Figure on the Rocks, 1926

Oil on panel
10¾×16 inches (27.3×40.6 cm)
Salvador Dali Museum, St Petersburg,
Florida

Following Picasso's interest in Dali's first one-man exhibition at Barcelona in 1925, the influence of the older artist became increasingly evident in Dali's work during the next two years. *Figure on the Rocks* belongs to a phase which Dali called 'neo-Cubist' although it relates to Picasso's classical style of the early 1920s. Its subject would have been a common sight whenever Dali stayed at Cadaqués: female bathers stretched out under the Mediterranean sun on the rocks surrounding the bay. A primary characteristic of Picasso's classical style was the massive, sculptural quality with which he invested the human figure. In *Figure on the Rocks* Dali employs this stylistic trait to describe the sexually provocative nature of the bathers' reclining positions. But Dali's bather is depicted as clumsy rather than seductive; based on a composition of crossed diagonals, the figure is prostrated on the rocks, her legs splayed and arms stretched out in a position of overt sexual abandon. Her drapery suggests a yawning vagina and accentuates rather than conceals the enlarged breasts. Advertised in this manner her sexual availability is grotesque, her attitude agonized rather than pleasured. The massive quality of the figure conjoins her to the large rocks on which she lies and the drapery clasped in her left hand evokes a waterfall rather than cloth. In this way the bather is depersonalized and reduced to the level of the material object: 'a piece of ass', as Dali referred to the Cadaqués sunbathers. The sexual allusion in this work marks the first appearance of subject-matter which would preoccupy Dali at the end of the decade.

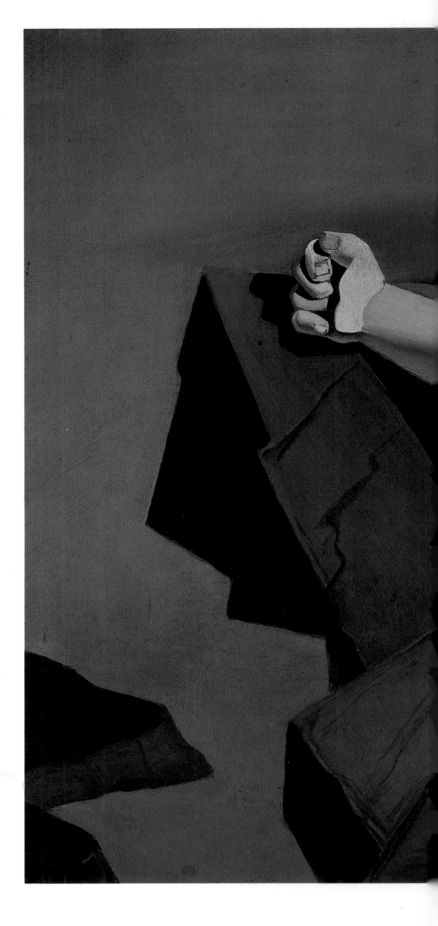

Apparatus and Hand, 1927

Oil on panel
24½×18¼ inches (62.2×46.3 cm)
Collection of Mr and Mrs A Reynolds
Morse, on loan to Salvador Dali
Museum, St Petersburg, Florida

In October 1926 Dali was expelled from the School of Fine Arts in Madrid. Shortly after, in February 1927, he commenced nine months of military service. During this time he painted only one painting but the experience appears to have afforded him the opportunity to take stock of his artistic direction. In the autumn of that year Dali wrote to his friend the poet Federico Garciá Lorca: 'Federico I am painting pictures which make me die for joy, I am creating with an absolute naturalness, without the slightest aesthetic concern, I am making things that inspire me with a very profound emotion and I am trying to paint them honestly'.

Apparatus and Hand is one of the first works which Dali completed when he recommenced painting. It demonstrates Dali's assimilation of the Surrealist ethos of fidelity to unconscious imagery unfettered by aesthetic, moral or intellectual forces. The 'apparatus' is a geometric structure with the suggestion of some human attributes: legs, torso, head, an eye and, most obviously, a hand. The latter is a recurrent motif in Dali's iconography around this time and refers to masturba-tion, a theme which he pursued obsessively during the next five years. The means of auto-eroticism – the 'ever-dissatisfied hand' – is depicted here as tumescent, veined and in place of a brain. In this way, the 'apparatus' is a self-portrait in which Dali depicts himself, with brutal frankness, as an automaton in the grip of onanistic obsession. The apparatus is depicted surrounded by the causes of this obsession. To its right a female bather is depicted as a cut-out, an image conveying Dali's contempt for, and also his fascination with, the Cadaqués bathers' sexuality. Other ghostly images, including a naked female torso, float around the head of the apparatus, suggesting a delirium of erotic imaginings. To the left, a donkey rears on its hind legs, reaching for a fish. The Surrealists often used a fish to denote female genitalia and Dali employed it in this way in his painting *Barcelonese Mannequin* (1927). The donkey's behavior thus evokes sexual desire. Its swollen belly is eaten by flies, suggesting putrefaction. This, and the fish skeleton inside the donkey's head, evoke Dali's fear of sexual intercourse, a neurosis which accounts for the apparatus's obsession.

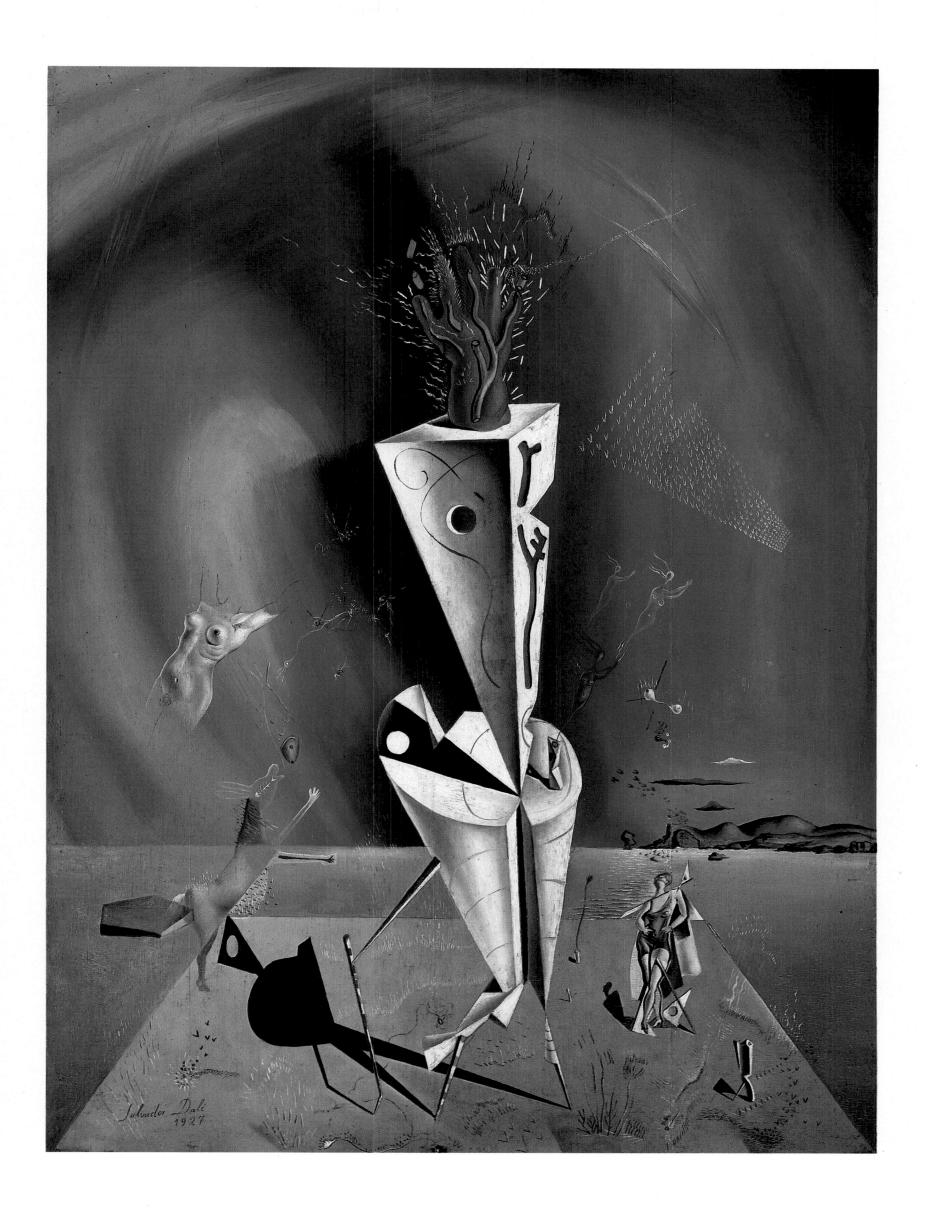

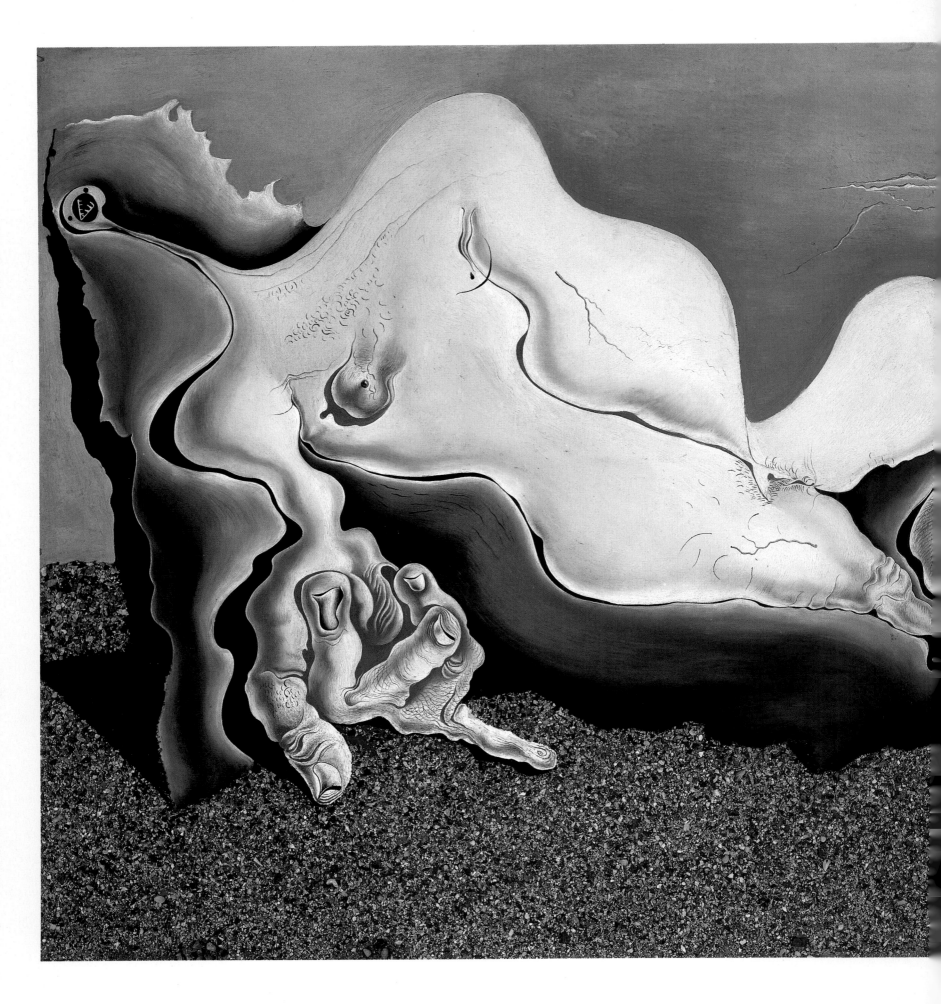

Bather, 1928

Oil on panel with sand
25×29½ inches (63.5×74.9 cm)
Collection of Mr and Mrs Reynolds
Morse, on loan to Salvador Dali
Museum, St. Petersburg, Florida

The female bathers which Dali saw during his summer vacations at Cadaqués inspired a number of paintings of this subject during the 1920s, several of an overtly erotic nature. In this painting the subject becomes a vehicle for Dali's exploration of the theme of masturbation. The bather is shown reclining on a beach which Dali describes using collaged sand, a device borrowed from Masson. The figure is both female and male, both masturbator and the object of Dali's onanistic fantasy. The reduction of its head to miniscule proportions and the biomorphic distortion of the limbs and body reflects the influence of Miró. The bather possesses female breasts but the presence of chest hairs makes it a hermaphrodite. A large fluid shape describes an arm leading to a tiny hand caressing female genitalia. The other enlarged hand is again a masturbation motif. Two fingers compress the palm into a vulva-like cleft to which a rigid middle digit intends. The torn edge of the rocky outcrop on which the figure is lying suggests the profile of a face cry-

The First Days of Spring, 1929

(next page)
Oil and collage on panel
19½×25⅛ inches (49.5×64 cm)
Private Collection

The First Days of Spring represents Dali's complete assimilation of Surrealist ideas and also the emergence of an original vision capable of galvanizing the Surrealist movement at a point when it had lost unity, direction and purpose. Dali described this work as one in which 'libidinous pleasure was described in symbols of surprising objectivity'. In it Dali found a way of elaborating the autobiographical and erotic subject-matter of the work completed during the previous year by harnessing it to imagery and symbolic material derived from his reading of psychoanalytic textbooks. Dali rendered the imagery thrown up by this process with meticulous realism: 'hard done color photography', as he described it. This painting represents Dali's first extensive use of a creative method which proceeded by willed irrationality. The method had also been used, slightly earlier, in Dali's creation of the scenario for *Un Chien Andalou,* the film on which he collaborated with Luis Buñuel, which was filmed in Paris in March 1929. Images were formed by recording an initial idea which had been arrived at without premeditation, and then forging a chain of irrationally associated images suggested by this first element. This painting thus represents the first systematic application of the process of simulating paranoiac thought processes, which lies at the heart of Dali's painting during the course of his association with the Surrealist group and also informs some later work.

The painting records a 'veritable erotic delirium'. In the foreground a gagged man kneels beside a female figure, her legs splayed and a breast exposed, her face taking the form of an orifice which draws a swarm of flies. The man's hands also form a pair of buttocks placed above a bucket. Growing from this is a phallic finger above a pair of balls, a form of double image which Dali would later develop by means of the paranoiac-critical method. The central image derives from Freudian symbolism. A jug - a receptacle and hence symbolizing a female – is conjoined with a fish head, previously used by Dali to represent female genitalia. This is positioned on some steps which, in Freudian symbolism, represent sexual intercourse. To the left of this a grasshopper clings to an image of Dali's own face, which is linked in turn to a chain of other elements. At extreme right, a small girl offers her purse to a bearded father figure, a situation formed from classic Freudian symbols. At centre Dali has collaged a photograph of himself as a child, thus confirming the importance which Freudian psychoanalysis attaches to childhood experience. All are set within a deep perspectival space leading to an empty horizon; a dream-like landscape which provides the setting for numerous paintings by Dali during the 1930s.

ing out on the point of orgasm. The description of the figure's left leg and buttocks also alludes to ejaculated semen. The ambivalent visual significance of the hand, rock and leg represents the beginning of Dali's interest in double images and in investing objects with hidden meanings. The association of disparate elements, which was to be central to Dali's development of the paranoiac-critical method, may thus be traced to this work, and others which Dali completed around this time.

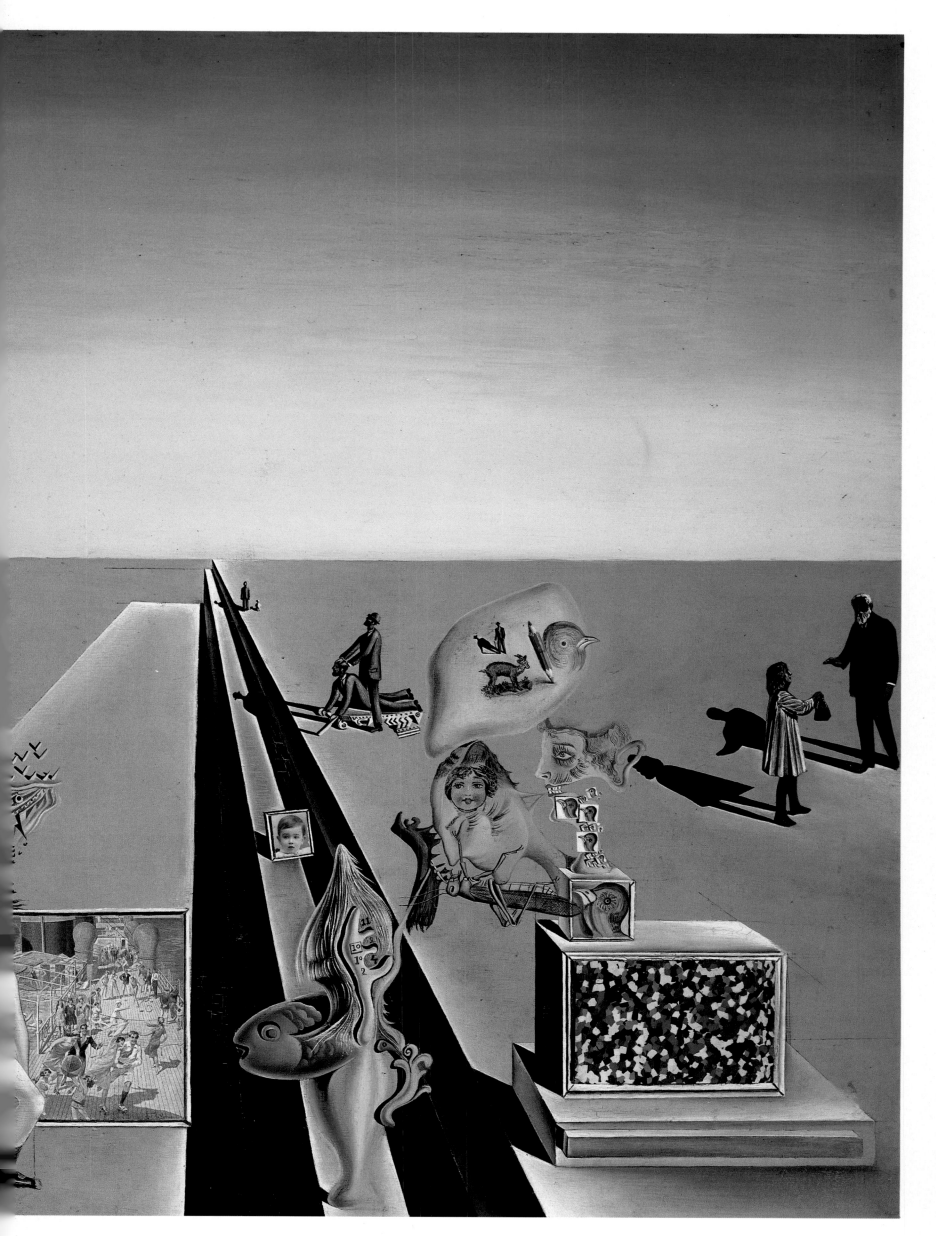

The Lugubrious Game (Dismal Sport), 1929

Oil and collage on cardboard
17½×11¹⁵⁄₁₆ inches (44.5×30cm)
Private Collection

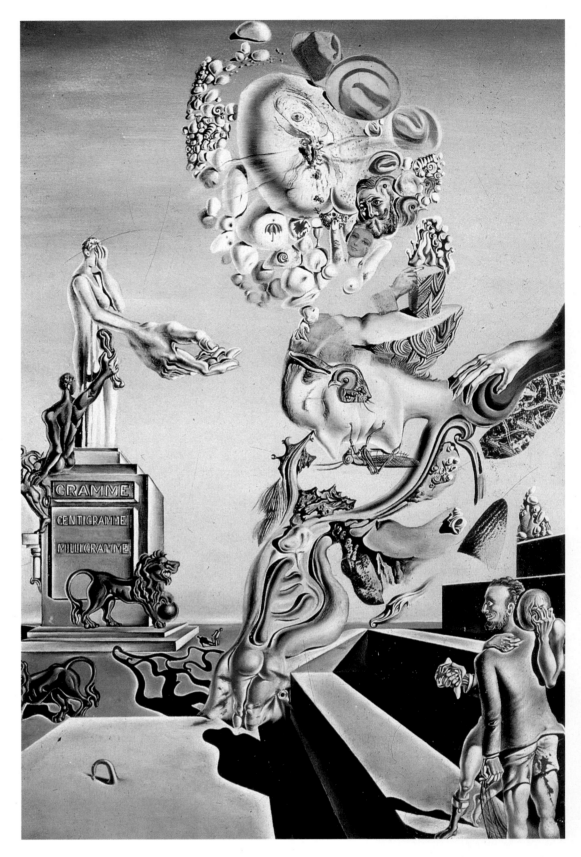

The Lugubrious Game was painted during the summer of 1929. Dali had returned from filming *Un Chien Andalou* in Paris and his state of nervous exhaustion seems to have unleashed his latent hysteria. He spent days seated before his easel, 'staring fixedly, trying to "see" like a medium ... the images that would spring up in my imagination'. The subject of this painting is again masturbation. The enlarged hand of the statue symbolizes onanism and the figure beneath, holding up a fossilized phallus, betrays the guilty secret. The cause of this practice is revealed in the delirium of sexual images which spiral upward in the center of the picture. A pair of female buttocks and legs rises out of the ground, curling biomorphically into a huge self-portrait head, a grasshopper attached to the mouth. This image, a recurrent one in Dali's painting, refers to an incident in his childhood and epitomizes feelings of horror and revulsion. The object of these feelings is suggested by the vulva-shape passing across the head, which doubles as the ear of a rabbit, its eye also belonging to a parrot within the rabbit's head. Dali described these images as 'seething' beneath the skin while he was painting, this irritation being relieved only by feeling 'the protective finger of my imagination scratch me reassuringly'. At the top of the head a hand performs this function. Issuing from the head is a whirlpool of erotic imagery linked by irrational association. A hand holds a cigarette and leads to a parrot's head. Alongside is a human face whose beard is parted to reveal the lips of female genitalia. This shape connects with the clefts in the hats above, which in turn merge with a collection of rocks and shells in which other images appear, a halluc- inatory phenomenon which Dali experienced while walking on the beach at Cadaqués. The rocks are linked to the breasts of a female torso, the arm becoming a phallic finger pointing toward an orifice surrounded by ants. The eye of the whirlpool is a vagina, the source of Dali's erotic fantasies and also of his fears. The consequences of masturbation are evoked by the figure at the right of the picture; employing the symbols of Freudian dream analysis, a bearded father figure holds a bloody handkerchief, suggesting castration, while supporting the victim of this mutilation.

This painting was the centerpiece of Dali's first one-man show at the Galerie Goemans in Paris in November 1929.

Illumined Pleasures, 1929

Oil and collage on panel
9⅜×13¾ inches (23.5×34.9 cm)
The Museum of Modern Art, New
York, Sidney and Harriet Janis
Collection

In this painting Dali drew together the central preoccupations of Surrealism. Dream images, irrationality, the fusion of fantasy and reality, eroticism, neurosis, obsession, childhood experience and Freudian symbolism are its raw materials. These elements are set in a space whose ambivalent perspective derives from de Chirico. The horizon seems distant and yet also like a precipitous edge, which makes the foreground action seem to occupy a stage, investing it with a sense of theatricality, and hence unreality. This impression is heightened by the presence of three box-like pictures; the image within each appears as real as the objects

outside them, an effect increased by the use of a collaged photograph of a church facade in the left-hand picture. This subverts our sense of actuality and undermines, as in dreams, the ability to distinguish between reality and illusory mental pictures. The images in the boxes on either side are irrational; in one, a man fires a gun at a rock outside a church. The other seems connected in some way; a swarm of men riding bicycles carry smaller rocks on their heads. The central box contains images of a more personal nature. The head is a recurrence of the self-portrait motif, here shown with blood issuing from its nostrils, a reference to the frequent nosebleeds from which Dali suffered as a child. Above this, and fixed within a recess in the picture space like an indelible memory, is one of Dali's greatest fears, a grasshopper. On the horizon and visible through an opening in a rock-like shape is another image from

Dali's childhood, a down-covered seedball which he called his 'dwarf monkey'. Outside the boxes images of sexual neurosis predominate, some expressed as Freudian symbols. On the top of the large frame a jug, denoting female sexuality, is linked with a lion's head, a Freudian symbol for desire. At the left a youth hides his face in shame, his guilty hand suggesting the cause. In the foreground a bearded father figure ravishes a fullbreasted female. This image generates Oedipal jealousy and a related fear of castration evoked in the pair of hands struggling with a bloody knife, and linked in turn with the reappearance of the shadow cast by the castrating father and the mutilated son in *The Lugubrious Game*. The focused intensity of these images derives from the small scale of this work and from the meticulous miniaturist technique which Dali employed and would use extensively throughout the next decade.

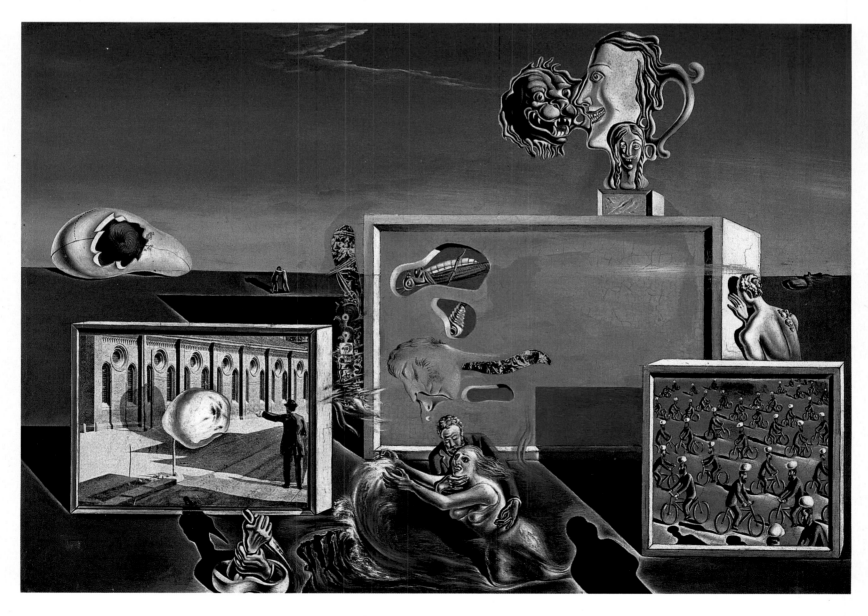

Accommodations of Desire,

1929
Oil and collage on panel
8⅝×13¾ inches (21.6×35 cm)
Private Collection

During the summer of 1929 Dali was visited by Camille Goemans, the Parisian art dealer with whom he had recently signed a contract; the Belgian Surrealist painter René Magritte and his wife; and the Surrealist poet Paul Eluard, accompanied by his wife Gala. A mutual infatuation quickly developed between Dali and Gala. This was inflamed by the symptoms of abnormal sensibility which both displayed. Dali appears to have been on the brink of madness; his behavior was becoming increasingly bizarre and was marked by bouts of hysterical laughter. Gala was subject to fits of neurogenic vomiting, a relic of a mental illness during her childhood. The relationship attained a greater intensity as the question of its consummation arose, but Dali was torn between passion and sexual neurosis. Still a virgin, he saw sexual intercourse as 'terribly violent and disproportionate to my physical vigor', and concluded that 'this was not for me'.

Accommodations of Desire was executed against this background and it expresses the apprehension which the prospect of sexual union with Gala excited in Dali. It employs the characteristic conjunction of personal and Freudian symbolism which Dali had began to develop by this time. The obsessing idea of the female as sexual receptacle is established by the recurrence of the Freudian symbols of vases and a jug in the shape of a woman's head. Dali had described how 'desires were always represented by the terrorizing images of lion's heads'. This motif appears in the landscape and is also entwined in the erotic embrace of the couple whose torsos are set on a plinth at the top of the painting. Below them a young man – Dali – holds his head in shame and guilt. The rock enclosing Dali's 'dwarf monkey' recurs to their left. Dali has described how he would often see images in the pebbles on the beach at Cadaqués and this phenomenon is depicted here. In the stone at top right, a number of apparitions are visible. A small lion replaces a woman's pubic area, echoes of which occur in a woman's smiling mouth and orifices in the rock surrounded by hair. The lion's head, a collage element which Dali incorporates seamlessly within the painting, appears in various forms in the pebbles in the foreground. Unaltered, it symbolizes sexual desire and the terror this causes, the duality of passion and danger also being evoked in the red silhouette of the lion's head. In another pebble the lion's face has

been removed, creating a void surrounded by the lion's mane. The terror inspired by this suggestion of female sexual parts is focused in the fanged mouth and also in the swarming ants which assume the shape of a vulva.

This work was included in Dali's first one-man exhibition at the Galerie Goemans in Paris in November 1929 and was reproduced in *La Révolution Surréaliste* in the following month.

The Great Masturbator, 1929

(next page)
Oil on canvas
43⅜×59¼ inches (115.6×150.5 cm)
Spanish State Patrimony

Following Gala's return to Paris in September 1929, Dali returned to Figueras where he shut himself away in his studio for the whole of the following month and executed two related works, *The Enigma of Desire* (page 44) and *The Great Masturbator* which he described as follows: 'It represented a large head, livid as wax, the cheeks very pink, the eyelashes long and the impressive nose pressed against the earth. This face had no mouth, and in its place was an enormous grasshopper. The grasshopper's belly was decomposed and full of ants. Several of these ants swarmed across the space that should have been filled by the non-existent mouth of the great anguishing face, whose head terminated in architectural ornamentation of the style of 1900'.

Gala had departed without their relationship having been consummated and this work expresses the sexual anguish and auto-eroticism which assailed Dali in his solitude. The enormous head derives from a rock formation at Cadaqués and is also a self-portrait. This motif occurs in a number of Dali's paintings, notably *The Enigma of Desire, The Persistence of Memory* (page 48) and *The Lugubrious Game* (page 38). The source of this image is a childhood experience which Dali described as one of the great enigmas of his life. Having previously liked grasshoppers he discovered one morning that a slimy little fish which he had caught and was examining had a face like a grasshopper. Thereafter, the grasshopper became a nightmare thing to Dali, capable of inspiring feelings of extreme terror, associated here with sex. This is reflected in the chain of connections linking the rigid stamen of the lily, the lion's head with its lascivious tongue, and the woman's head inclining toward male genitalia. Dali attributed his sexual neurosis to 'a false memory, of my mother sucking, devouring my penis . . .' the consequences of this fear manifested in the solitary figure embracing an outcrop of rock in the shape of a woman, and another figure wandering alone.

41

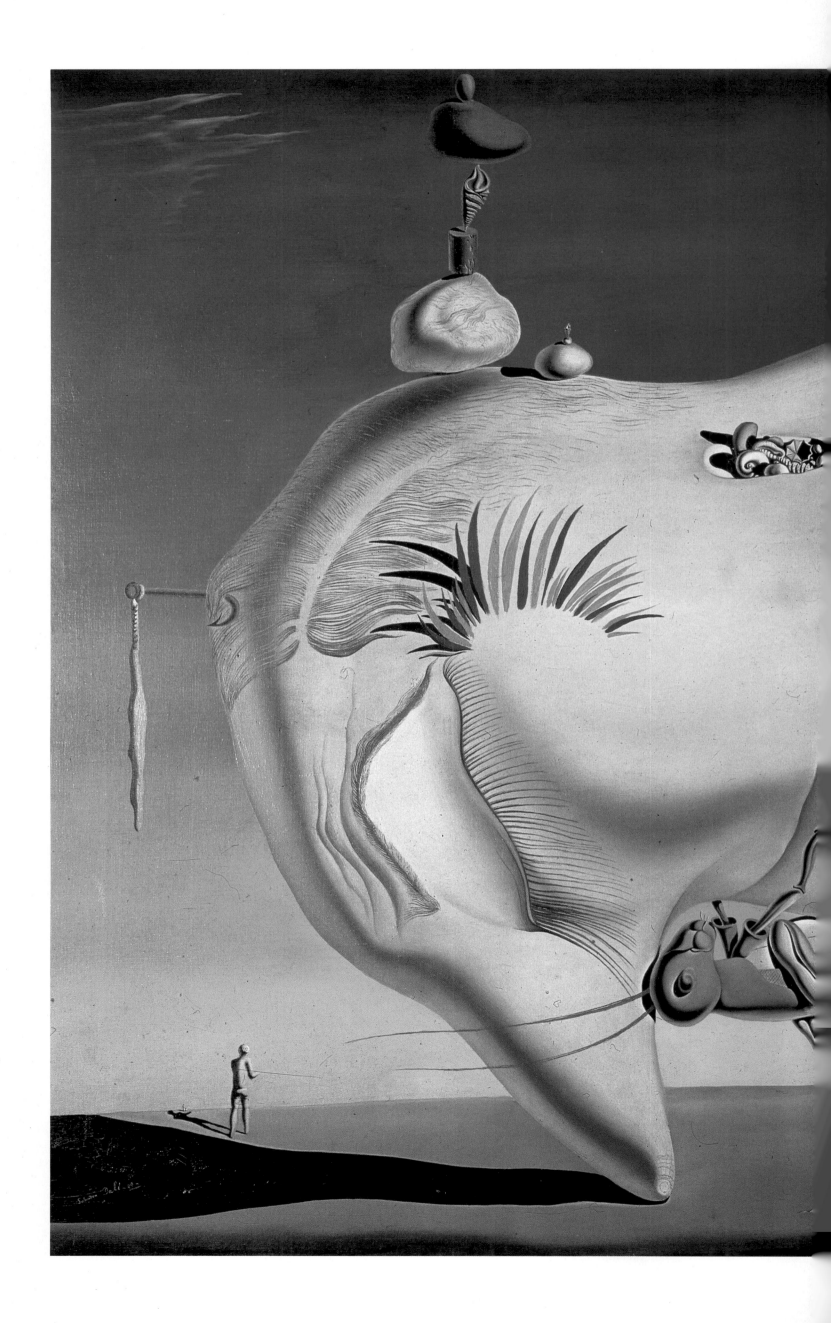

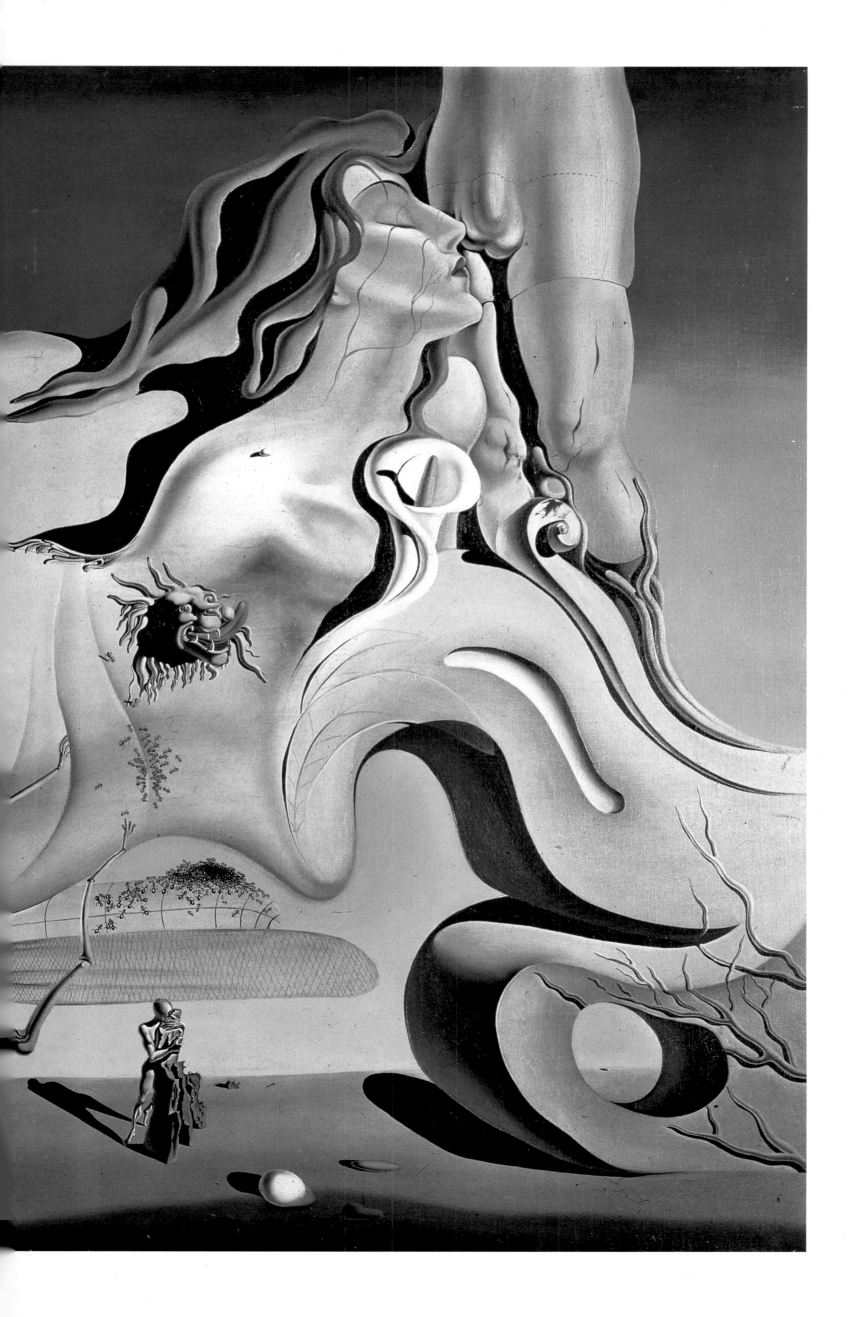

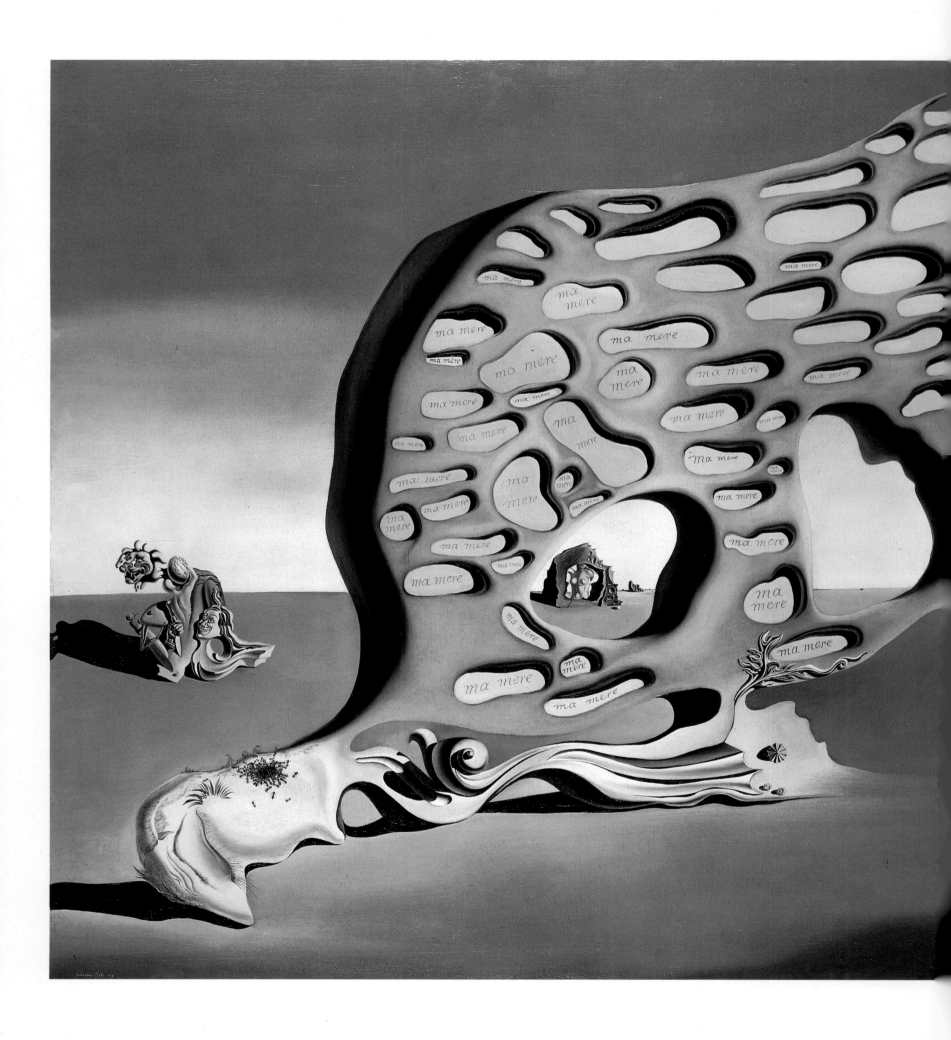

44

The Enigma of Desire: My Mother, My Mother, My Mother, 1929

Oil on canvas
43⅝×59 inches (110.7×149.9 cm)
Former Collection Oskar R Schlag, Zurich

In this work Dali focuses on and embellishes the cause of his sexual neurosis using his knowledge of Freudian psychoanalytical theory. As in *The Great Masturbator* (page 42), a self-portrait head grows out of an ornamental form reflecting Dali's admiration for Art Nouveau. Also attached to the head is an enormous biomorphic shape, within which are a number of recessed cavities, some containing the inscription '*ma mère*', its repetition suggesting the obsessive nature of this thought. This large form is in turn linked to the lion's head motif, symbol of terrorizing sexual desire. Two large cavities pierce the form. Through one a rocky outcrop beyond is visible and a hole driven, in turn, through this reveals a naked female torso behind it. The outline shape of the other cavity suggests the interlocking of two facial profiles which appear to kiss. The presence of these images invests the idea of his mother with erotic significance, transforming this painting into a symbol of Oedipal desire. Its Freudian nature is developed in the group at the left of the picture. Two figures embrace and are conjoined with another lion's head, a grasshopper and a hand clasping a knife. This conflation of images suggests the consequence of Oedipal desire: paternal love, transformed by awareness of its offspring's aberrant passion into the horrific threat of castration.

This work represents Dali's success in transferring the technique of meticulous realism to a large canvas so that irrational thoughts are rendered with the cogency of photography. One of eleven paintings exhibited at the Galerie Goemans in November 1929, it was purchased by the Viscount of Noailles, who also bought *The Lugubrious Game*. When it was sold in May 1982 it realized £453,600, a record at that time for a living painter.

The Hand, Remorse, 1930

Oil and collage on canvas
16¼×26 inches (41.3×66cm)
Private Collection

This painting is one of Dali's last works on the theme of masturbation. Visually it is analogous to his description in *The Secret Life* of his adolescent discovery of onanism: 'I was growing, and so was my hand. "It" finally happened to me one evening in the outhouse of the institute; I was disappointed, and a violent guilt-feeling immediately followed ... I could never struggle more than that day and one night against my desire to do it again, and I did "it", "it", "it", "it" again all the time ... I could look forward to the moment with more and more agreable and welcome vertigos and agonies'.

A bearded figure apparently made of stone is attached to a volute form whose ornamentation reflects the influence of Art Nouveau. Between 1930 and 1934 the 'undulant convulsive' style of Art Nouveau is a recurrent feature in Dali's painting and reflects the aesthetic defined in *Conquest of the Irrational* (1935): 'I hate simplicity in all its forms'. Only the figure's hand, grossly enlarged, appears to be flesh, suggesting that all life is concentrated in that part of the body which serves its obsessive auto-erotic activity. During the previous summer, when Gala was staying with Dali at Cadaqués, he had attempted to impress her by deliberately making small cuts on his own body using his shaving razor. The bloodstains on the various parts of the figure in this painting recall this hysterical behavior as well as his childhood nosebleeds. Attached to the back of the figure, flowing locks of hair, in the style of Art Nouveau decorative busts, have been painted to merge seamlessly with a fragment of collage depicting a woman's face taken from a *fin de siècle* chromo-lithograph. The tiny figures on the steps give the impression that the bearded man is situated above at a great height, evoking the sense of vertigo which Dali described as being associated with the prospect of masturbation. All are set within a space in which the treatment of perspective, long shadows and lighting are reminiscent of de Chirico.

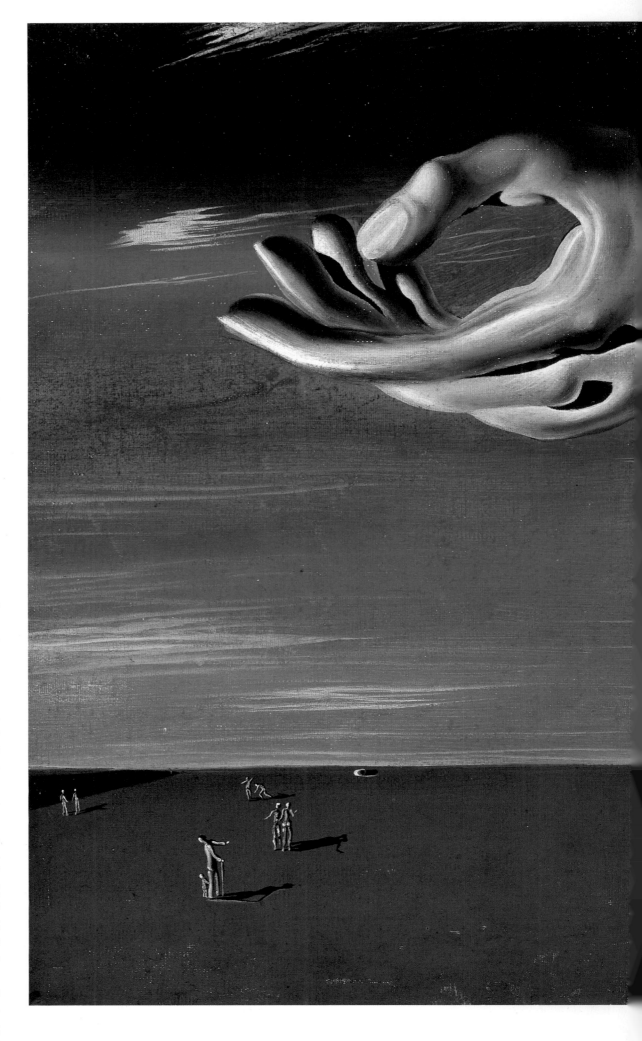

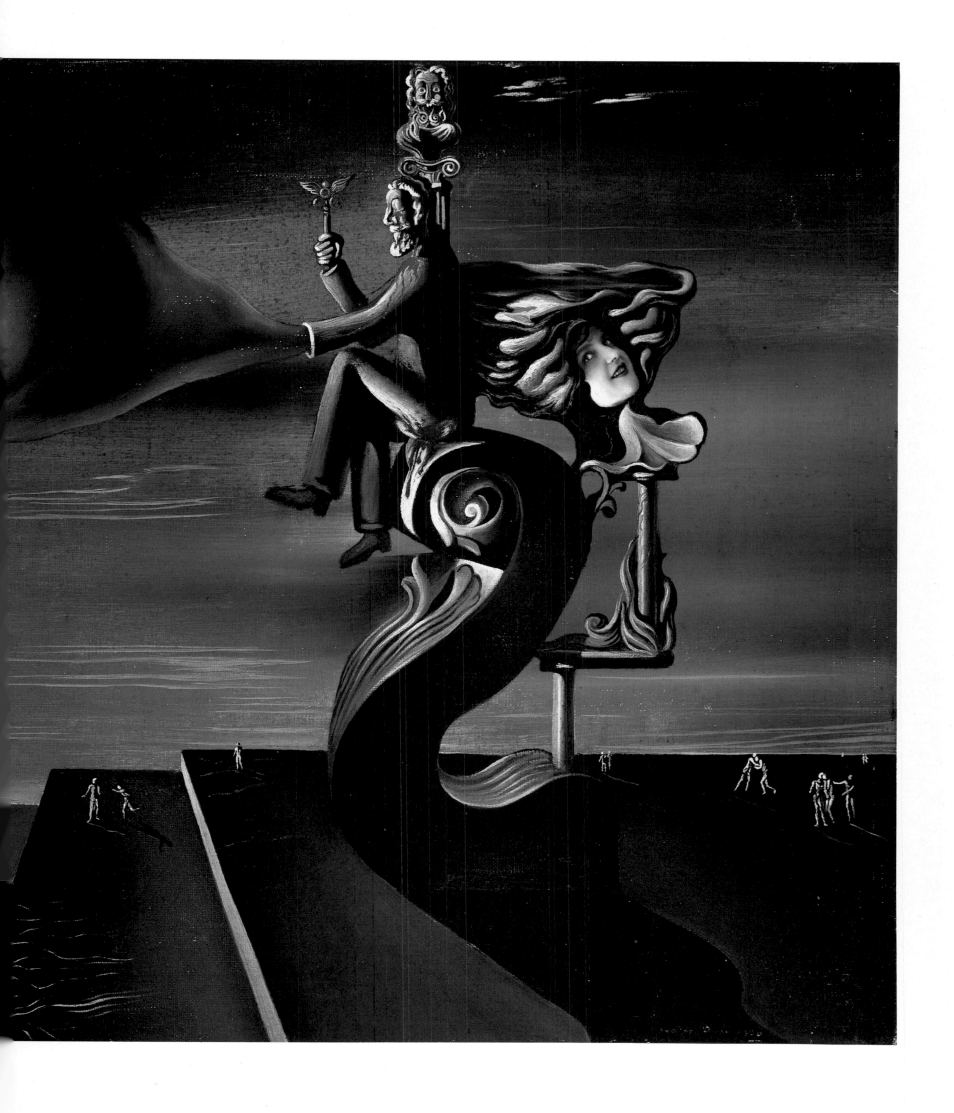

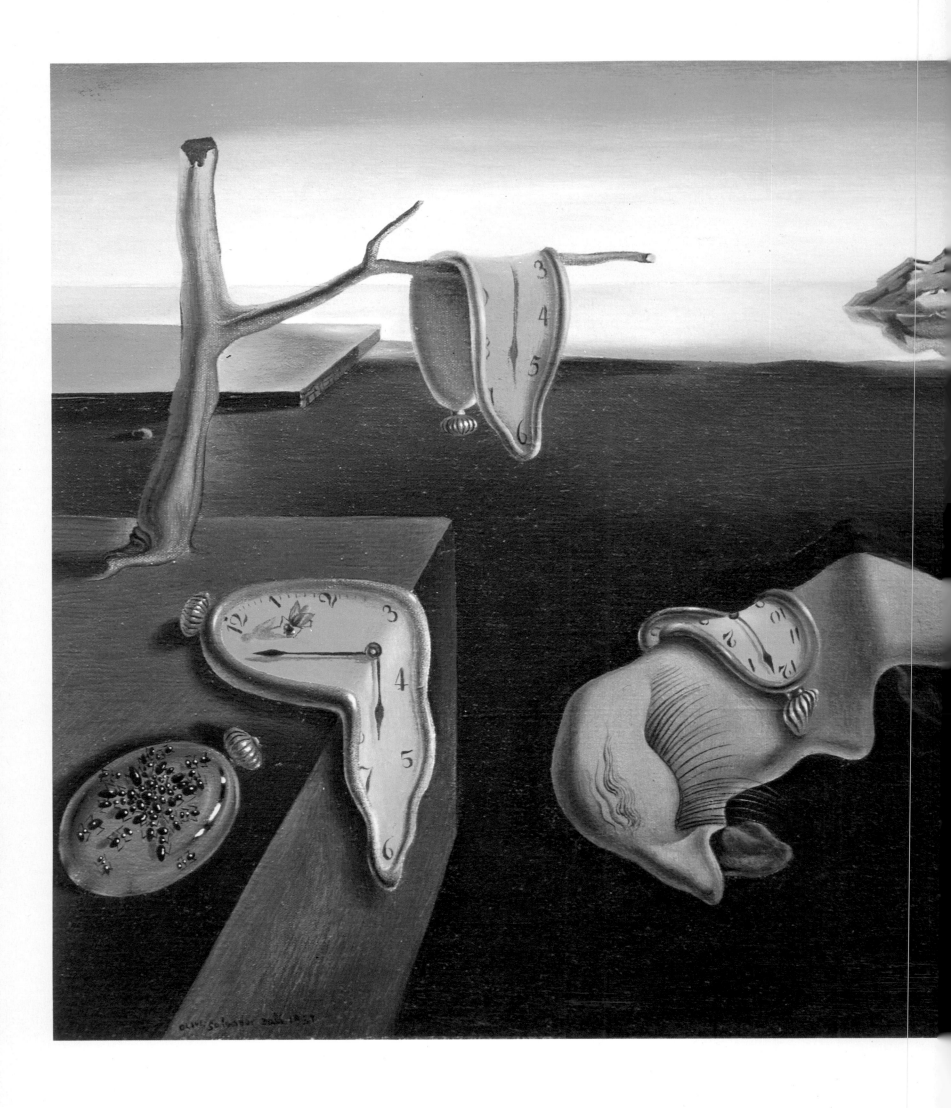

48

The Persistence of Memory,

1931
Oil on canvas
9½×13 inches (24.1×33cm)
Museum of Modern Art, New York

One of Dali's most famous paintings, *The Persistence of Memory* was first shown at the Pierre Colle Gallery in Paris in June 1931, and caused a sensation when it was included in a group show of Surrealist work at the Julien Levy Gallery in New York in January 1932. The enduring fascination generated by this enigmatic image is due to the way it fuses the banal and the fantastic, the symbolic and the irrational, inviting yet resisting explanation. Dali's observation that 'the soft watches are nothing else than the tender, extravagant and solitary paranoiac-critical camembert of time and space' is similarly ambivalent, referring to the painting's genesis and also to its tantalizing significance.

Essentially the soft watches demonstrate that one aspect of the paranoiac-critical method is its capacity to link objects to qualities normally associated with other, completely different, elements. Dali painted the setting first, a deserted landscape at Port Lligat where he and Gala had bought a fisherman's hut the previous summer. Initially he had no idea how to develop the picture. Inspiration came unexpectedly. About to retire to bed, he glanced at the painting; suddenly the memory of the softness of the camembert he had been eating earlier projected itself into his imagination, attaching itself to and transforming the idea of watches in his mind. (Gala had gone out for the evening and Dali was probably wondering at what time she would return). He instantly and faithfully transcribed the resulting image, draping a watch over the branch of an olive tree. The other elements in the painting show how this initial irrational idea was then developed and invested with significance. In the foreground the self-portrait motif reappears in the form of a foetus abandoned on a beach. This refers to Dali's professed memories of intrauterine life and suggests the trauma of birth. A watch sagging across the foetus and another hanging from a plinth evoke the feelings of timelessness associated with the experience of pre-birth. The title of the painting thus refers to prenatal memories and its subject is 'the horrible traumatism of birth by which we are expunged from paradise'. The title also relates to Gala's response when Dali asked her whether in three years time she would have forgotten this painting. She replied 'no one can forget it once he has seen it'.

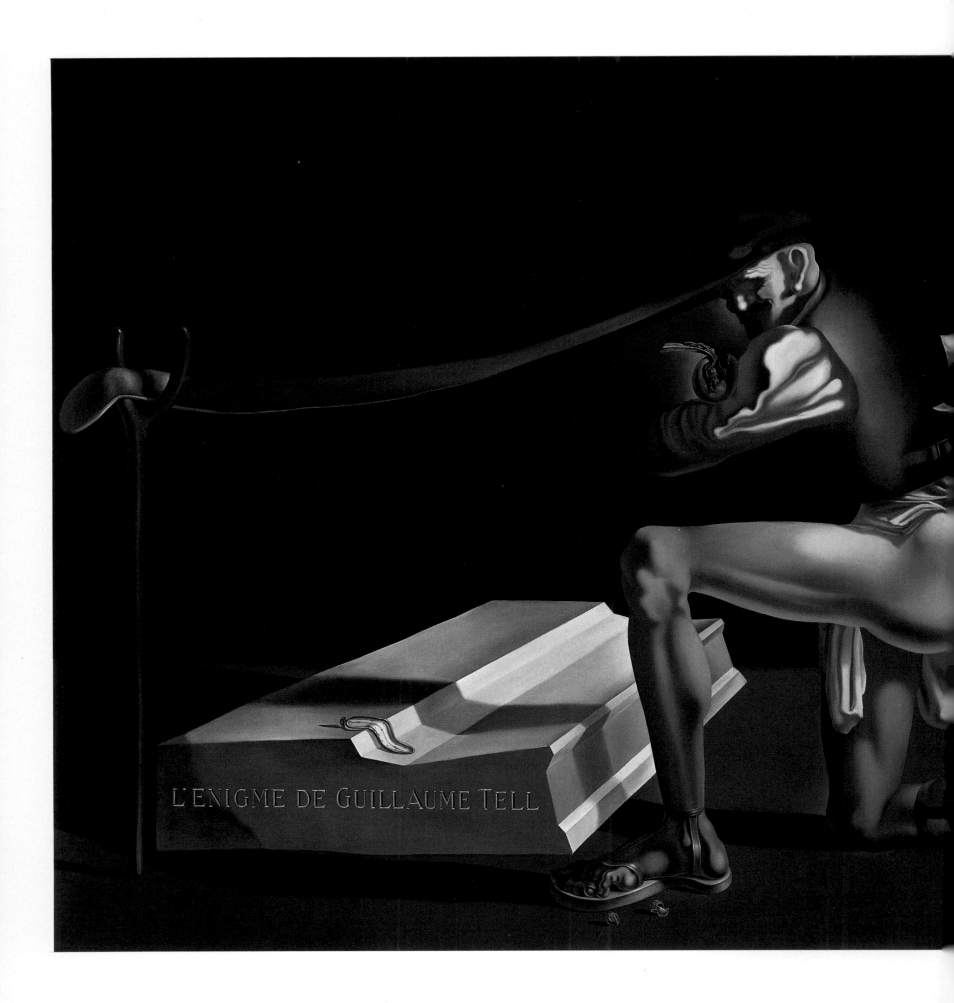

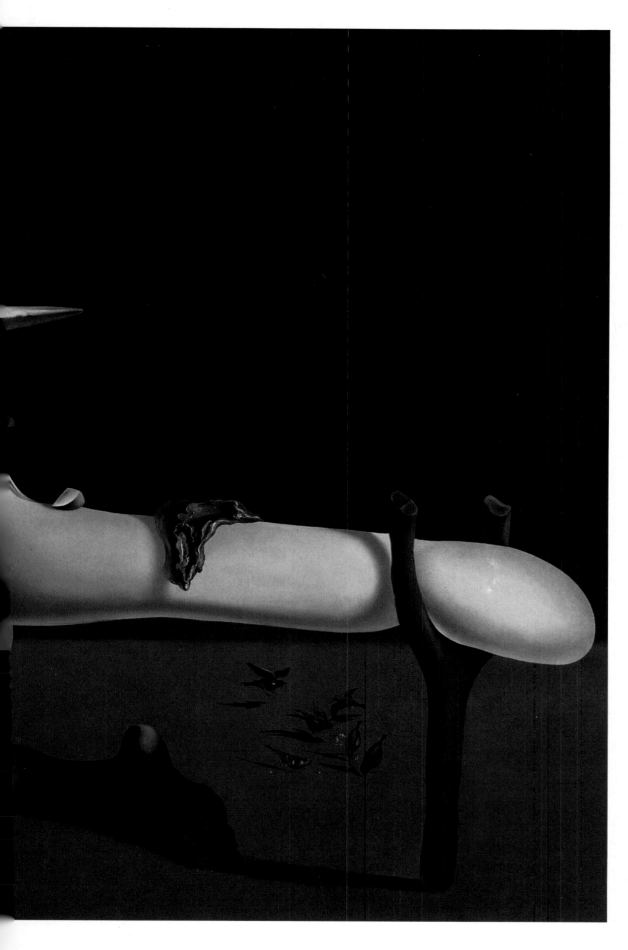

The Enigma of William Tell,
1933

Oil on canvas
79⅜×57½ inches (201.9×146 cm)
Moderna Musset, Stockholm

The Enigma of William Tell is the climactic painting in the William Tell series. In it the anxiety inspired by the revolt against his father became interwoven with Dali's paranoiac-critical interpretation of the legend, leading him to perceive in the father-son relationship the threat not only of castration but of annihilation. The William Tell story became 'the eternal theme of the father sacrificing his son; Saturn devouring his sons with his own jaws'. William Tell – the father figure – is depicted with the face of Lenin, cradling the infant Dali in his arms. Interpreting the apple on the son's head as 'the symbol of the passionate cannibalistic ambivalence' – and as the target of 'paternal vengeance' – Dali makes the father's intentions explicit by placing a lamb cutlet rather than an apple on the baby's head, showing that the father wants to eat the child. This threat of extermination is amplified by the tiny cradle positioned perilously near the father's gigantic foot. It is also represented by the crutches which, in Dali's iconography, symbolize death and resurrection. One supports a phallic-shaped buttock, the other the flaccid peak of Lenin's cap. These elements echo the sexual anxieties explored in Dali's painting at the end of the previous decade. They also allude to the cause of the hiatus with his father, Dali's relationship with Gala. The depiction of Lenin in this way provoked the first of Dali's clashes with André Breton who was infuriated by this 'anti-revolutionary act' and called for Dali's expulsion from the Surrealist group. This painting narrowly escaped an attempt to deface it by Breton, Péret and Tanguy when it was hung, just out of reach, at the Salon des Indépendants at the Grand Palais in February 1934. The work survived but Dali's relations with Breton were soured from this point.

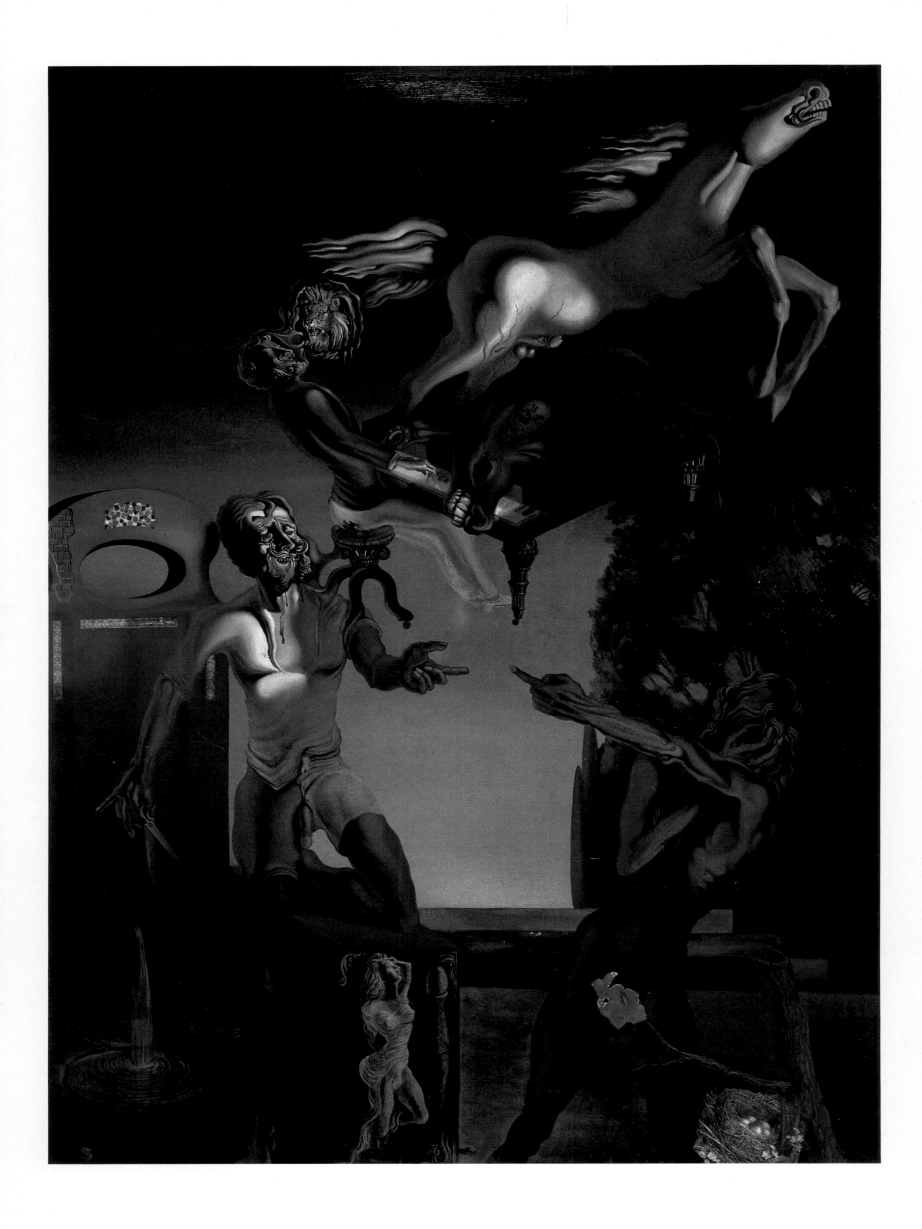

William Tell, 1930

Oil and collage on canvas
44½×34¼ inches (113×87 cm)
Private Collection

Invisible Sleeping Woman, Horse, Lion, 1930

(next page)
Oil on canvas
23⅝×27½ inches (60.7×60 cm)
Private Collection

Concurrent with Dali's development of the paranoiac-critical method to create chains of irrationally associated elements and double images was his exploration, from 1930 onward, of the method as a means of 'psychic-interpretive illustration'. Evoking the way paranoiacs 'interpret' reality, perceiving hidden meanings by establishing irrational links between disparate objects and experiences, Dali applied a process of paranoiac interpretation to an existing narrative, the legend of William Tell. Subjecting it to the force of personal obsession, Dali reinterpreted this story so that it assumed a bizarre significance. *William Tell* was the first of a number of paintings in which the legend of the fifteenth-century Swiss bowman, who fired an arrow at an apple placed on his son's head, became bound up with the severance of relations between Dali and his father. In this way the legend became a vehicle for ideas relating to paternal threat and for Freudian symbols of castration anxiety.

William Tell is depicted as a bearded father figure wielding a pair of scissors. The images growing from his head amplify his threatening presence and allude to the cause of his latent violence. The head of a second bearded figure playing a piano is linked, in turn, to a lion's head, a symbol which relates to Dali's desire for Gala. Dali's father disapproved of the relationship. The carcass of a donkey lies across the top of the piano (an image which also appears in Dali's scenario for *Un Chien Andalou*). A bolting stallion springs out of the piano, its genitalia shown explicitly. The outstretched fingers of the two figures, almost touching, refer to the scene in Michaelangelo's Sistine Chapel fresco where God the Father reaches toward Adam in order to give him life. Dali reinterprets this gesture also, however; the father in his painting sheds tears of blood and threatens castration, his intention made apparent by his own exposed penis and the water gushing into a pool. The force of paranoiac association in Dali's life and art, and the reciprocal nature of the two, is evident in an incident which occurred shortly after Dali's banishment from his father's house. Observing the shadow of his profile on a whitewashed wall he immediately took a sea-urchin, placed this surrogate apple on his head 'and stood at attention before my shadow – William Tell'.

Invisible Sleeping Woman, Horse, Lion is one of three versions of this subject, each with the same title, which Dali executed during the summer of 1930. Following the experiments he had begun in *The Invisible Man*, this trilogy of paintings reflects Dali's observation that 'the double image may be extended, continuing the paranoiac advance, and then the presence of another dominant idea is enough to make a third image appear . . . and so on, until there is a number of images limited only by the mind's degree of paranoiac capacity'. A sequence of contemporary sketches depicting the transformation of a woman into a horse and then into a lion reveals that Dali had plans for realizing this paranoiac advance cinematically. This never happened, however, and in the paintings the technical complexity generated by this aim means that, rather than experiencing a succession of independent images, the viewer is confronted with a single composite form. Despite Dali's claim that he obtained 'the image of a woman, whose position, shadow and morphology, without altering or distorting her real aspect, is at the same time a horse', both forms have been modified in order to suggest alternative readings. The posture of the reclining woman and the associaton of this image with that of a horse would seem to have been inspired by *The Nightmare* (1781) by Johann Fuseli, a painter whom the Surrealists regarded as a precursor. Fuseli's painting depicts a sleeping woman and an equine apparition. Dali's conflation of these two forms into a single image first appeared in the background of *The Invisible Man*. In *Invisible Sleeping Woman, Horse, Lion*, the lower part of the woman's body also merges into the depiction of a lion, its head and mane readable as the horse's tail. This version is the larger of the surviving pair of paintings, the third having been destroyed by demonstrators when it was displayed in the lobby of 'Studio 28' during a showing of *L'Age d'Or* in December 1930.

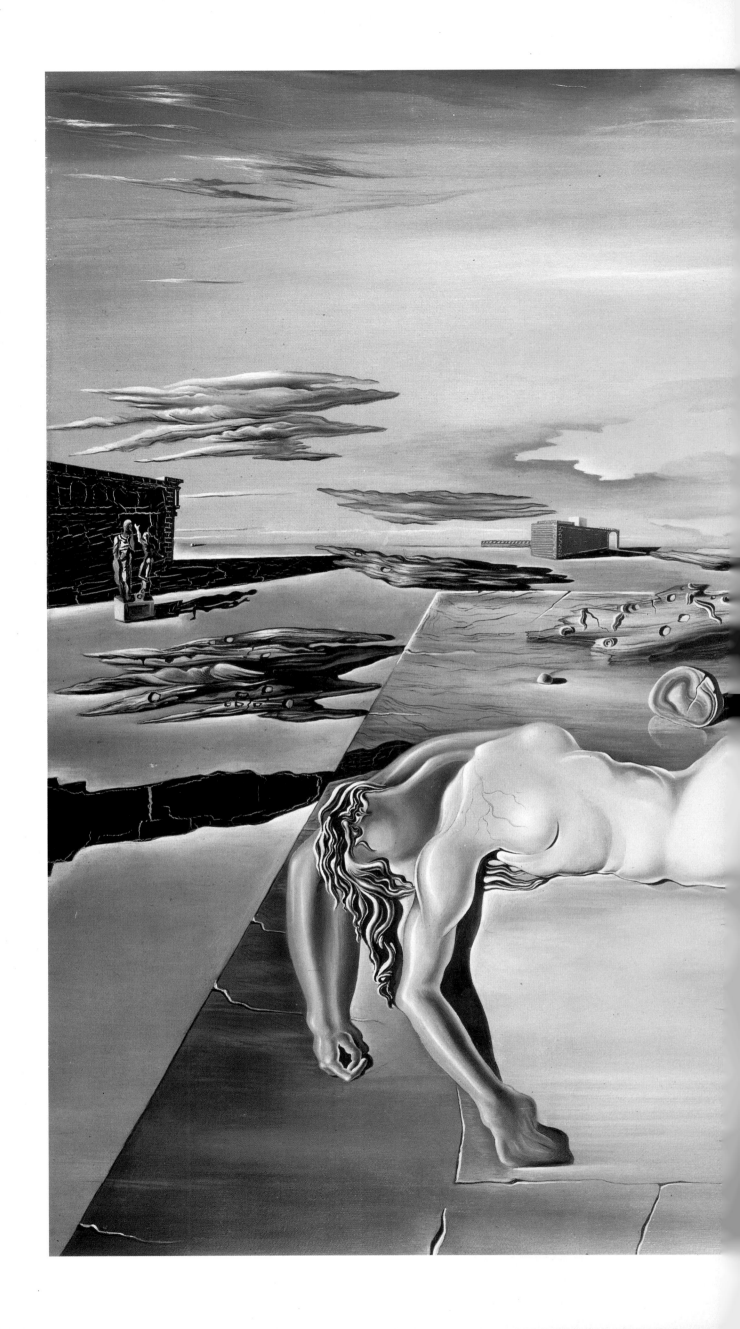

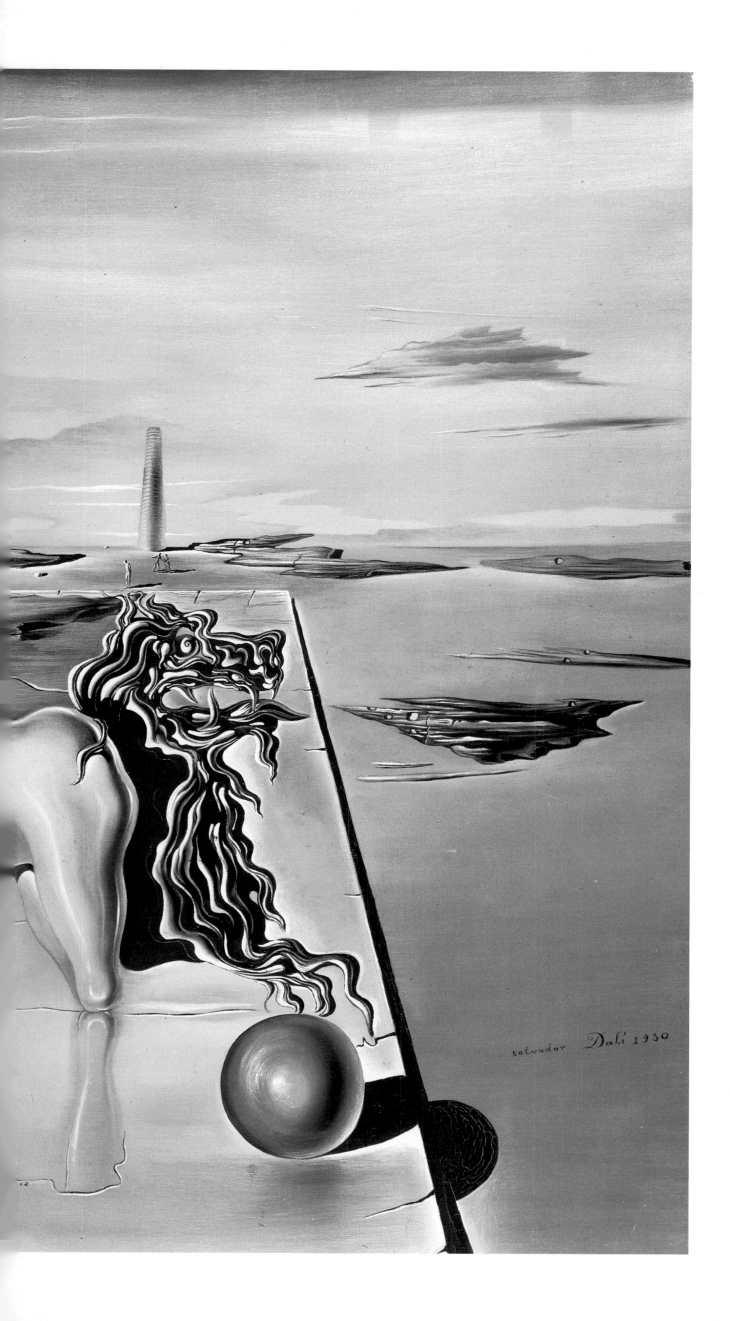

salvador Dalí 1930

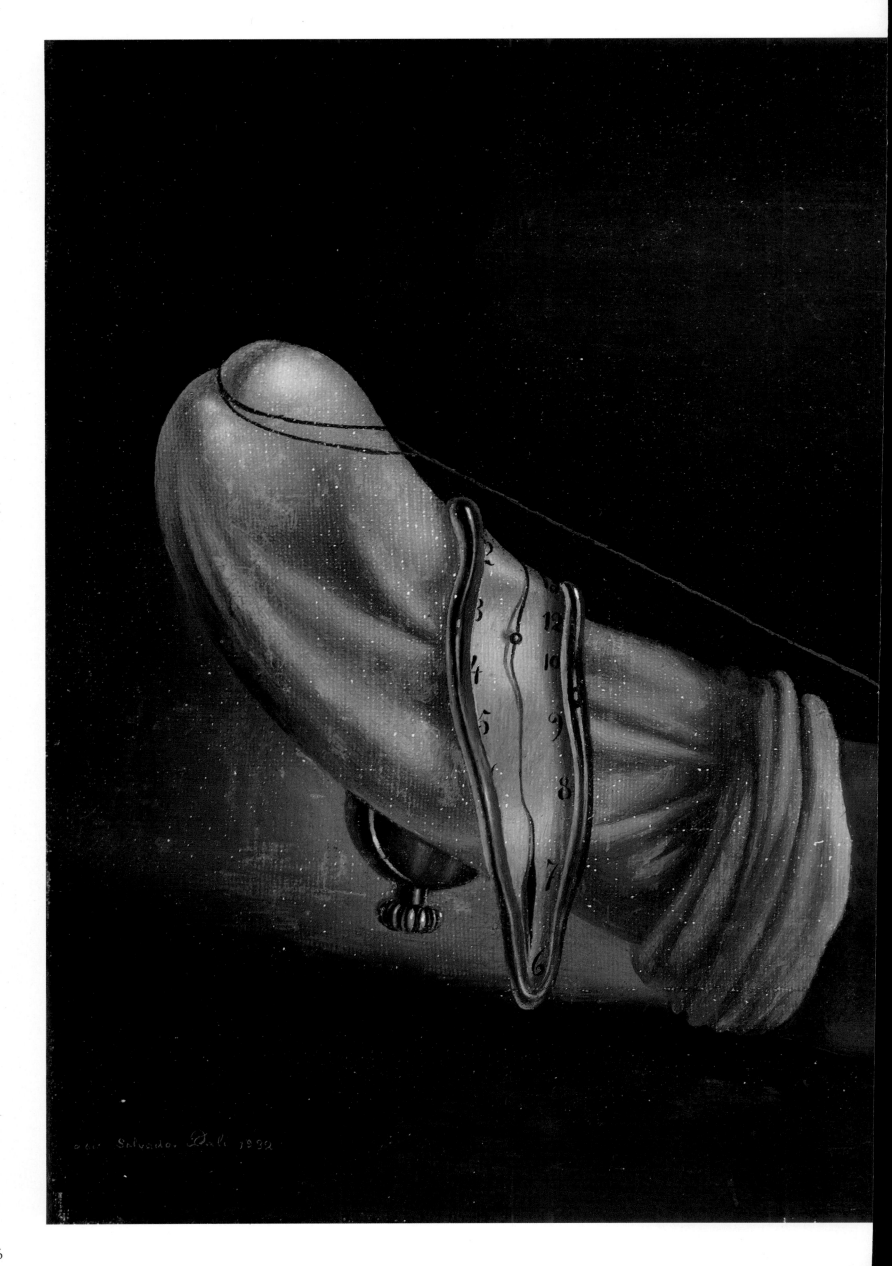

Anthropomorphic Bread, 1932

(previous page)
Oil on canvas
9⁹⁄₁₆×13 inches (24.1×33 cm)
Collection of Mr and Mrs A Reynolds
Morse, on loan to Salvador Dali
Museum, St Petersburg, Florida.

Dali explained that 'bread has always been one of the oldest subjects of fetishism and obsession in my work, the first and the one to which I have remained the most faithful'. This fascination reached a peak of intensity when he returned to Paris in 1930. Earlier in the year Dali had moved with Gala to the old fisherman's house which they were renovating at Port Lligat. Dali had apparently overcome his fear of sexual intercourse and they spent a passionate and idyllic two months together. This was also a period in which Dali took stock, reflecting on the success of his Paris show and preparing for the publication of L'Ane Pourri in which his ideas on paranoia received their first theoretical exposition. This sojourn was closed by an apparently banal incident which for Dali was charged with significance. After finishing a meal he became fascinated by a long piece of French bread. Having sucked the top of it, he pressed the softened end of the loaf on to the table where it remained in a vertical position. Dali claimed that this gesture 'summarized the whole spiritual experience of the period'. Arriving in Paris he pursued this obsession with fervor. In his personal encounters he repeated 'bread, bread, and more bread. Nothing but bread' to whoever would listen; and in his work bread recurs in numerous paintings and objects executed around this time.

Anthropomorphic Bread demonstrates how, by paranoiac association, animate and inanimate objects become linked and manufactured articles assume a biological significance. Not a double image, the loaf retains its own identity but is invested with phallic meaning. The basis of this association is formal but also relates to the phenomenon of the hard bread becoming soft, an essentially phallic characteristic. The flaccid watch which drapes over the bread and the rope, apparently sustaining the rigidity of the loaf artificially, refer to the changed circumstances of Dali's relationship with Gala. They suggest that Dali's fear of sex had been replaced by a new anxiety: impotence. Dali explained the inkwell in the following way: 'What could be more degrading and aesthetic than to see this bread-ink-stand become gradually stained in the course of use with the involuntary splatterings of "Pelican ink"? . . . one had only to have one's bread-ink-well changed every morning just as one changes one's sheets . . .'

Meditation on the Harp, 1932-4

Oil on canvas
26¼×18½ inches (66.7×47 cm)
Morse Charitable Trust, on loan to
Salvador Dali Museum, St Petersburg,
Florida

Meditation on the Harp was one of the first of several paintings executed by Dali between 1932 and 1935 in which Millet's painting *The Angelus* (page 21), like the legend of William Tell, became interwoven with, and a vehicle for, the exploration of personal obsessions. By a process of paranoiac-critical association, Dali reinterpreted Millet's painting, investing it with irrational meaning in a manner analogous to the formation of delusion in paranoiacs. Dali's obsession with *The Angelus* began in his childhood. A copy of the painting hung in the corridor leading to his classroom at school and he described how this produced in him 'an obscure anguish, so poignant that the memory of these two motionless silhouettes pursued me for several years with the constant uneasiness provoked by their continual and ambiguous presence'. The same emotional disturbance seized him when in 1929 he saw a reproduction of *The Angelus*. It recurred in 1932 when the image spontaneously appeared with hallucinatory force and seemed to Dali 'charged with such latent intentionality that *The Angelus* of Millet suddenly became for me the pictorial work which was the most troubling, the most enigmatic, the most dense and the richest in unconscious thoughts that I had ever seen'. In 1938, Dali wrote an essay entitled *The Tragic Myth of Millet's Angelus*, based on his earlier pictorial exploration of the image. In this work he analysed this obsession and expounded his interpretation of *The Angelus* as 'the maternal variant of the immense and atrocious myth of Saturn, of Abraham, of the Eternal Father with Jesus Christ and of William Tell himself devouring their own sons'. Dali attributed the cause of his sexual neurosis to a 'false memory' of an act of fellatio with his mother. This anxiety is evident in *Meditation on the Harp*. Dali depicts the peasant couple embracing, the woman nude, the man holding his hat in a way which hides but also draws attention to what Dali identified as his state of erection. A third dark-suited figure occupies the foreground, his elbow extended into a shape in which is set the anamorphic face of a grinning skull. In Freudian psychoanalysis teeth are connected with sex and this protruberance also suggests the peasant's displaced phallus. (Freud described displacement as a dream mechanism which symbolizes disturbing ideas in innocuous form.) In Dali's painting this protruberance links sex with death and, appropriately, is supported by a crutch, Dali's own symbol of death and resurrection.

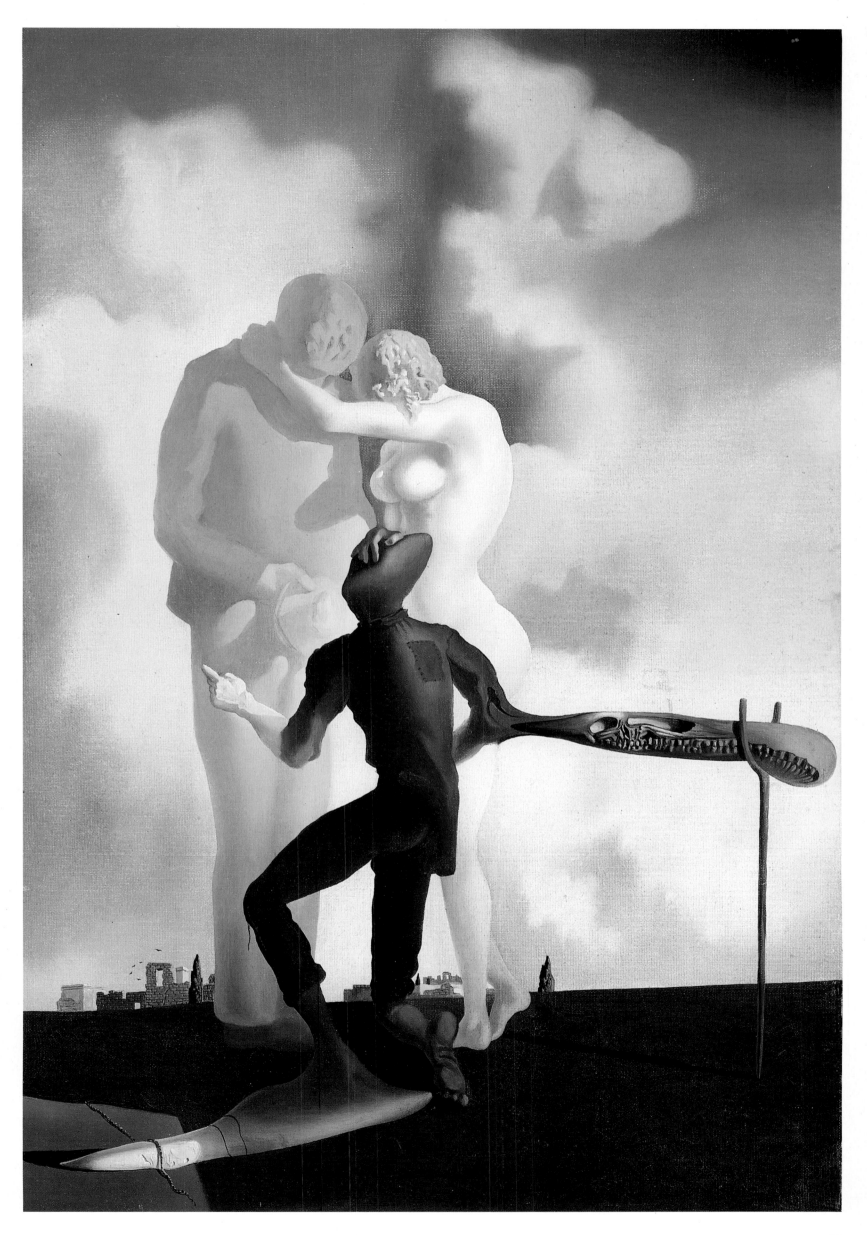

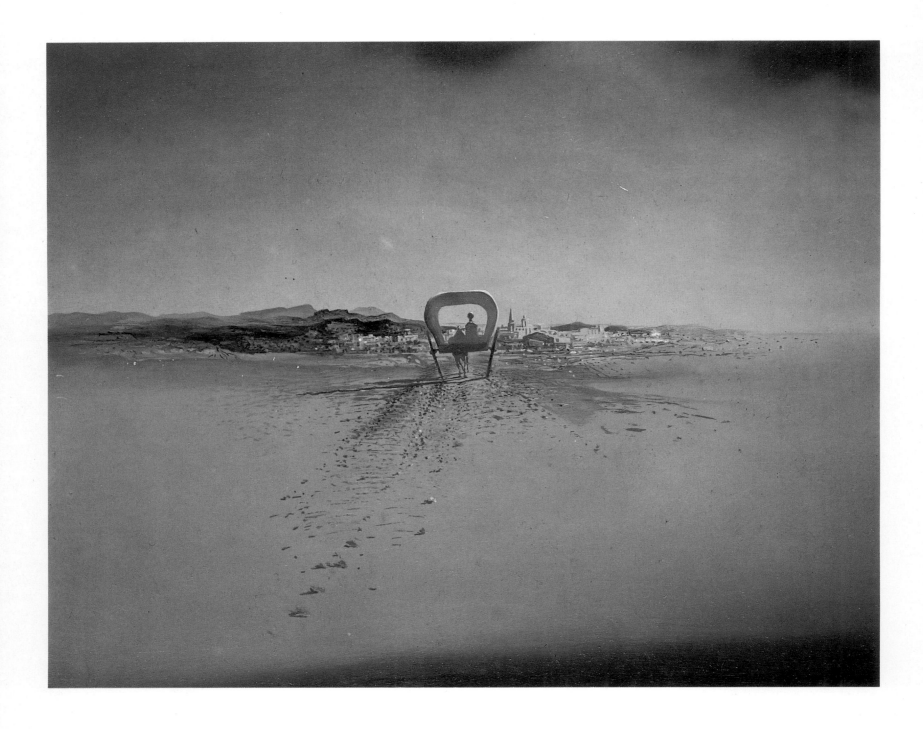

The Phantom Cart, 1933

Oil on panel
7½×9½ inches (19×24 cm)
Former collection of Edward James,
now private collection.

Dali's development of the double image relates to the capacity of the paranoiac mind to read hidden meanings or recognize hidden appearances beneath the surface of reality as a result of irrational association. As Breton stated: 'The paranoiac . . . [regards] the very images of the external world as unstable and transitory, if not as suspect'. *The Phantom Cart* represents Dali's first complete success in achieving a double image in which the viewer experiences the 'representation of an object that . . . is also, without the slightest physical or anatomical change, the representation of another entirely different object'.

Unlike Dali's earlier attempts at multiple figuration, which resulted in a composite form, the hallucinatory effect of this painting rests on the formal association of two disparate elements, without modification of either, so that alternative, exclusive and sequential readings are possible. This is achieved by simplifying the constituent images. Initially we are presented with the view of a cart being driven by a lone figure toward a distant town. By linking the shape of the driver with that of a tower beyond, and the horse with a road receding through the town, Dali precipitates the illusion of the driver and horse vanishing so that buildings are seen

through the canopy of the unoccupied cart. In this way, the double image forms part of Dali's strategy to 'systematize confusion and contribute to the total discrediting of the world of reality'.

This painting is still rooted in personal experience; the scene relates to Dali's childhood memories of traveling with Señor Pitchot and their daughter Julia between Figueras and Cadaqués. But it also represents a movement away from the erotic and obsessional nature of his earlier work and is more lyrical in nature. It displays a subtlety of tone and a luminosity which reflect Dali's aspiration to achieve 'hand-done color photography.'

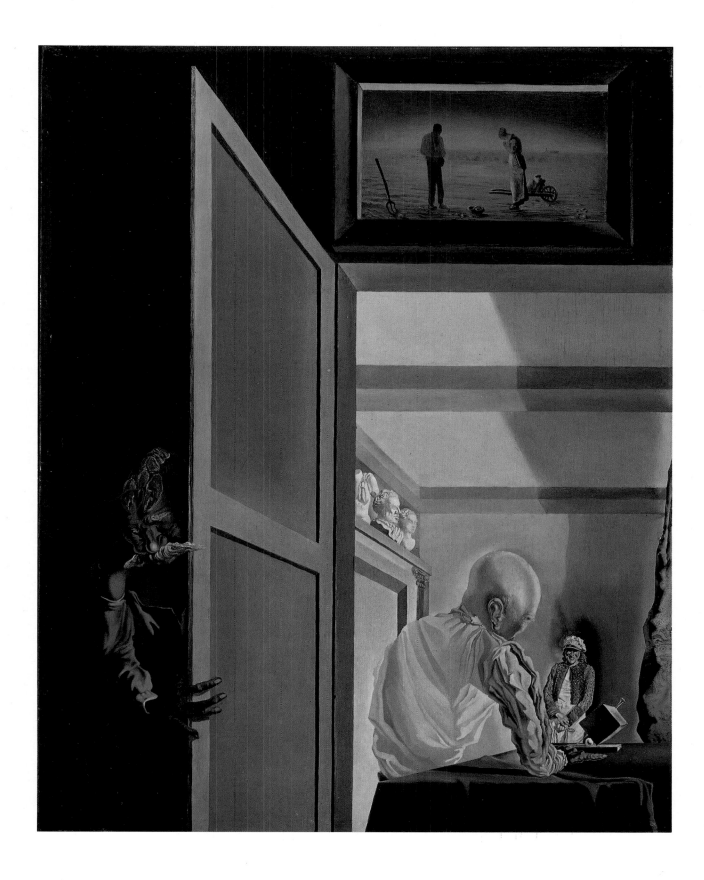

Gala and the Angelus of Millet Immediately Preceding the Arrival of the Conic Anamorphoses, 1933

Oil on panel
9⁷/₁₆×7³/₈ inches (24.1×18.8 cm)
National Gallery of Canada, Ottawa

In this painting, instead of being transformed by paranoiac interpretation, Millet's *The Angelus* (page 21), which plays a role in some of Dali's work in the early 1930s, is reproduced with little significant alteration and functions as the starting point for a chain of irrational association. Dali copies Millet's painting, extending it horizontally so that the space between and at either side of the figures is greater than in the original and fully occupies the width of the open doorway above which the painting is positioned. The first associative link with *The Angelus* is Maxim Gorky, the Russian novelist, who is shown hiding behind the door. Gorky's work, in common with Millet's, focused on the lives of the poor and was rendered with stark realism. When Dali exhibited a telephone the receiver of which was surmounted by a lobster, Breton explained that this was 'an artistic evocation of the self-mutilatory mechanism of ear-cropping begun by Van Gogh'. Breton's observation identified a paranoiac association between lobsters and ears. The presence of a lobster on the top of Gorky's head thus suggests that he is eavesdropping. The figure seated within the room with his back to the door is Lenin, with whom Gorky was involved as a propagandist at the time of the 1917 Revolution. Facing Lenin is Gala, wearing the richly embroidered jacket which also features in Dali's *Portrait of Gala,* 1935 (page 74). A further connection can be traced between Lenin, the leader of the Communist Revolution, and the central bust on the shelf at the left of the room which resembles André Breton, leader of the Surrealist Revolution, who was aspiring to form an alliance between the Surrealists and the Communist Party.

Inexplicable by logical means, this work illustrates the way in which paranoiac-critical reasoning systematizes a delirious succession of elements, resulting in an image of 'concrete irrationality of the same persuasive, cogniscative and communicable thickness as that of the exterior world of phenomenal reality'.

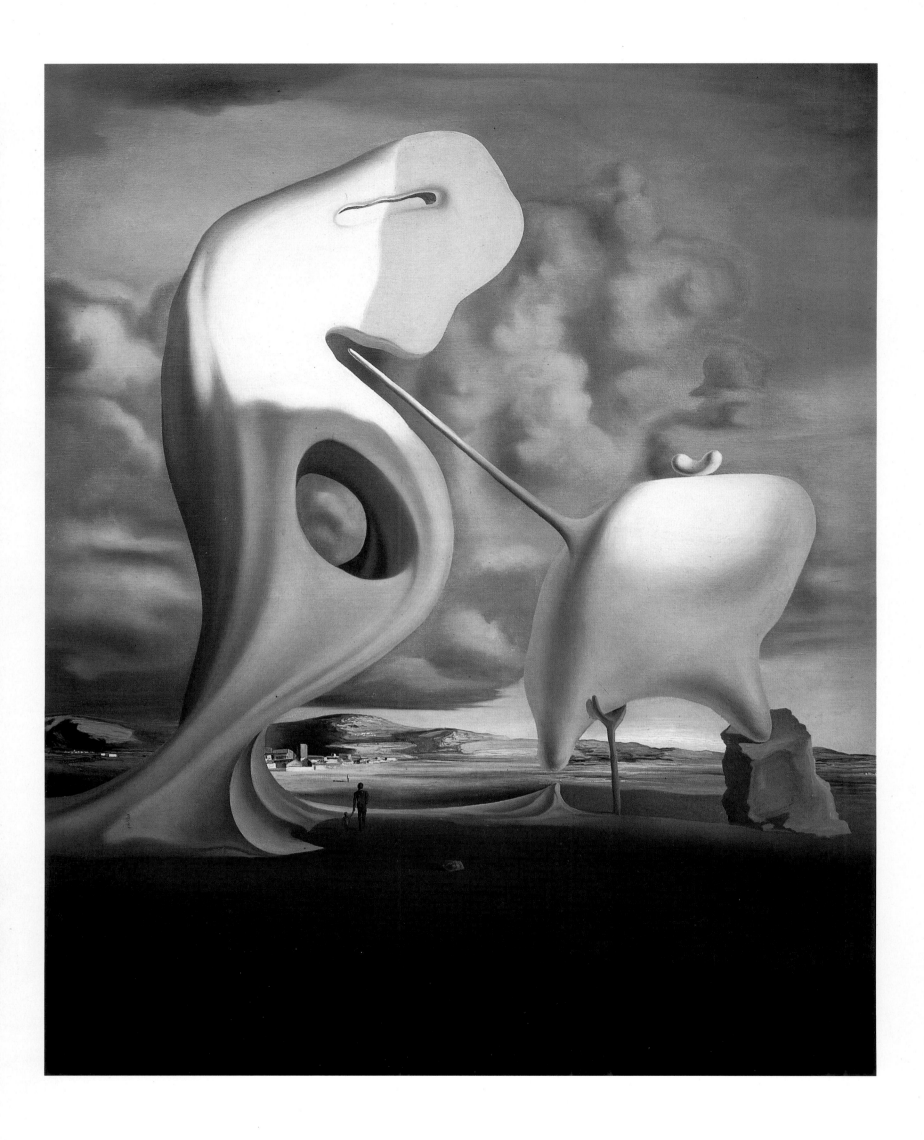

The Architectural Angelus of Millet, 1933

Oil on canvas
28¾×24 inches (73×61 cm)
Hanover Gallery, London

The Architectural Angelus of Millet is one of three paintings, related in their interpretation of Millet's *The Angelus* (page 21), which Dali executed between 1933 and 1935. The other two are *Atavistic Vestiges After the Rain,* 1934 (page 66), and *Archaeological Reminiscence of Millet's Angelus,* 1933-35 (page 64). All these works were inspired by an experience which Dali described in *The Tragic Myth of Millet's Angelus* (1938): 'During a brief fantasy to which I surrendered myself on an excursion to Cape Creus [located in the northeast part of Catalonia], whose mineral landscape constitutes a veritable geological delirium, I imagined sculptures of the two figures in Millet's *Angelus* carved into the highest rocks there. Their spatial positions were the same as those in the painting, but they were completely covered with fissures'.

The Architectural Angelus of Millet depicts the transformation of Millet's peasants as a result of this paranoiac association. Both figures have been turned into tall monumental stones, whose biomorphic shape recalls their previous identity. The 'male' stone towers over the female, its body pierced by a cavity, as in *The Atavism of Dusk*. Dali's further association of the two laborers in Millet's painting with Lautréamont's 'chance encounter of a sewing machine and an umbrella' is evident in the needle-like form which grows from the 'female stone', reflecting Dali's paranoiac notion of 'the sewing machine – well known as a female symbol'. This stone is supported on a crutch, symbolizing death, as it attempts to pierce the other, 'the activity of which may be identified with the superfine perforation of the praying mantis 'emptying' her male that is to say emptying her umbrella, transforming it into that tormented, flaccid and depressive victim which every closed umbrella becomes after the magnificence of the amorous, paroxysmal, extended functioning which it recently displayed'. Beneath and dwarfed by the stones stand two figures, the infant Dali and his father, an allusion to the grip which Millet's figures had on Dali's imagination from his earliest years.

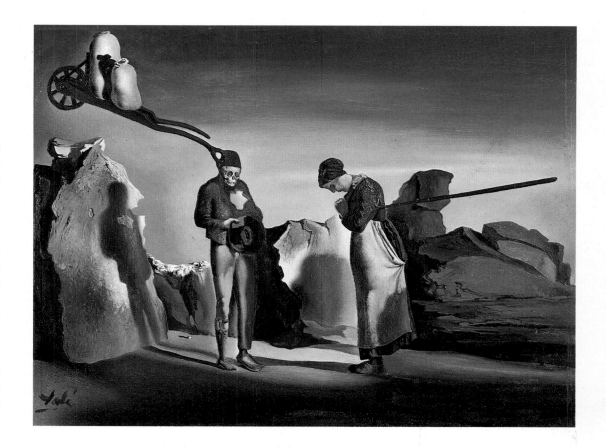

The Atavism of Dusk, c. 1933-34

Oil on panel
5¹¹/₁₆×6¹¹/₁₆ inches (14.5×17 cm)
Kunstmuseum, Berne

Dali stated 'It is to my mother that I owe my terror of the sexual act . . . It is specifically a matter of a memory or a "false memory" of my mother sucking, devouring my penis'. Sex, cannibalism and death were linked in Dali's mind. By paranoiac association, precisely these anxieties were inspired by Millet's painting depicting the piety of two field laborers. In *The Atavism of Dusk* Dali expressed more explicitly this irrational significance which he divined in *The Angelus* (page 21).

The postures of the two peasants are reproduced faithfully. The male stands at the left, his hat concealing his sexual arousal, but his face has been transformed into a skull, an image which evokes the consequences of his fatal sexual encounter with the female peasant standing at the right. The threat posed by the woman is evident in the way she assumes the attitude of a praying mantis. This alludes to the practice of the female insect of the species of devouring the male after coition. Dali also interpreted the wheelbarrow in Millet's painting as an echo of the posture of the praying mantis. In *The Atavism of Dusk* it has been relocated and grows from the head of the male peasant.

Here again Dali made a connection between the relation of the two peasants in Millet's painting and Lautréamont's observation about the 'chance encounter on a dissecting table of a sewing machine and an umbrella'. The umbrella, in Dali's view 'a typically Surrealist object with a symbolic function – as a result of its flagrant and well known phenomenon of erection', was associated with the male peasant. The female was linked with the sewing machine, and 'the mortal and cannibal virtue of her sewing needle' may be seen growing out of the back of her arm in this painting.

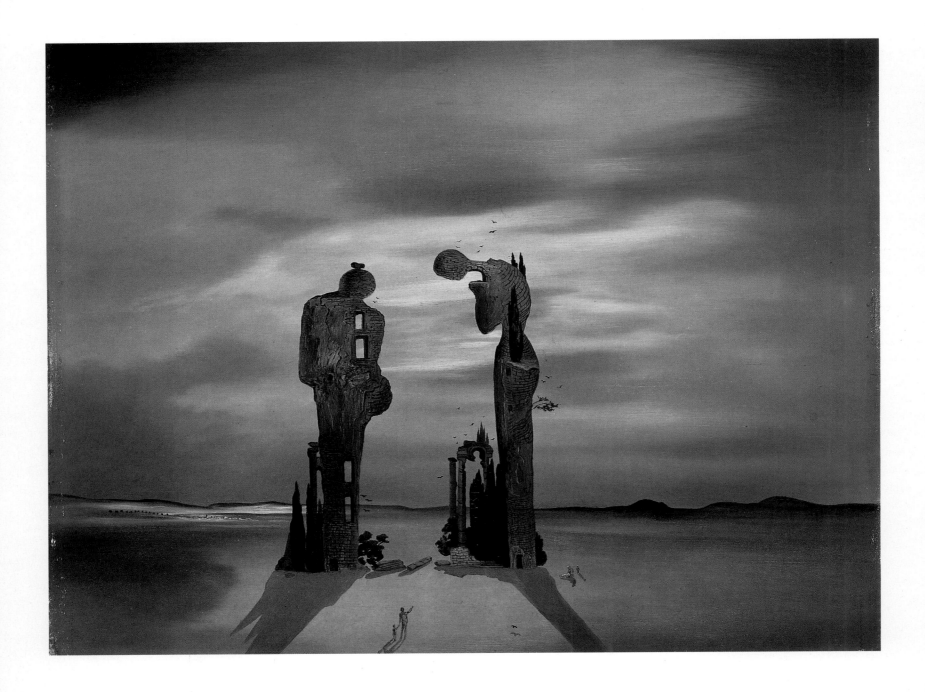

Archaeological Reminiscence of Millet's Angelus, 1933-35

Oil on panel
12½×15½ inches (31.75×39.4 cm)
Morse Charitable Trust, on loan to
Salvador Dali Museum, St Petersburg,
Florida

In this painting the two peasants in Millet's *The Angelus* (page 21) have been transformed not into menhirs, as in *Atavistic Vestiges After the Rain* (page 66) but into ruined buildings whose weathered and eroded surfaces evoke a sense of their great age. The fading light falling on a deserted plain invests the scene with a poignancy and a sense of the passage of time. This impression is reinforced by the inclusion of two elements evoking memories of childhood. In the foreground Dali repeats the depiction of himself as a child holding the hand of his father. In addition, at the right of the picture, Dali has shown himself as an infant standing behind a seated nurse, an image which appears in a number of Dali's paintings, most notably *The Weaning of Furniture-Nutrition*, 1934 (page 68). It refers to Dali's memory of himself as a child pressing himself against the back of a large nurse, her breathing suggesting to him the lapping of waves on the deserted beaches at Cadaqués; the bay of Cadaqués can be seen in the far distance at the left of the painting. Dali recalled suddenly appearing to see a window being cut into the flesh of the nurse's back through which he distinguished 'only a vast beach utterly deserted, lighted by the melancholy light of a setting sun.' Here this window has been relocated in the building relating to the male peasant, so that Dali's interpretation of *The Angelus* has also become associated with this particular childhood memory.

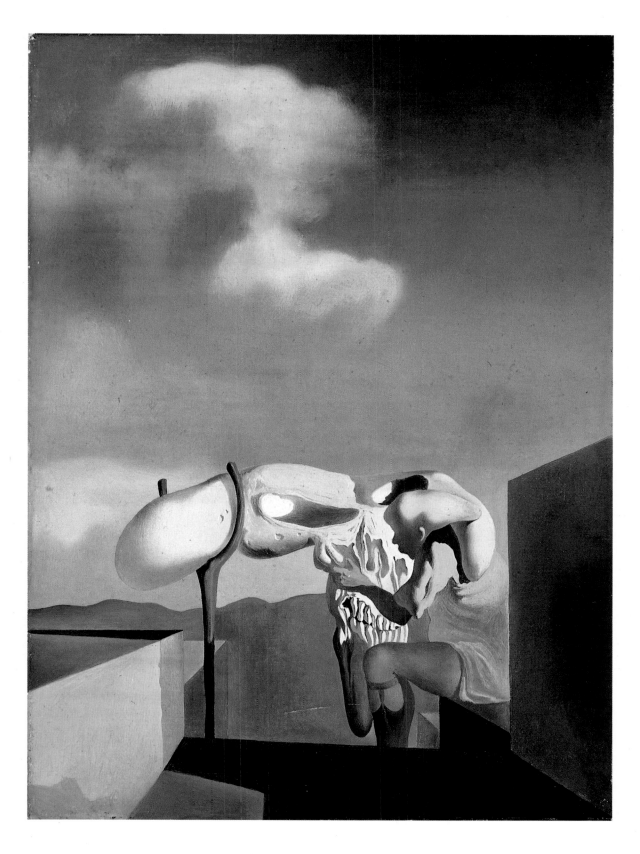

Average Atmospherocephalic Bureaucrat in the Act of Milking a Cranial Harp, 1933

Oil on canvas
8¾×6½ inches (22.2×16.5 cm)
Collection of Mr and Mrs A Reynolds
Morse, on loan to Salvador Dali
Museum, St Petersburg, Florida

In this painting Dali extends the phenomenon seen in *Anthropomorphic Bread* (page 56), whereby the paranoic association of disparate objects produces not double images, but distortions in form which allude to hidden significances. As a result one object is invested with the characteristics of others while retaining its own identity. In *The Secret Life* Dali argued that 'matter is adapted to the pleasure of molding itself by contracting in its own way before the tyrannical impact of space [and] is able to invent its own original form of life'. In *Average Atmospherocephalic Bureaucrat in the Act of Milking a Cranial Harp,* a chain of irrational significances is suggested by allusive distortion.

A figure, identified as a bureaucrat, is shown seated. The shape of his skull is softened and is associated with an enormous soft skull draped across his shoulder and supported on a crutch. The shape of this large skull and the way the bureaucrat is seated before it suggests a harp on which he is playing. This *cranial* harp carries the further implication that the bureaucrat, in playing on it, is *thinking.* Other associations are also evident. The skull sags and suggests a cow's udder, which the bureaucrat is therefore milking, but the soft distortion of the skull also carries phallic connotations so that 'milking', in this context, suggests a return to the obsessive theme of Dali's earlier pictures – masturbation. The painting may thus be read as a visual metaphor for an individual contemplating onanism. The compounding of these different elements within a single fantastic form is the result of paranoiac associations which are essentially formal in origin. At the same time, the way these associations dovetail together suggests a degree of conscious manipulation combined with the lucid recovery from the unconscious of genuine irrational associations. In particular it reflects seemingly deliberately Freud's theory, which he expressed in *The Interpretation of Dreams,* that 'dreams "with a dental stimulus" . . . [are] derived from nothing other than the masturbatory desires of the pubertal period'.

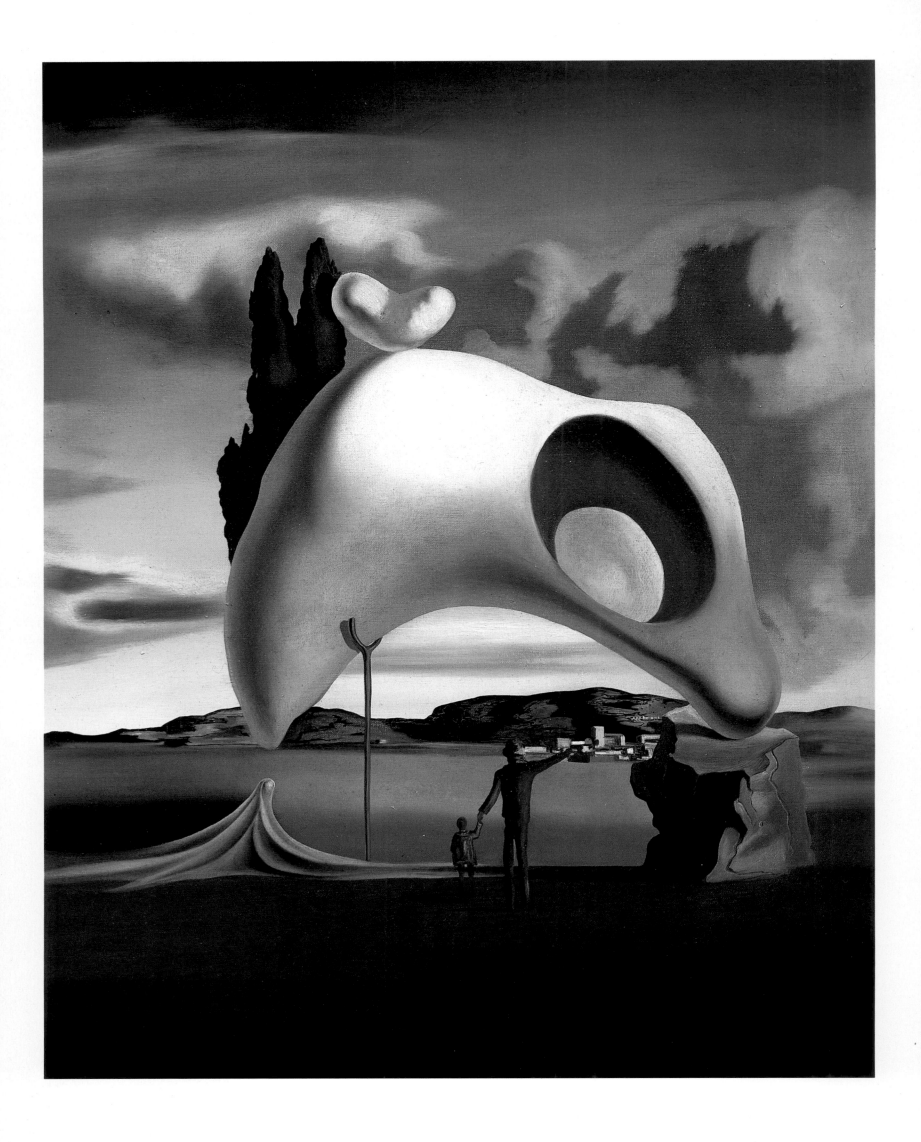

Atavistic Vestiges After the Rain, 1934

Oil on canvas
25⅝×21¼ inches (65.3×54 cm)
Museo Espanol de Arte Contemporaneo

Atavistic Vestiges After the Rain relates, like *The Architectural Angelus of Millet* (page 62), to Dali's description of his hallucinatory experience at Cape Creus which continued: 'Several details of the two figures had been effaced by erosion, which contributed to make their origin seem to date back to a long bygone era, contemporary with the origin of the rocks themselves. It was the man's figure that had been most deformed by the mechanical action of weathering; practically nothing remained of him except the vague and formless block of the silhouette, which thus became fraught with a terrible and particular anguish'. The title of the painting refers to the way the peasants from Millet's *The Angelus* (page 21) have been turned into menhirs, ancient monumental stones. This reflects Dali's conviction that Millet's figures are atavistic, their paranoiac association with sex and death relating to forces which have existed in the human psyche from earliest times. As in Dali's description, the male menhir is a vestige; only a small point rising from the ground remains. The female stone dominates, its body pierced by a cavity as was the male's previously. This conflation of forms suggests that the female has devoured the male, thus realizing Dali's 'false memory' of his mother and the cannibalistic threat he perceived in Millet's painting. The scene is again witnessed by Dali and his father, the latter pointing to the rock at the right of the picture which has assumed the profile of a face. Beyond are the two cypresses which Dali contemplated as a child through the window of the classroom of the Christian Brothers' School at Figueras. He remembered that these 'seemed to burn in the sky like two dark flames'.

The Weaning of Furniture – Nutrition, 1934

(next page)
Oil on panel
7×9½ inches (17.8×24.1 cm)
Collection of Mr and Mrs A Reynolds Morse, on loan to Salvador Dali Museum, St Petersburg, Florida

This painting represents a further variation in the capacity of the paranoiac-critical method to 'interpret' reality by establishing irrational connections between disparate elements. Unlike Dali's development of the double and multiple image, in which several elements may be recognized within a single configuration, here the same configuration is repeated in various parts of the canvas but with different visual significances. As a result associations are made between disparate objects on the basis of repetition of outline or form. Dali developed this aspect of paranoiac-critical activity in a number of other works, particularly *Paranoiac-Critical Solitude*, 1935 (page 76), *Suburb of the Paranoiac-Critical Town*, 1936 (page 80), *Swans Reflecting Elephants*, 1937 (page 86), and *Metamorphosis of Narcissus*, 1937 (page 88).

The setting for this painting is the bay of Port Lligat. The figure seated in the foreground and seen from behind has a composite identity. The woman is Llucia, Dali's childhood nurse, who was notable for her 'immense stature'. At the same time her posture refers specifically to a 'false childhood memory'; while playing with a friend Dali hid behind the back of the large nurse seated on the ground and recalled experiencing the hallucination of the nurse's back being transpierced as if by a window. Dali has depicted this experience in the painting and embellished it by the processes of paranoiac logic. The night table, by virtue of its outline shape, appears to have been formed from the nurse's body. A smaller cabinet, on which a bottle of wine stands, seems in turn and for the same reason to have been formed from the larger cupboard. This again manifests the paranoiac phenomenon of flesh being transformed into inert objects. The implication is that the wine bottle is associated with the nurse's breast and has been formed from it. This connection completes the circle of association by returning to Llucia who was Dali's wet nurse; hence the nutritive quality of the furniture expressed in the title.

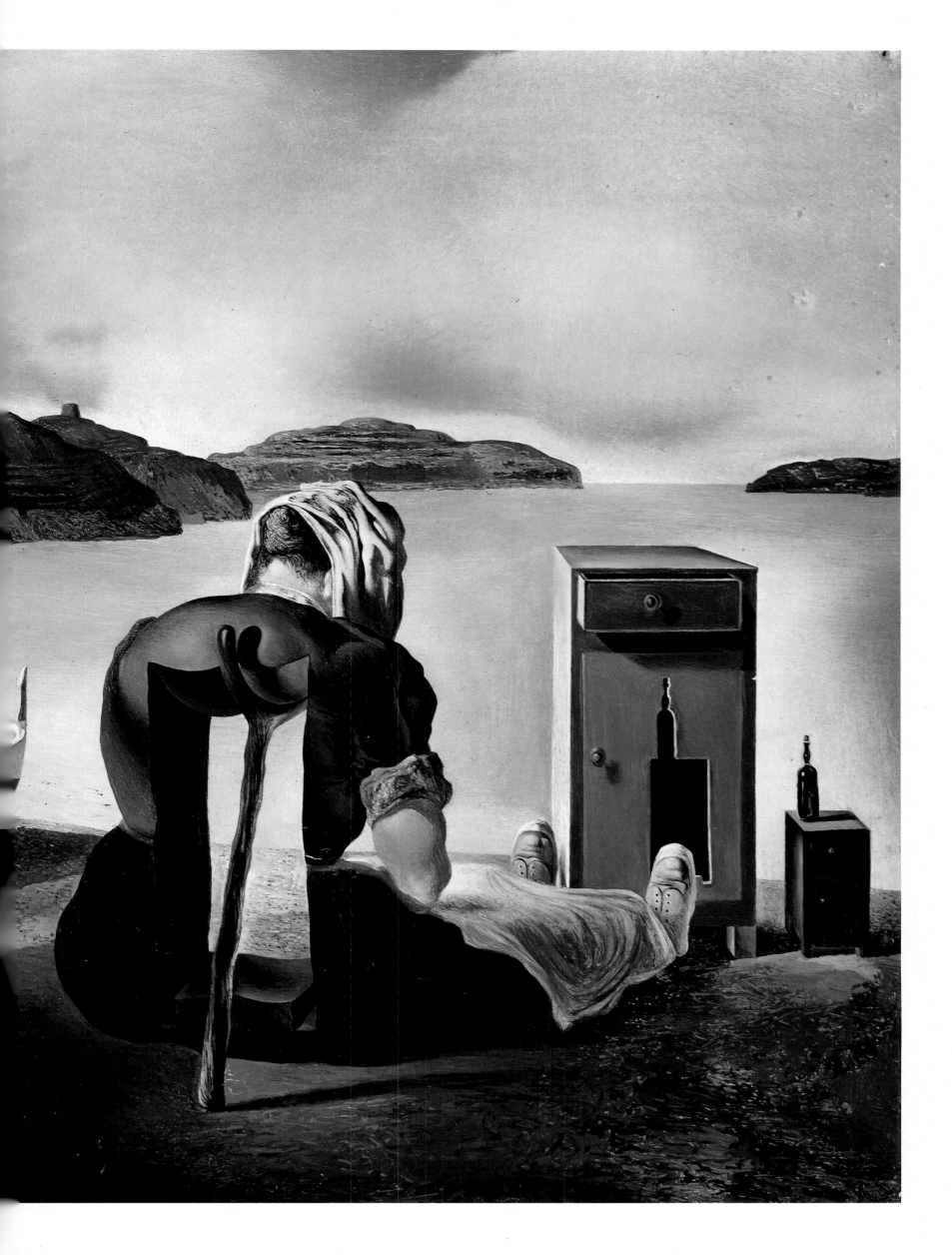

Ghost of Vermeer of Delft Which Can Be Used as a Table, 1934

Oil on panel
7⅛×5½ inches (18.3×14 cm)
Collection of Mr and Mrs A Reynolds Morse, on loan to Salvador Dali Museum, St Petersburg, Florida

In aspiring toward the condition of photography in his painting Dali turned to the techniques of the Old Masters. He stated: 'In the degree that the images of concrete irrationality approach phenomenal reality the corresponding means of expression approach those of the great realist painters – Vélasquez and Vermeer of Delft – to paint realistically according to irrational thought, according to the unknown imagination'. He revered Vermeer in particular; the painter's image occurs in many of Dali's paintings, notably *Enigmatic Elements in a Landscape,* 1934, in which Vermeer is shown from behind painting a landscape occupied by elements from Dali's childhood. Vermeer's painting appealed to Dali because of the

'mysterious luminosity' and 'iridescence of space' which he found in it. He characterized Vermeer as 'the authentic painter of specters'. In *Ghost of Vermeer of Delft Which Can Be Used as a Table* Vermeer himself is depicted as a ghostly apparition, standing mysteriously in a space enclosed by walls. The paranoiac interdependence of the animate and the inanimate evident in those of Dali's paintings featuring a skull and a piano (pages 72, 73) is reversed here and also in *The Weaning of Furniture-Nutrition* (page 68). Instead of inanimate objects becoming infused with life, flesh becomes furniture. The leg of Vermeer thus serves as a table on which are positioned a bottle of wine and a glass.

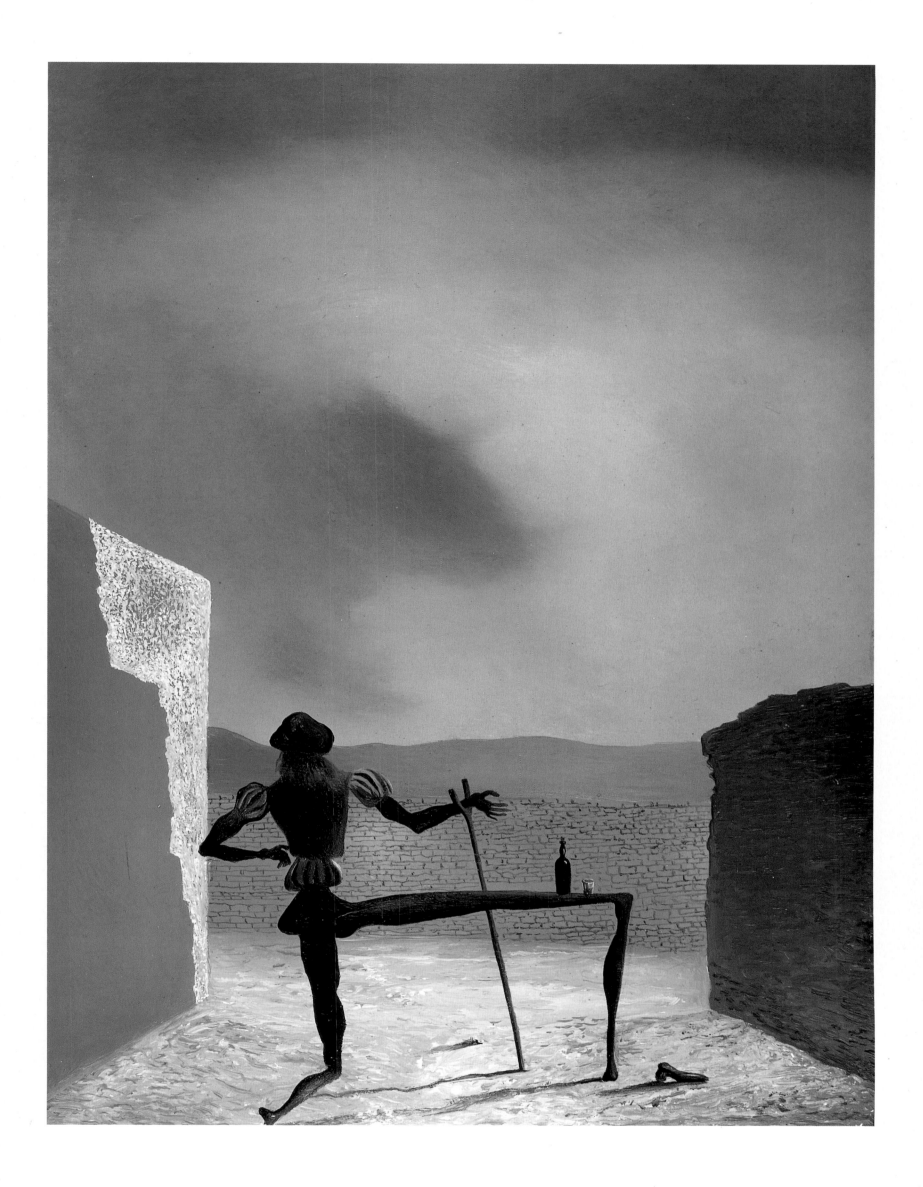

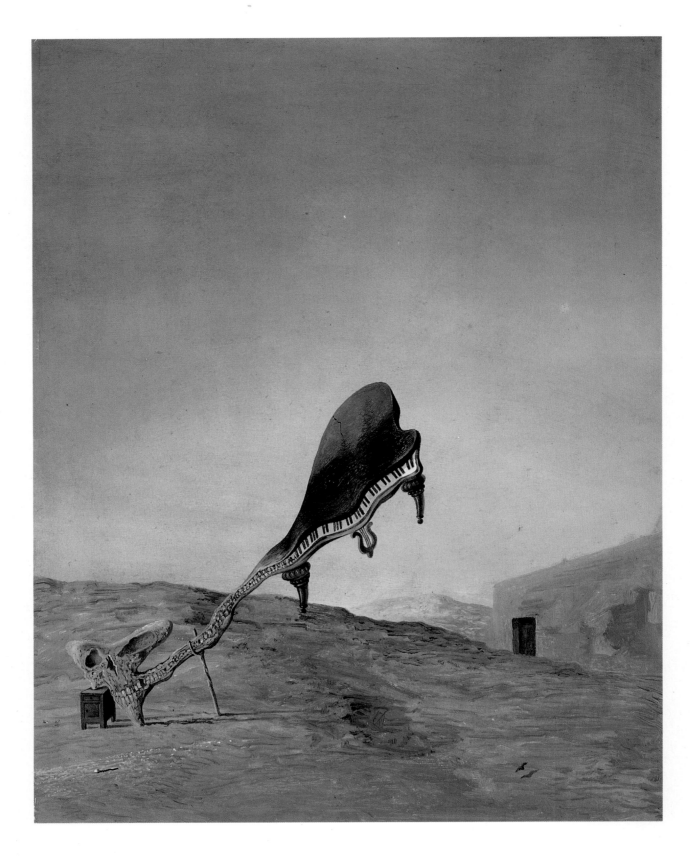

Skull with its Lyric Appendage Leaning on a Night Table which should have the Exact Temperature of a Cardinal's Nest, 1934

Oil on panel
9½×7½ inches (24.1×19 cm)
Collection of Mr and Mrs A Reynolds Morse, on loan to Salvador Dali Museum, St Petersburg, Florida

This painting is one of a number which Dali executed during the mid-1930s using a miniaturist technique on a surface often no larger than a snapshot photograph. Working on this scale permitted him to develop a focused and intense realism which more effectively conveyed images proceeding from the unconscious into the world of phenomenal reality. Dali's purpose was, he explained, to create 'instantaneous and hand-done color photography of the super-fine, extravagant, extra-plastic, extra-pictorial, unexplored, super-pictorial, super-plastic, deceptive, hyper-normal and sickly images of concrete irrationality'.

Three recurrent elements in Dali's painting from around this time – a skull, a piano and a night table – here make a simultaneous appearance. The skull relates to Dali's conviction that 'the most philosophic organs man possesses are his jaws . . . for it is at the supreme moment of reaching the marrow of anything that you discover the very taste of truth, that naked and tender truth emerging from the well of the bone which you hold fast between your teeth'. This reflects a central tenet of Dalinian logic which holds that eating has ontological implications; Dali attached to food 'essential values of a moral and aesthetic order'. That which is most edible is most real because most tangible. For this reason Dali claimed 'I like to eat only things with well defined shapes that the intelligence can grasp'. The jaws of the skull, instruments of mastication and hence of the intellect, are here conjoined with their opposite; the keys of a piano, instrument of lyrical thought. The visual conjunction of teeth and piano keys is a result of the paranoiac perception of a formal association. It is also the outcome of irrational thought processes which paranoia systematizes into its own logical order. The skull and its appendage lean on a night table, an allusion to the way this image originated; according to Dali it floated to the surface of his mind, fully formed, during the course of a siesta.

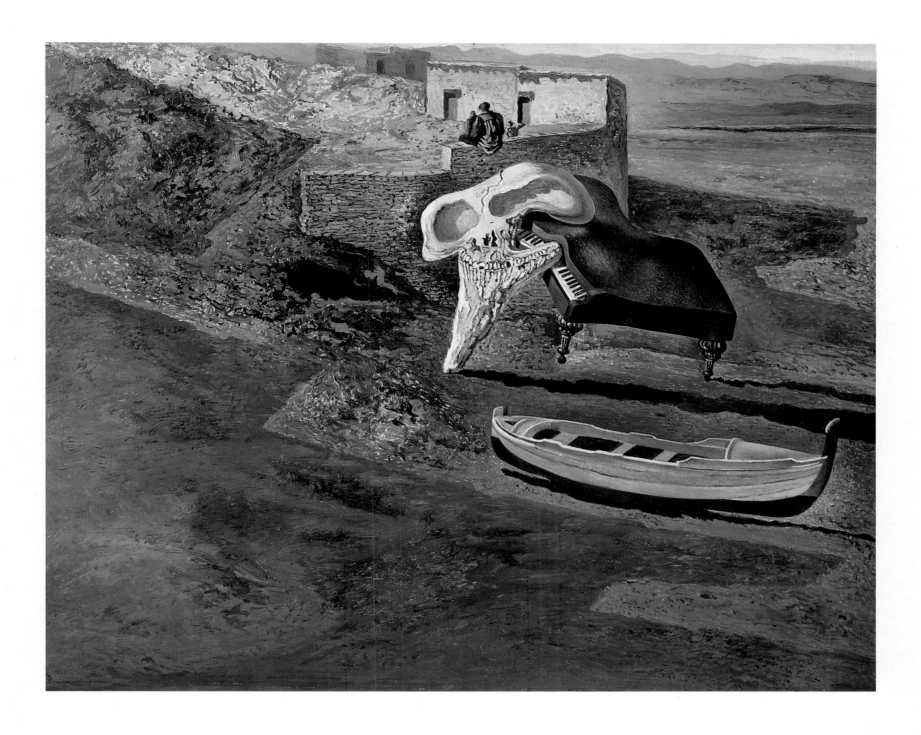

Atmospheric Skull Sodomizing a Grand Piano,

1934

Oil on panel
5½×7 inches (14×17.8 cm)
Collection of Mr and Mrs A Reynolds
Morse, on loan to Salvador Dalí
Museum, St Petersburg, Florida

In this painting the skull and the piano are invested with anthropomorphic characteristics so that a fossil remnant of human life indulges in an erotic act with a manufactured object. This reflects the way in which, as a result of paranoiac reasoning, inanimate objects became infused with life and objects from entirely different categories of being become associated and interact. More particularly it reflects Dali's knowing use of the Freudian theory of transposition. In *The Interpretation of Dreams* Freud explained that 'sexual repression makes use of transposition from a lower to an upper part of the body . . . one instance . . . is the replacement of the genitals by the face in the symbolism of unconscious thought'. Freud goes on to demonstrate how the parts of the face – cheeks, lips and nose – are homologous to the sexual parts of the female and male respectively. Transposition may thus be understood to be the migration of a set of characteristics from one bodily area to another. This mechanism is manifest in the way the skull has become invested with the character of male genitalia. Dali's extension of the notion of transposition is evident in the way that in this painting parts of the piano have assumed anal significance.

Although extreme in the force of its irrationality – even by Dalinian standards – this image attains cogency through the way it simulates photography. This is one of Dali's smallest paintings and he often used a watchmaker's eyeglass when working on this scale, as evidenced by the minute and precise detail with which the setting has been described. Dali transcribed the view from his house at Port Lligat. This conjunction of elements drawn from delirium and from the real world implements literally the express aim of Surrealism, which was to bring about 'the future resolution of these two states, dream and reality . . . into a kind of absolute reality, a Surreality'. For this reason Dali's painting was at the cutting edge of the movement at this time.

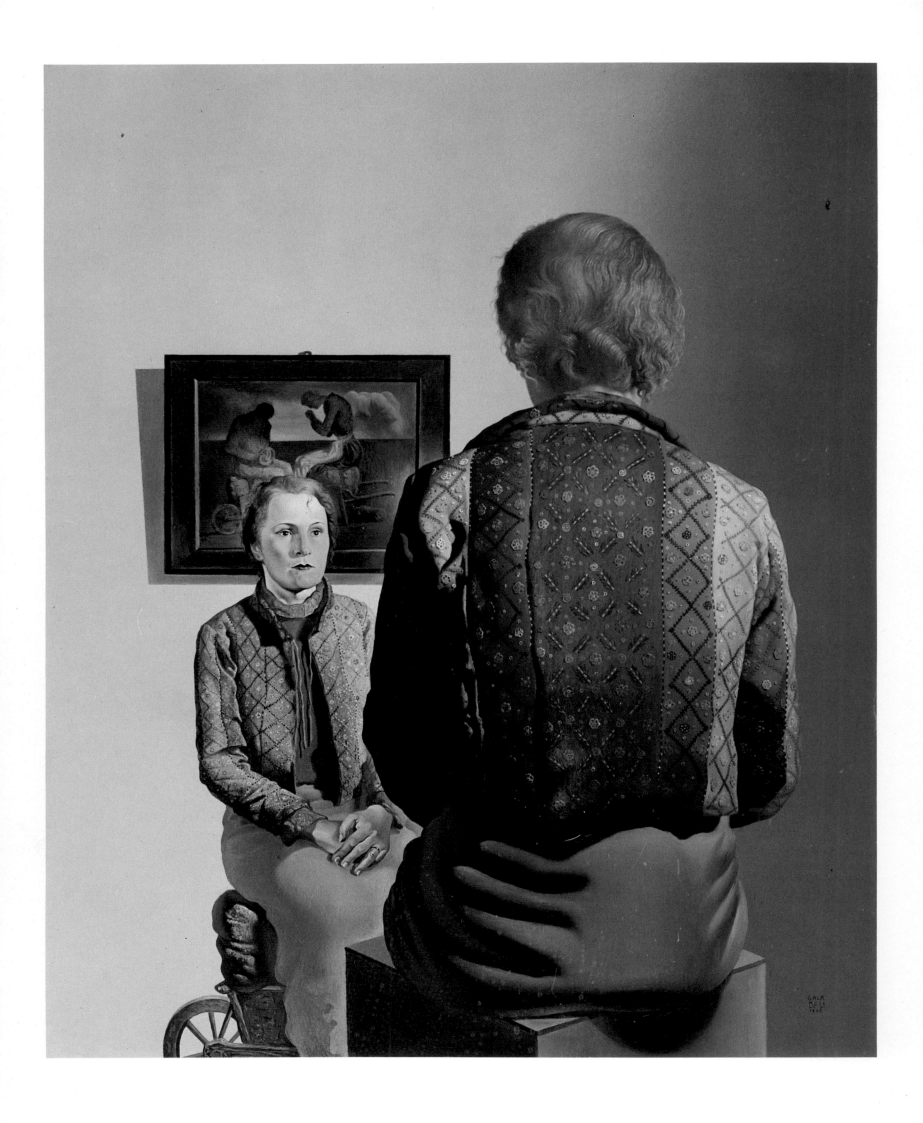

Portrait of Gala, 1935

Oil on panel
12¾×10½ inches (32.4×26.7 cm)
The Museum of Modern Art, New
York

Here the phenomenon of the association
of elements by repetition of their shape is
bound up with Dali's paranoiac interpre-
tation of Millet's *The Angelus* (page 21). A
version of the Millet painting appears on
the wall behind Gala's head, modified so
that the two peasants are shown sitting on
the wheelbarrow. In other respects the
figures have not been changed dramat-
ically. The man sits with his head bowed,
still covering his sexual parts with his hat.
The woman is shown in profile as in the
original; her hands are raised in a more ex-
aggerated manner so as to evoke more
overtly the attitude of the praying mantis.
This situation is repeated in the space in
front of the picture. Gala is shown facing
forward and, like the male peasant in the
picture behind her, she is seated on a
wheelbarrow with her hand clasped on
her lap. Simultaneously, she is shown
with her back to the viewer, as if facing
her other image and looking into the pic-
ture. Her depiction in this way connects
her with the viewer in the real world as
well as linking her with the relation of the
figures in the picture on the wall. Thus
three levels of reality are invoked and
associated. Small in scale, this picture is
notable for the meticulous photographic
precision of its technique, which height-
ens our sense of the reality of the image,
while also confounding our concept of
what is 'real'.

Paranoiac-Critical Solitude, 1935

(next page)
Oil on panel
7½×9⁹⁄₁₆ inches (19×22.9 cm)
Former collection of Edward James,
now private collection

Paranoiac-Critical Solitude, like *The
Weaning of Furniture-Nutrition* (page
68), establishes paranoiac associations be-
tween disparate elements in different
parts of the painting through the repeti-
tion of an outline shape. It also develops
the hallucinatory image of one element
creating a void in another entirely dif-
ferent object, having been apparently re-
moved from it. In this painting the wreck
of an automobile, filled with flowers,
seems abandoned in the desert-like space
in front of a rocky outcrop. Its material
presence is attested by the shadow which
it casts on the ground. Despite this, a cav-
ity driven through the rock behind also
cuts through the upper outline of the car,
implying that the car and the rock are
joined. As a result the car's three-dimen-
sionality is confounded. The temptation
to reinterpret its appearance is advanced
by the shallow cutout, duplicating the
outline of the car, in the rockface at the
left of the picture. The large stoneplug
projecting from the rock corresponds to
the cavity piercing the car. These two ele-
ments, rock and mechanical object,
although physically separate, are thus
associated and the implication is that
formerly they were somehow cosubstan-
tial. In this way appearance is discredited
and invested with irrational significance.

Unlike Dali's earlier paintings, there is
in this work a notable absence of imagery
derived from personal obsession; from
this point his work is marked by an ex-
pansion of subject-matter. At the same
time Dali applied the photographic real-
ism which his technique had by this time
attained to images produced by the para-
noiac-critical method. This produced
paintings of increased visual sophistica-
tion which are less obviously autobio-
graphical in nature.

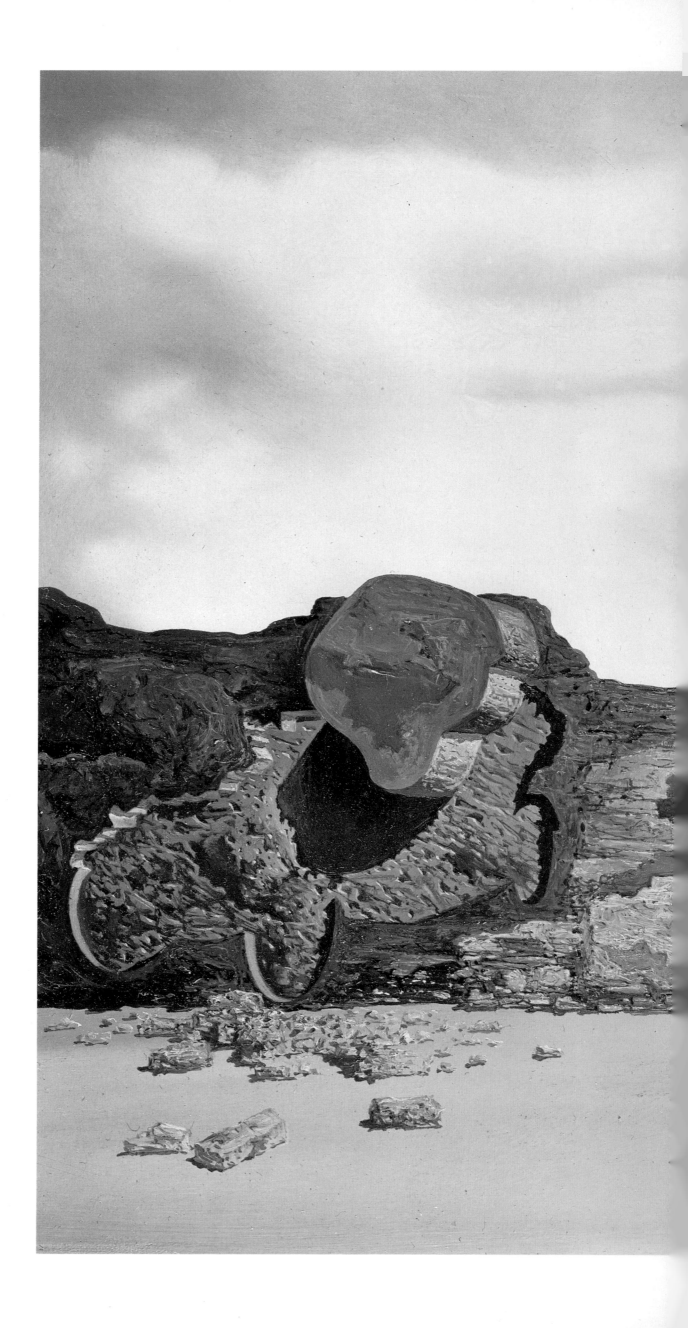

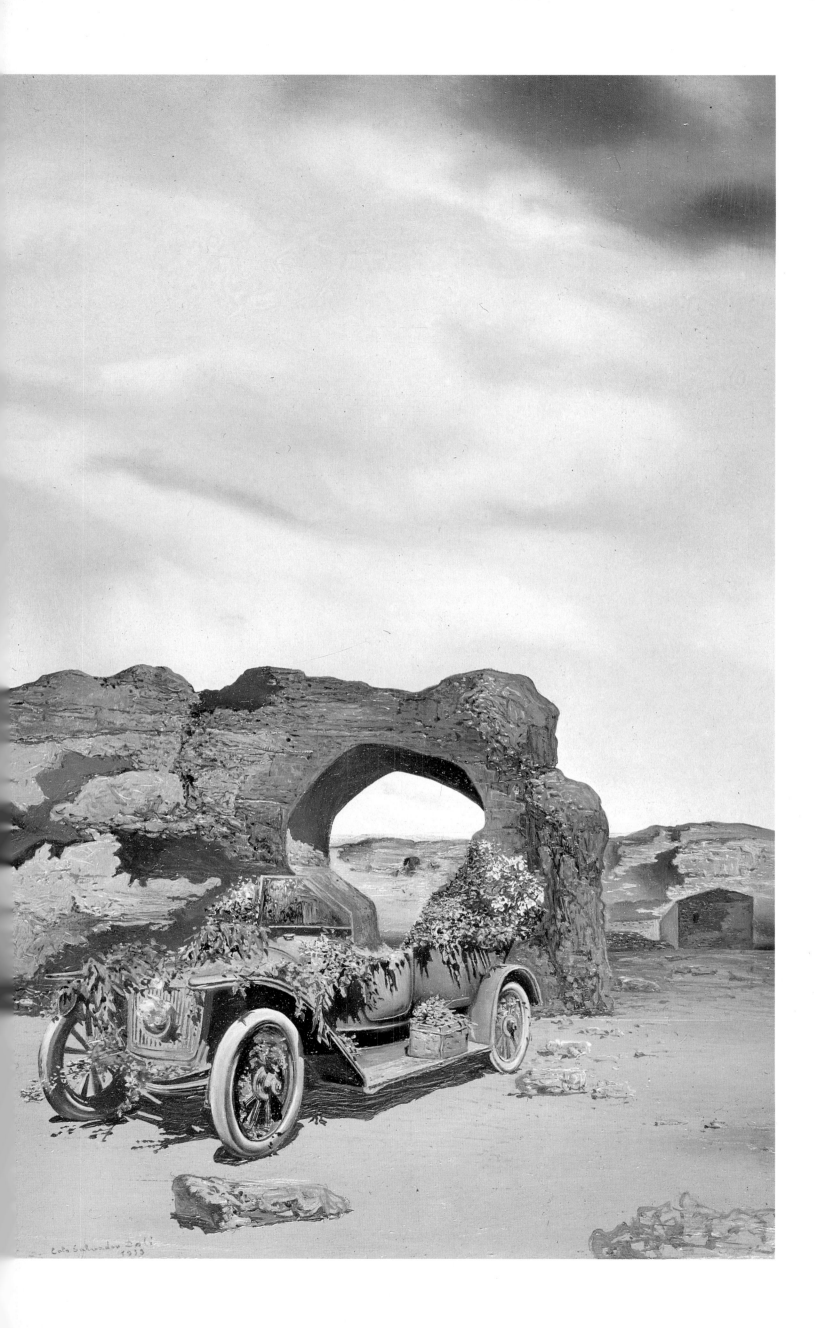

The Great Paranoiac, 1936

Oil on canvas
24⅜×24⅜ inches (62.2×62.2 cm)
Former collection of Edward James,
now Museum Boymans-van-Beuningen,
Rotterdam

The antecedents for Dali's development of the double and multiple image can be found in Leonardo da Vinci's description of a related phenomenon in his *Treatise on Painting*. Leonardo observed that 'it is not to be scorned, when you recall certain aspects that you have stopped to look at, a spot on walls, in the ashes on the hearth, and clouds or in streams. If you look often carefully, you will discover wonderful things there . . . battles of animals or men . . . landscapes . . . monsters . . . devils and other fantastic things'. Dali first encountered this phenomenon, which he described as 'the keystone of my future aesthetic', during his school days. His description of these experiences bears a close similarity to Leonardo's: 'The great vaulted ceiling which sheltered the four sordid walls of the class was discolored by large brown moisture stains. . . . In the course of my interminable and exhausting reveries my eyes would untiringly follow the vague irregularities of these moldy silhouettes and I saw rising from this chaos, which was as formless as clouds, progressively concrete images which became endowed with an increasingly precise detailed and realistic person-

ality'. The essential difference lies in the way Dali specifically links the recognition and formation of 'common images having a double figuration' with the capacity of the paranoiac mind to 'interpret' reality by means of irrational association.

Dali's mastery of the technique of double figuration is evident in *The Great Paranoiac*. Set in a desert landscape, a group of figures writhe grotesquely; the woman in the foreground clasps her head in her hands, others gesticulate and recoil from some invisible apparition. Without any of these figures being modified it is possible to perceive, in their gesture and movements, the appearance of an enormous head. In the distant group of figures the phenomenon is repeated.

Despite its psychoanalytical significance, allusions to Leonardo are evident in this work. Its areas of loosely applied paint evoke Leonardo's sources of inspiration in stained walls and Dali's color scheme recalls the brown underpainting apparent in Leonardo's unfinished work *The Adoration of the Magi* (begun 1481), in which the treatment of human forms seems to have been a source of inspiration for the figures in Dali's painting.

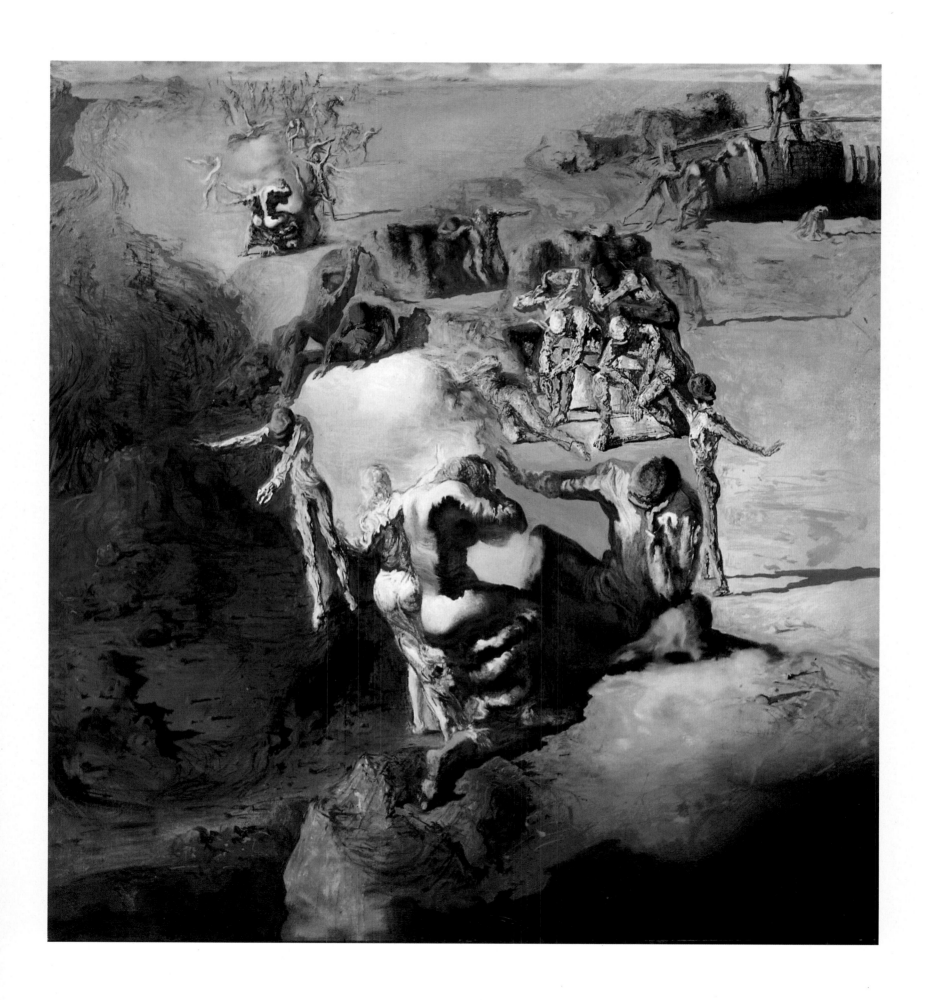

Suburbs of a Paranoiac-Critical Town: Afternoon on the Outskirts of European History, 1936

Oil on panel
18½×26 inches (47×66 cm)
Former collection of Edward James

In this painting Dali developed the phenomenon of paranoiac association by the repetition of formal configurations. A network of visual conjunctions links the various elements within the scene, while a more generalized substructure of hidden, mysterious significances gradually reveals itself to the viewer and invests the scene with an atmosphere of anxiety and foreboding.

A smiling Gala stands in the foreground. Holding a bunch of grapes she invites the viewer to partake of the fruit and to enter the world of the picture.

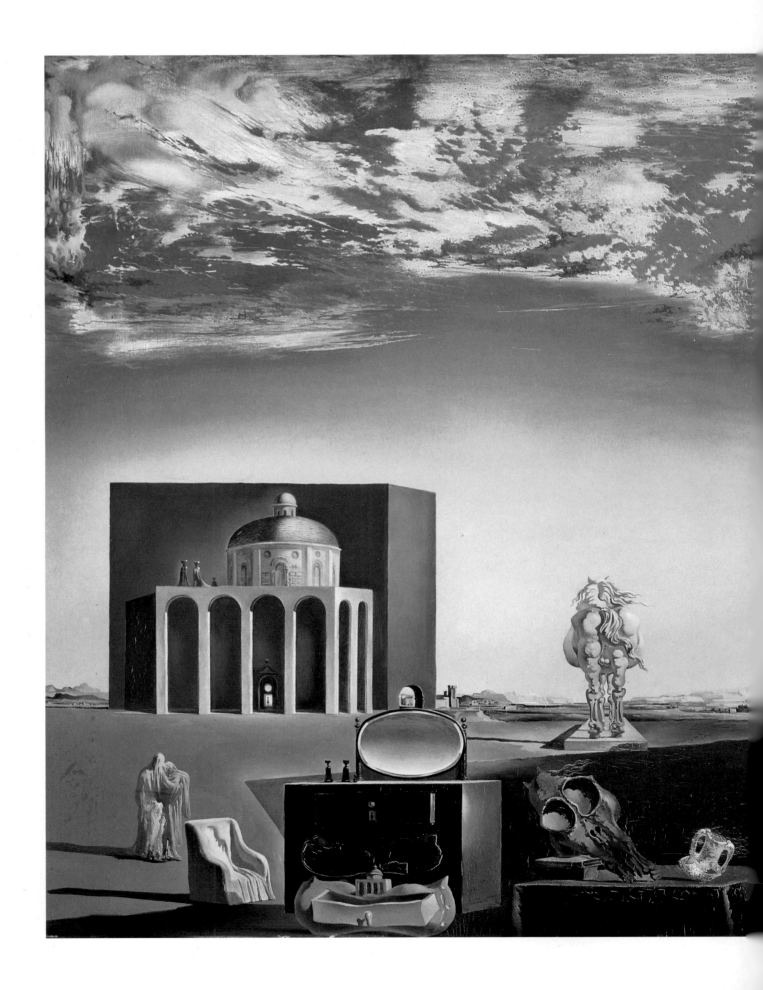

Recognition that the form of the grapes suspended from Gala's fingers is echoed in the horse's skull on the table interweaves the observer's perceptual processes with the disturbing logic of paranoia. The formal links between the skull and the rear view of the equestrian statue, and also the way the eye sockets seem to rhyme with the spaces enclosed by the handles of the adjacent amphora, further entangle the observer. Other connections are implied: the shape of the entrance to the town is repeated in the distant belltower; the large arcaded structure at the left of the painting reappears in the miniature building resting on the cushion in front of the chest of drawers; a visual echo of the girl skipping in the town square can be seen in the bell beyond. Further, the shape of the girl standing in the passage at the end of the street is repeated in the keyhole in the cabinet and in a similar figure standing in the doorway framed by the arcaded building. The shrouded figures standing on top of the arcades are connected with the bell-like shapes on top of the dresser and also with the pair of figures at the left.

An impression of decay pervades this work. The walls are flaking and in one place a wall is supported by a crutch. This atmosphere is heightened by the presence of the skull and the ghostly figures, and also by the Renaissance building with its Bramantesque dome, and the broken amphora evoking civilizations which have passed into history. The painting belongs to a group of works which Dali commenced at this time, expressing anxiety inspired by the threat and subsequently by the reality of the Spanish Civil War.

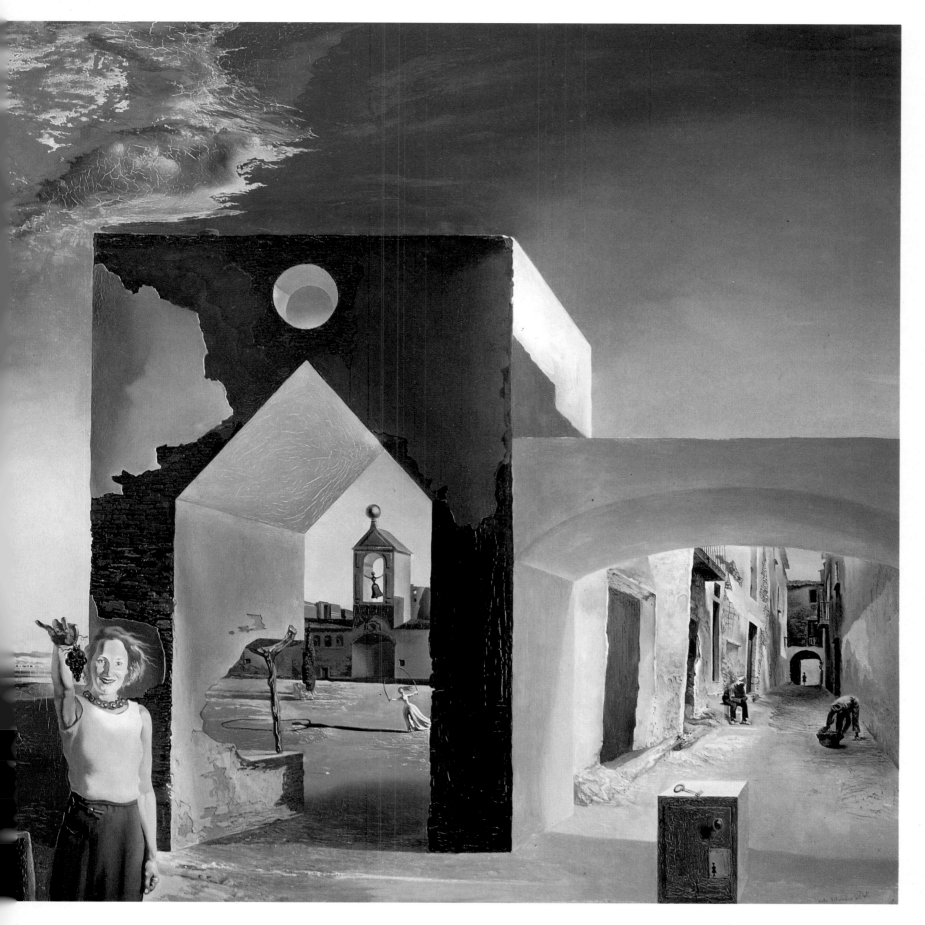

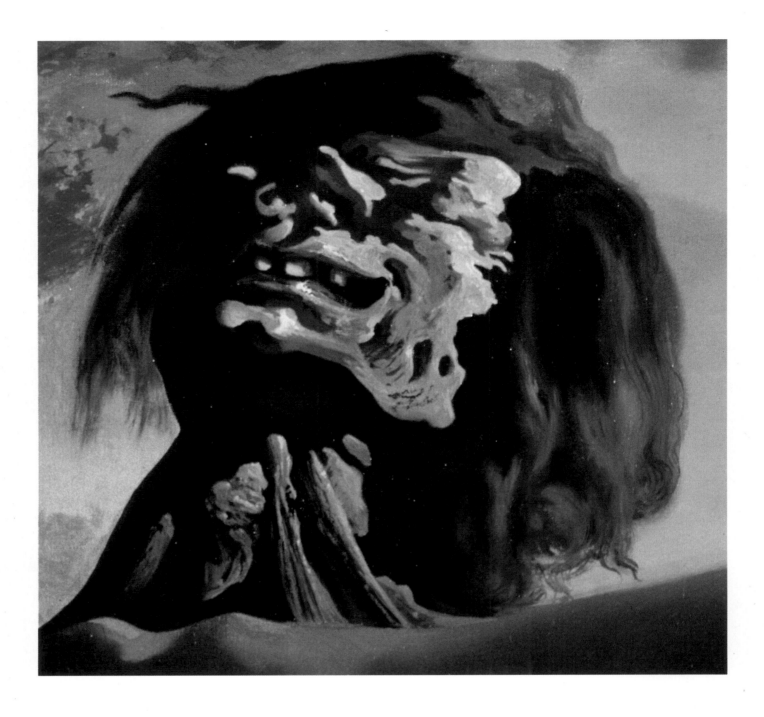

Soft Construction with Boiled Beans – Premonition of Civil War, 1936

Oil on canvas
39⅜×39 inches (100.1×99.1 cm)
Philadelphia Museum of Art

In October 1934 Dali and Gala traveled to Barcelona where Dali was to deliver a lecture. Finding themselves in the midst of a general strike and an armed uprising by Catalan separatists, the pair were forced to flee immediately. Although they arrived safely in Paris their escape had been a narrow one: the chauffeur who had conveyed them to the frontier was killed on his return. Dali sensed in these events 'the approach of the great armed cannibalism of our history, that of our coming Civil War'. This large canvas, begun in Paris, expresses his vision of the carnage and destruction he anticipated.

Dali observed, 'I showed a vast human body breaking out into monstrous excrescences of arms and legs tearing at one another in a delirium of auto-strangulation. As a background to this architecture of frenzied flesh devoured by a narcissistic and biological cataclysm, I painted a geological landscape that had been uselessly revolutionized for thousands of years congealed in its "normal course". The soft structure of that great mass of flesh in civil war I embellished with a few boiled beans, for one could not imagine swallowing all that unconscious meat without the presence (however uninspiring) of some mealy and melancholy vegetable'.

Dali professed to have no political sympathies, believing only in 'the supreme reality of tradition'. This is evoked by the plain of Ampurdán, which he had loved since childhood. Its presence as a backdrop for this monstrous evocation of war demonstrates the way he saw the coming conflict as a bloody engagement, not only of opposed ideologies, but also of the forces of revolution and tradition. It would be a war marked by dreadful reciprocation: 'suffering and inflicting suffering, for burying and unburying, for killing and resuscitating'.

The presence of the beans reflects Dali's association of the very real and the eminently edible, a continuing theme in his work. This motif also shows how the Civil War was linked in Dali's mind with eating and with love; in a related picture, *Autumn Cannibalism* (page 84), the association of war eating and love is the central theme.

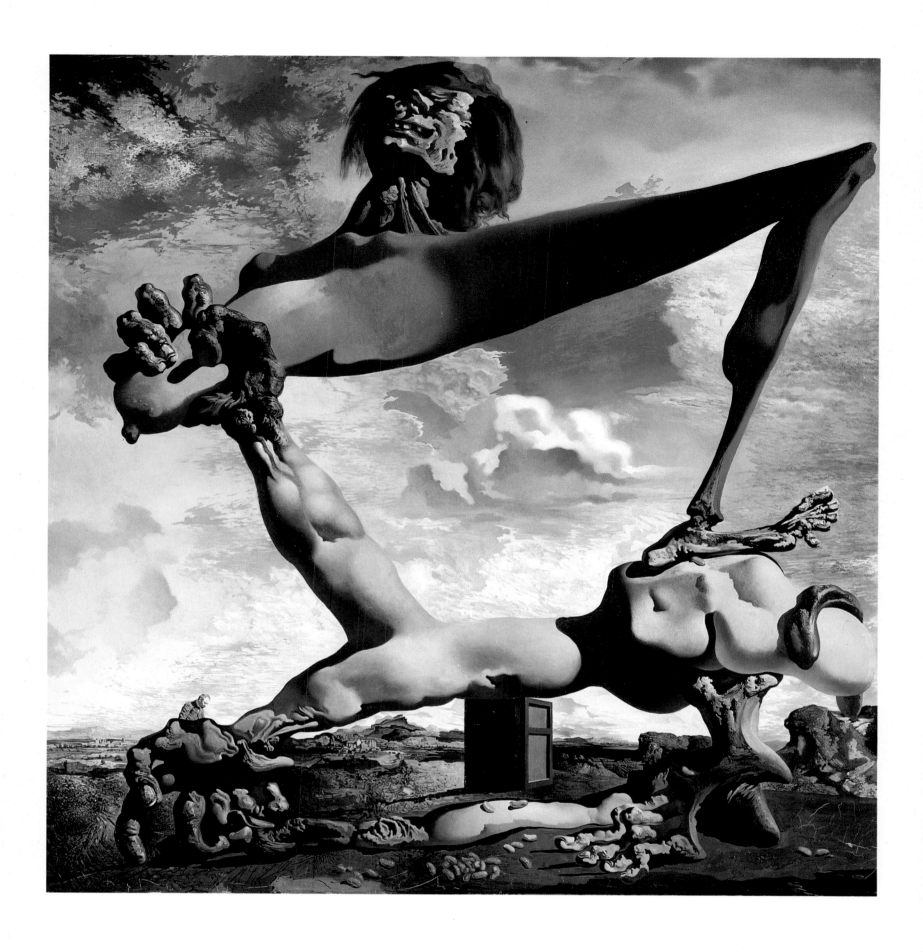

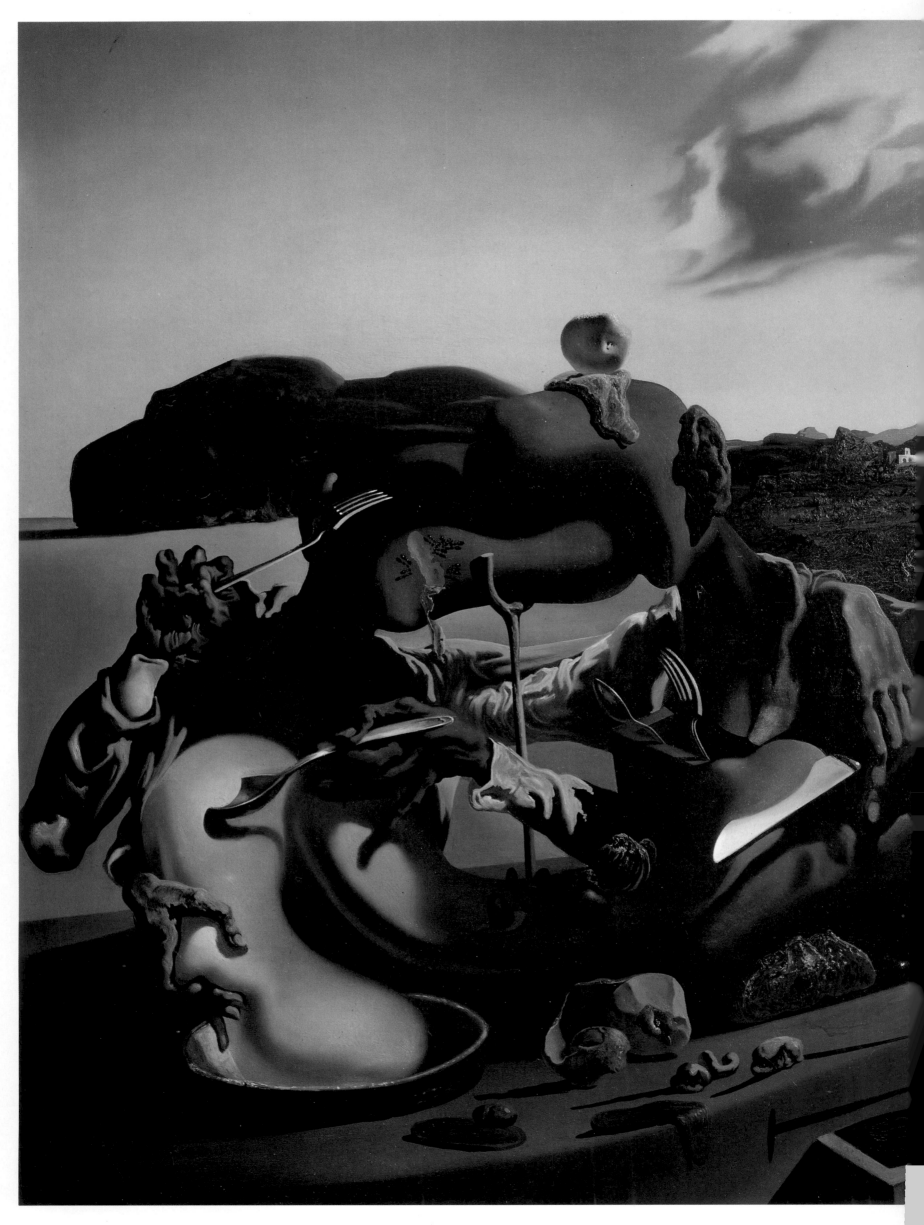

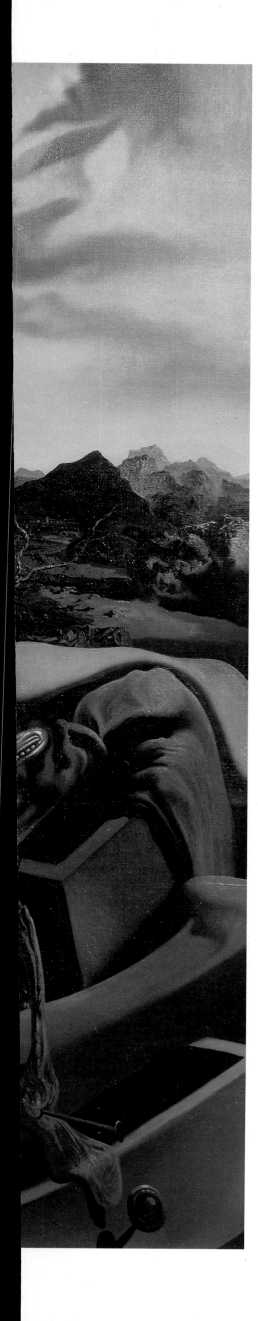

Autumn Cannibalism, 1936

Oil on canvas
25⅝×25⅝ inches (65.3×65.3 cm)
Tate Gallery, London

In *Autumn Cannibalism,* painted after the outbreak of the Spanish Civil War in July 1936, the conflict is represented as a couple locked in a deadly embrace of mutual cannibalism. But love and eating were also linked in Dali's mind. This is evident in his description of the first eruption of his passion for Gala: 'This first kiss, mixed with tears and saliva, punctuated by the audible contact of our teeth and furiously working tongues, touched only the fringe of the libidinous famine that made us want to bite and eat everything to the last! Meanwhile I was eating that mouth whose blood already mingled with mine'. The depiction of civil war as the embrace of two beings devouring each other is thus underpinned by a tragic ambivalence which expresses the pathos of civil war as well as its violence. As Dali observed: 'Nothing is closer to an embrace than a death grapple'.

The figures are ostensibly male and female. The figure on the left has an elongated flaccid breast draped over the shoulder of her counterpart. There is also, however, an allusion to the capacity of civil war to pit father against son; the apple and cutlet placed on the head of the other figure relates to Dali's interpretation of the William Tell legend as an allegory of paternal threat. The severed tongue with a nail driven through it evokes the idea of crucifixion but also the pointlessness of the war: the 'meal' in which the beings are engaged is futile because the food cannot be tasted. A further connection between eating and war lies in the use of cutlery as weapons. The ants which can be seen flaying the head of one of the figures relates to Dali's first 'false memory', the horrific vision of a child's flesh being consumed by a swarm of ants.

Lovemaking, eating, violence and death were all associated in Dali's mind and he saw the Civil War as the manifestation of these forces. The horrific nature of this image thus reflects Dali's conviction that 'people learn to love one another in killing one another'.

Swans Reflecting Elephants, 1937

(next page)
Oil on canvas
20⅛×30⅜ inches (51.3×77.2 cm)
Private Collection

The end of the 1930s saw the spread of Dali's reputation to America. Official recognition was conferred by his appearance, on 14 December 1936, on the cover of *Time* magazine (page 11). At the same time there was a corresponding increase in his artistic output. One aspect of this was his concentration on the 'morphological echo', an aspect of paranoiac association which he had begun to develop somewhat earlier, in *The Weaning of Furniture-Nutrition,* 1934 (page 68). Between that year and the end of the decade Dali executed a number of works which feature the association of different images by repeating similar configurations with variant visual significances. In 1937 Dali executed a pair of paintings in which this kind of association is the central image; they are Dali's major statements of this manifestation of the paranoiac-critical method. These are *Swans Reflecting Elephants* and *The Metamorphosis of Narcissus* (page 88).

Swans Reflecting Elephants demonstrates the development which had occurred in Dali's style since the beginning of the decade. In contrast to the disorder and cacophony of his earlier paintings this work is rendered with extreme clarity, its atmosphere still and quiet. Its hallucinatory force achieves potency by being integrated within a natural, almost banal, setting, which is depicted with photographic precision. The swans and the twisted trees behind them are invested with hidden, irrational meaning. This is revealed in the repetition of these forms as reflections in the lake beneath, in which images of swans and trees have been transformed into elephants. This manifests the power of paranoia; the domination of reality by tyrannizing, subjective forces.

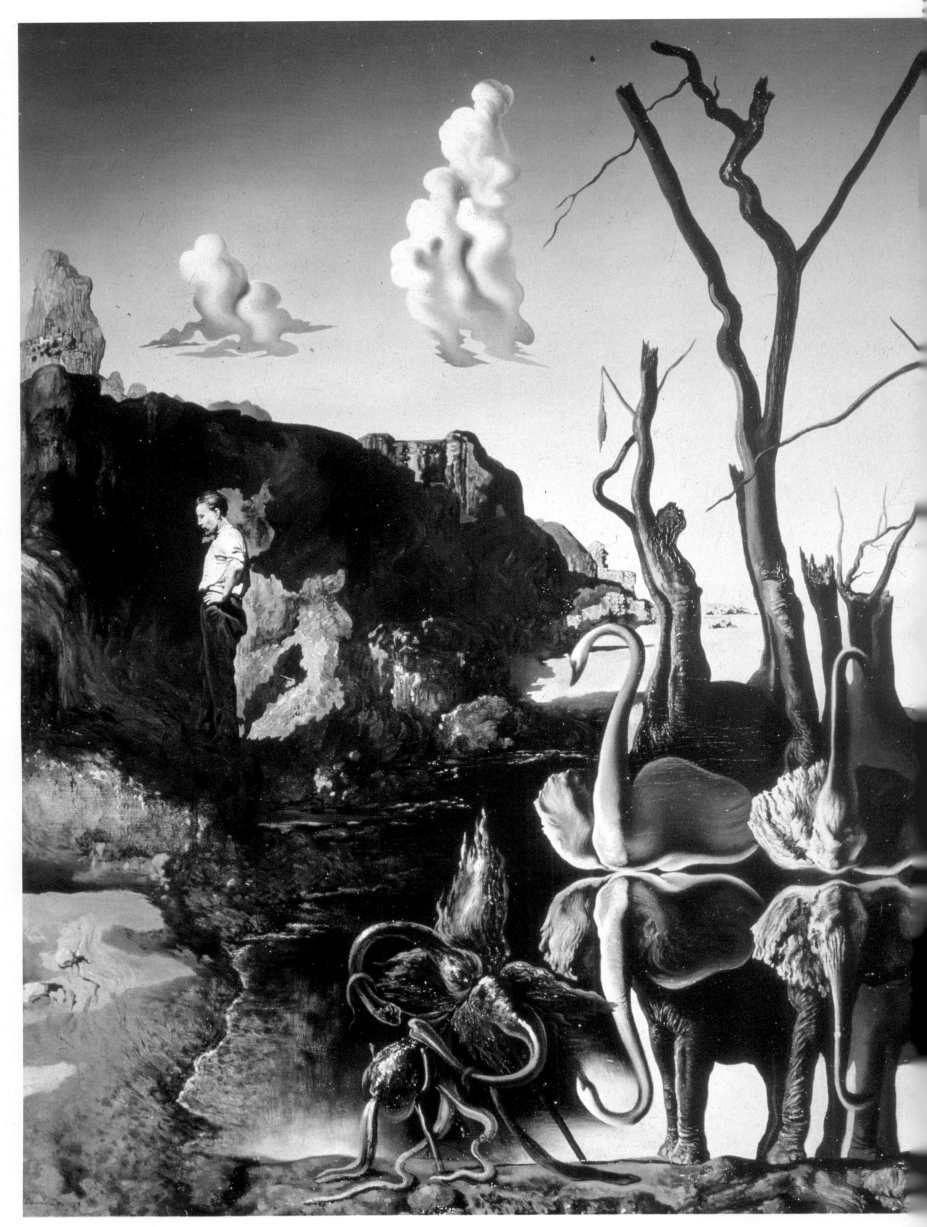

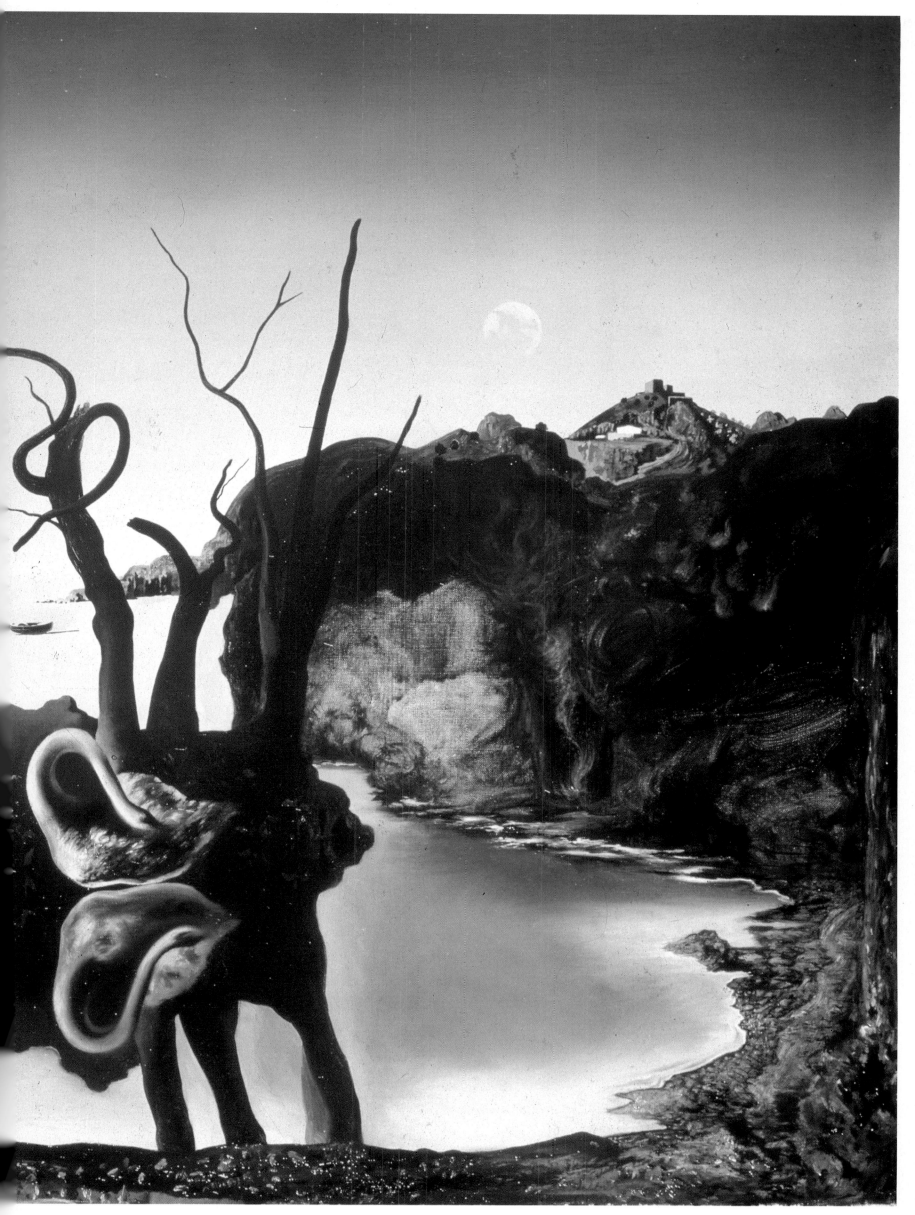

Metamorphosis of Narcissus,

1937

Oil on canvas
20⅛×30¾ inches (51.3×78 cm)
Tate Gallery, London

In *Metamorphosis of Narcissus* the repetition of a formal configuration not only links two different images, but alludes to the transformation of one into the other. In Greek mythology Narcissus was a beautiful youth who fell in love with his reflection in a fountain; he was drowned after jumping into the fountain in order to embrace his own image. No body was ever found, only a flower which became known by his name. In Dali's painting, the youth is shown before and after his metamorphosis into a hand holding a cracked egg from which grows the narcissus flower.

The nature of this transformation derives from a particular train of paranoiac thought, revealed in Dali's poem of the same title which was published in Paris in 1937. In it Dali recounts a conversation between two Port Lligat fishermen:

First Fisherman: What's the matter with that boy staring at himself in a mirror all day?

Second Fisherman: If you really want to know he's got a bulb in his head.

As Dali explained, in Catalan 'a bulb in the head' corresponds with the psychoanalytical concept of a 'complex'. In this way, the boy admiring himself in the mirror suggested the myth of Narcissus's self-love which, in turn, became associated with psychoanalytical terminology. These two strands were interwoven further. Dali's paranoiac logic led him to conclude that 'if a man had a bulb in his head it might break into flower at any moment, Narcissus!' As a result Narcissus's 'complex', and his mythical transformation into a flower, are compounded in Dali's depiction of his transformation.

In *The Interpretation of Dreams,* Freud used the term 'narcissism' to describe 'unbounded self-love'. To this extent the figure in Dali's painting connects with his earlier obsession with onanism and is invested with personal significance. However, Dali wrote: 'When that head slits/ when that head splits/ when that head bursts/ it will be the flower,/ the new Narcissus/ Gala -/ My Narcissus'. The implication is that Gala had become the object of Dali's self-love, a paradox which could only be resolved by the fusion of the separate identities of Gala and Dali into one. This development is evident in the way Dali began to sign his paintings from this point as 'Gala Salvador Dali'.

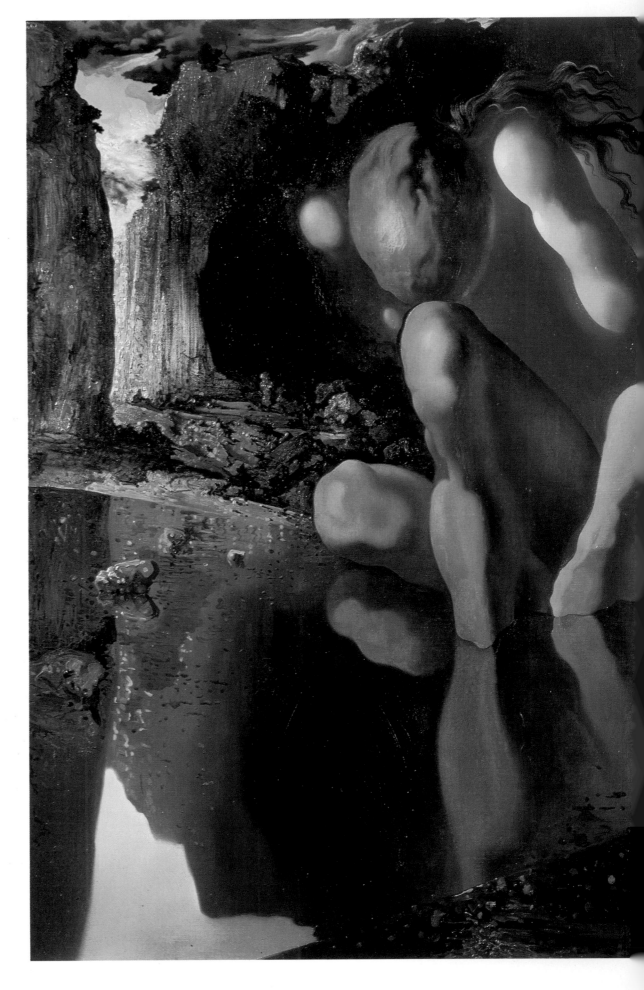

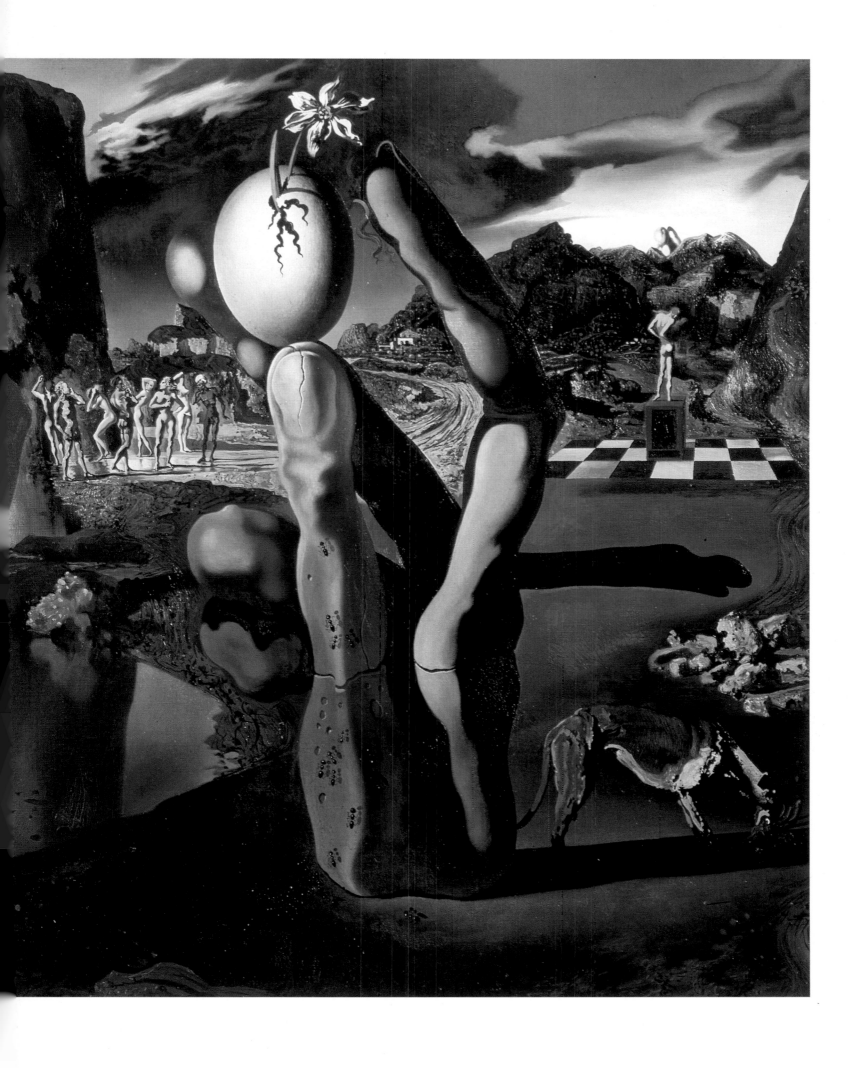

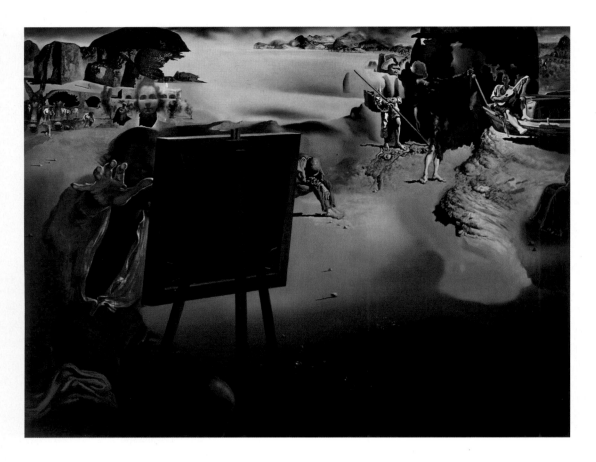

Impressions of Africa, 1938

Oil on canvas
35⅞×46¼ inches (91.6×118.4 cm)
Boymans-van Beuningen Museum,
Rotterdam

Unable to return to wartorn Spain, Dali and Gala traveled in 1937 to Italy. They stayed at the Villa Cimbrone near Amalfi, the home of Edward James, an English art collector who was at that time Dali's most important patron. Subsequently the couple moved to Rome where they were the guests of Lord Berners. It was during this stay, which lasted two months, that Dali painted *Impressions of Africa*.

The title is something of a misnomer. Dali never visited Africa and the title derives from a play by Raymond Roussel, a writer admired by the Surrealists. The painting depicts the process which Dali described in *The Secret Life*: 'I spent the whole day seated before my easel, my eyes staring fixedly, trying to "see", like a medium, the images that would spring up in my imagination . . . I would remain in suspense, holding up a paw, from which the brush hung motionless, ready to pounce . . .' The images which Dali mined from his imagination are arranged around the depiction of himself engaged in the act of painting. They take the form of a 'para-

noiac advance': clusters of double images and the repetition of shapes linked by formal association. Above Dali's head, as if signifying his preeminent obsession, is the face of Gala. This dissolves into the view of an arcaded building beyond. A bird in flight is perceptible in the rock formation on the horizon. To the left the image of a shadowy recess in a rock face is repeated and assumes a further significance, doubling as the foliage of a tree. In front of this stands the figure of a priest. In turn this shape is repeated and is transformed into the face of a donkey. Other interlocking elements generate further metamorphoses at the right of the picture. Dali claimed that the picture came about as the result of a brief excursion to Sicily, during which he formed 'mingled reminiscences of Catalonia and of Africa'. Reflecting his characteristic paranoiac logic this association manifested itself as a false memory: Dali observed that 'Africa counts for something in my work, since without having been there I remember so much about it!'

Spain, 1938

Oil on canvas
36⅛×23⅝ inches (92.4×60.4 cm)
Boymans-van Beuningen Museum,
Rotterdam

'The disaster of war and revolution in which my country was plunged', Dali observed, 'only intensified the wholly initial silence of my aesthetic passion, and while my country was interrogating death and destruction, I was interrogating that other sphinx . . . that of the Renaissance'. Between 1937 and 1939 Dali and Gala visited Italy three times and the impact made by the glories of Renaissance art on Dali was profound. *Spain* reflects Dali's fascination with Leonardo in particular. Dali stated: 'From the problems of the physical kitchen of technique, I fell back into that "all" that was the spirit of Leonardo – all, all, all.'

In this painting, Spain is depicted as a woman leaning on a night table. A partial double image, her head and upper torso may also be read as a group of embattled figures. A direct source of inspiration for these appears to have been the combatting *condottieri* in the background of Leonardo's *Adoration of the Magi* which Dali could have seen in the Uffizi in Florence. A specifically Spanish character has been imparted in the depiction of the woman's breasts and her abdomen as a couple of picadors fighting. The horror of civil war is conveyed in the way they have turned their lances on each other. A piece of meat hanging from the drawer of the night table conveys the idea of the carnage of the war and the lion, for once, suggests not desire but ferocity. That all are set in Dali's beloved Plain of Ampurdán, representing happy childhood memories, invests the scene with a sense of personal anguish. *Spain* has a strong graphic quality. The figures and the lower half of the woman are drawn in paint rather than modeled, reflecting the influence of Leonardo's underdrawing in *The Adoration of the Magi*, which remained unfinished. At the bottom of the painting Dali transcribed the word 'España', investing this image of his homeland turning upon itself with the status of an icon.

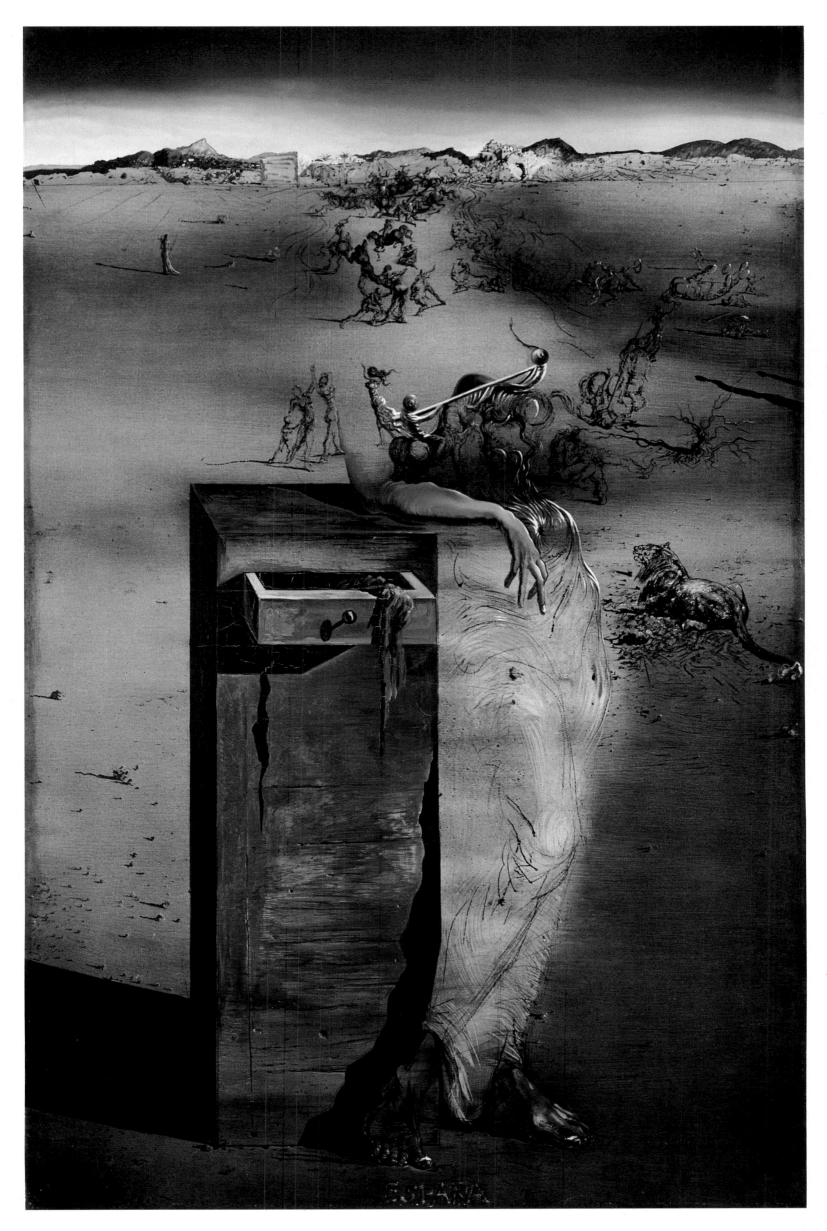

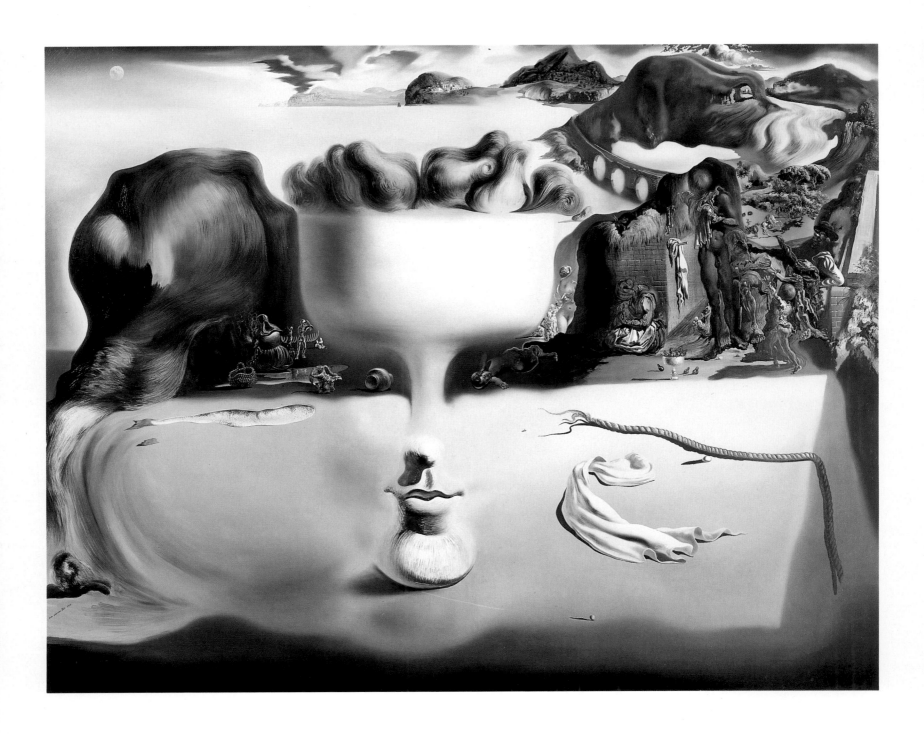

Apparition of Face and Fruit
Dish on a Beach, 1938

Oil on canvas
45¼×56⅝ inches (115.8×114.9 cm)
The Wadsworth Atheneum, Hartford,
Connecticut

During 1938, with Europe poised on the brink of war, Dali continued to travel widely and to immerse himself in work. In January and February he participated in the International Exhibition of Surrealism at the Beaux Arts Gallery in Paris. He also exhibited, later in the year, in a number of shows of Surrealist art in England, Holland and the United States. In July he met Freud in London who pronounced him 'a fanatic'. In September Dali and Gala joined Coco Chanel at her villa in La Pausa on the hills of Monte Carlo. During the four months they spent there Dali sketched out *The Secret Life* and prepared for his next exhibition at the Julien Levy Gallery in New York. The paintings he produced, including *The Endless Enigma* (page 93) and *Apparition of Face and Fruit*

Dish on a Beach, mark the climax of Dali's longstanding preoccupation with multiple images.

In these works Dali pushed the phenomenon of images within images further than either he or its earlier exponents had achieved hitherto. In an apparent reference to Delacroix, Dali claimed that 'the double images of the Romantic period were not as highly developed as these [Dali's]. In the former, both images were visible at the same time; whereas in mine, one of the images may remain long unnoticed'. In *Apparition of Face and Fruit Dish on a Beach* the complexity of the image challenges the observer to decode its matrix of hidden appearances. No longer content with interlocking double images, the surface of painting has

become the visual equivalent of a Russian doll; larger forms contain smaller elements which in turn fragment in further images. At first sight a dog appears to cross the picture space, but this image subsequently metamorphoses into a variety of other forms; its head becomes a hill, its collar a bridge, its body a bowl of fruit. These elements also break down; the bowl of fruit becomes a face, the face becomes a seated woman and some discarded amphoras. Dali's mastery in simultaneously asserting and denying appearance is reflected in this work and in others which were exhibited in his New York show. André Breton, however, perceived it differently and these works brought to a head the schism between Dali and the Surrealists.

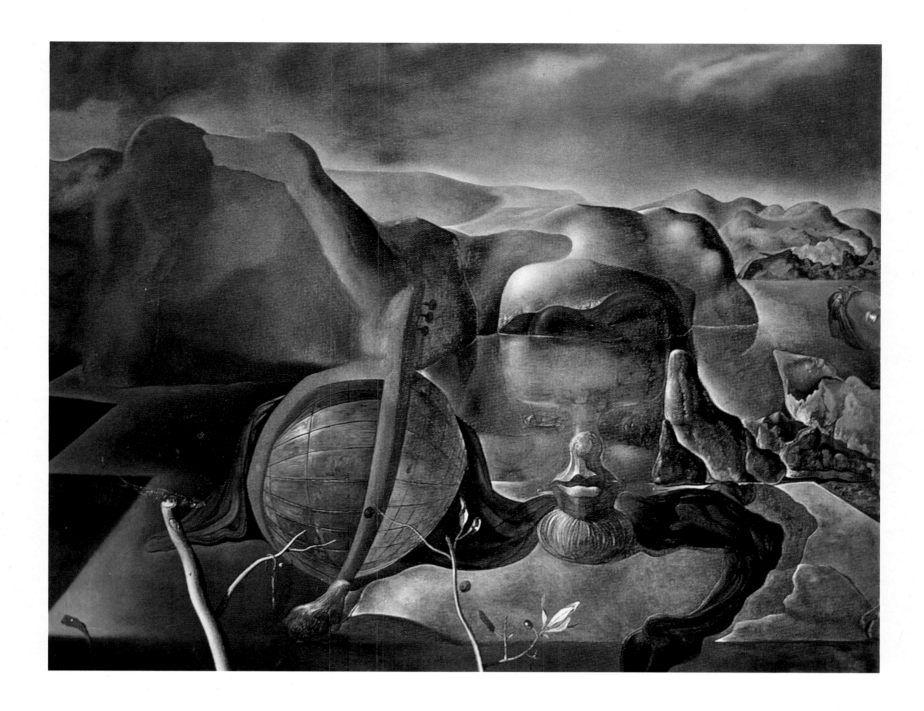

The Endless Enigma, 1938

Oil on canvas
45×56⅜ inches (115.2×144.4 cm)
Spanish State Patrimony

The visual complexity evident in *Apparition of Face and Fruit Dish on a Beach* (page 92) found its apogee in *The Endless Enigma*; so much so that, when it was exhibited at the Julien Levy Gallery between March and April 1939, Dali supplied a series of line drawings in the accompanying catalogue which provide a guide to unraveling its various constituent elements. A woman is seated on a beach, mending a sail, the prow of a fishing boat to her left; the boat may also be read as a mandolin, the woman as the base of a dish containing pears. Together these elements form a 'mythological beast' reclining on the ground. Parts of these forms interlock with the mountains on the far side of the lake which become transformed into the

images of a greyhound and of a reclining philosopher. Spanning the expanse of the lake, and formed by the mountains, fruit bowl, boat and seated woman, the face of a 'great cyclopean cretin' appears. Various unambiguous elements complete the scenario: the skeleton of a sardine mounted on the top of a branch, and the face of Gala peering out of the canvas.

Dali's provision of a key, mapping out these various images, was a virtual acknowledgment that such works posed a visual conundrum. But Dali saw this as essential to the nature of paranoiac delirium. He also saw it as completely consistent with Breton's declaration of the 'omnipotence of desire' – the domination of reality by fantasy – as Surrealism's

central tenet. In Dali's view the puzzle posed by *The Endless Enigma* manifested the principle he had outlined in *The Visible Woman*: 'I challenge materialists . . . to enquire into the more complex problem as to which of these images has the highest probability of existence if the intervention of desire is taken into account'. Therefore, Dali argued that the manipulation of appearance in this way was part of the Surrealists' campaign for transforming reality according to subjective forces. Breton took a different view. He observed that 'by wanting to be punctilious in his paranoiac method, it can be observed that [Dali] is beginning to fall prey to a diversion of the order of a crossword puzzle'.

Beach Scene with Telephone,

1938
Oil on canvas
29×36¼ inches (74.2×92.8 cm)
Tate Gallery, London

Although preoccupied by the destruction and suffering of his homeland, Dali was also observing events elsewhere in Europe. He saw that 'after Spain, all Europe would sink into war as a consequence of the communist and fascist revolution'. *Beach Scene with Telephone* is one of a number of works in which Dali anticipated the imminence of the coming conflict and expressed his despair at the futility of attempts to avert it. The other paintings of this subject are *The Enigma of Hitler*, 1937, *The Sublime Moment*, 1938, *Imperial Violets*, 1938, and *Telephone in a Dish with Three Grilled Sardines at the End of September*, 1939. In each of these works the recurring motif of a telephone receiver refers to the phone calls between Chamberlain and Hitler which culminated in the short-lived Munich Agreement of September 1938. In *Beach Scene with Telephone* the setting is a lake in the Pyrenees where Dali's parents stayed after the death of their first-born child, Dali's older brother, also named Salvador. The beauty of the valley near Requesens supported Dali's mother during this time of deep sadness, and its evocation in this painting expresses Dali's hope that it may work in the same way for him. Despite this there is a pervading sense of melancholy and decay. A green, subaqueous light pervades the scene. The receiver hangs from a crutch, its cord draped limply from a second, similar support, suggesting that the lines of communication are dead. Snails crawl over the telephone, symbolizing the protracted and hopeless nature of the negotiations. On the horizon the wreck of a boat, the spars of its hull exposed like a ribcage, evokes the end of a voyage. The lake is a double image and assumes the shape of a fish, a sardine, on a tabletop, its tail formed by cavities in the rock formations. As in Dali's earlier premonition of war, *Soft Construction with Boiled Beans*, (page 82) the edible in this context refers to death and destruction. In this way the scene is invested with personal pathos; the lake which brought consolation to his mother for Dali symbolizes death.

Slave Market with the Disappearing Bust of Voltaire, 1940

Oil on canvas
18¼×25¾ inches (46.7×65.9 cm)
Morse Charitable Trust, on loan to
Salvador Dali Museum, St Petersburg,
Florida

Dali's New York exhibition in 1939 was a popular success; *Life* Magazine reported that 'New Yorkers stand in line to see his six-in-one Surrealist painting'. Paradoxically, in making Dali the most famous Surrealist, the success of the paranoiac-critical method spelt the end of Dali's association with the Surrealists.

In some ways the pictures which Dali had shown in 1939 represented a regression in his artistic development. Their complexity had entailed a reversion to the use of composite forms which prevented exclusive readings of different elements. *Slave Market with the Disappearing Bust of Voltaire*, on the other hand, represents a reassertion of the hallucinatory force which characterizes Dali's most effective use of double images. As ever, the strength of the illusion derives from its simplicity. Gala is depicted sitting at a table on which there is a bust of the French philosopher Voltaire, by Houdon. Beyond, the position of a ruined arch permits the features of the bust to be re-read as a pair of women wearing seventeenth-century Spanish costume. They pass through the arch in which there are also a number of beggars. By means of this overlapping configuration Voltaire's bust 'disappears'. An echo of this illusion occurs in the bowl to the right of the bust which suddenly appears empty, the pear which previously occupied it having become part of the hillside on the horizon. Dali gave an enigmatic clue to the meaning of this painting: 'Through her patient love', he observed, 'Gala protects me from the ironic and swarming world of slaves. Gala in my life destroys the image of Voltaire and every possible vestige of scepticism'.

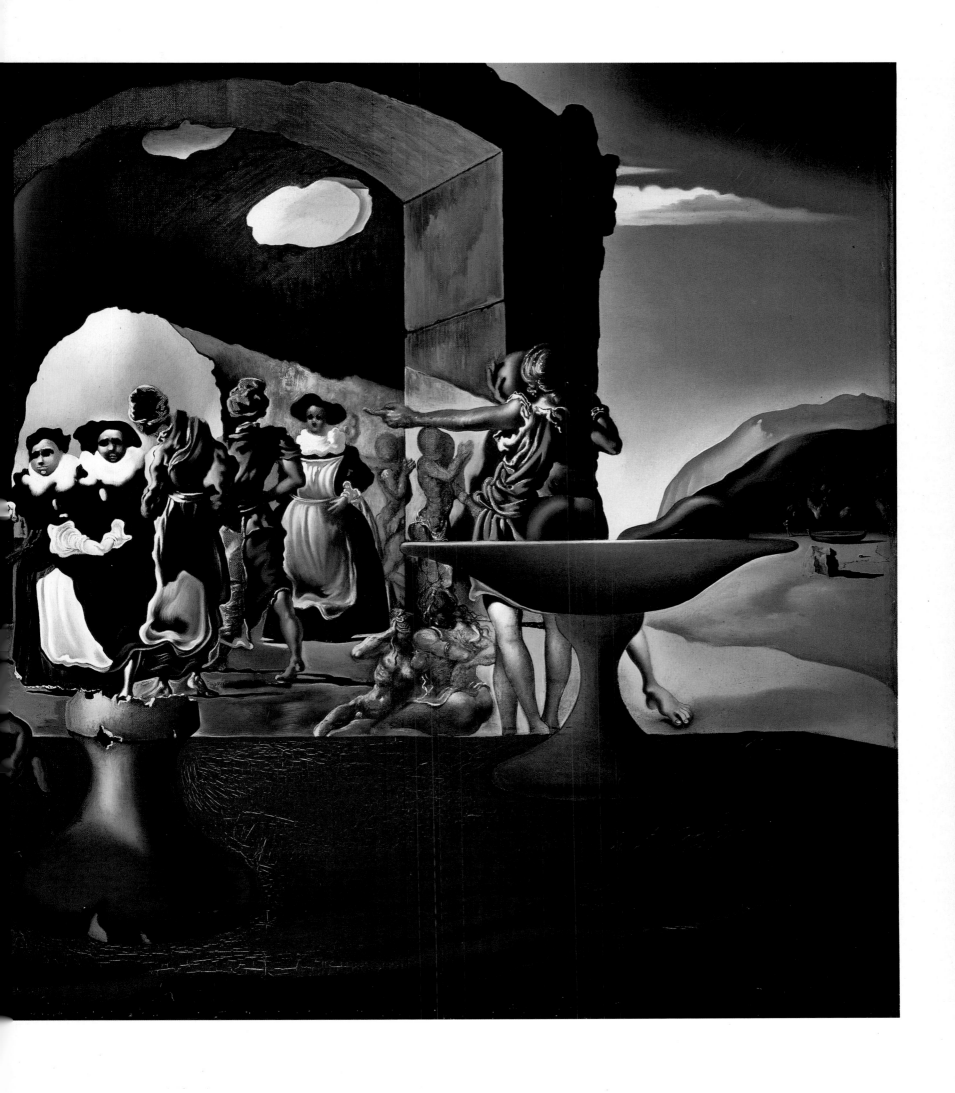

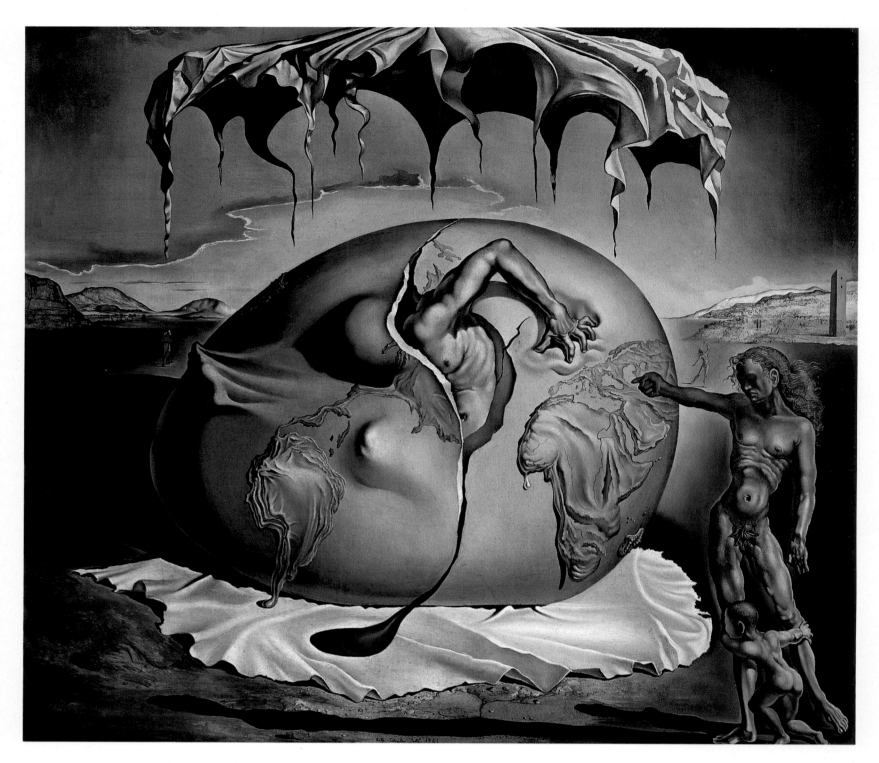

Geopoliticus Child Watching the Birth of the New Man,

1943

Oil on canvas
18×20 inches (46.1×51 cm)
Morse Charitable Trust, on loan to
Salvador Dali Museum, St Petersburg,
Florida

On 16 August 1940 Dali and Gala arrived in America, where they spent the next eight years. Relative to the output which he had sustained since the early 1930s, Dali produced rather fewer paintings during this period. The main reason for this was the change in direction that he announced in 1941, which presaged a period of transition. Writing under the pseudonym of Felipe Jacinto (his second and third names) in the introduction to the catalogue of his 1941 exhibition at the Julien Levy Gallery, Dali declared his intention 'TO BECOME CLASSIC'. In the long term this manifested itself in the development of a more academic style modeled on the techniques of the Old Masters; more immediately it heralded a change in ethos. Dali's classical ideals were expressed in his ambition to observe the world at large, rather than his own psyche as previously, with a detached objectivity and an unquenchable thirst for knowledge characteristic of the Renaissance Masters. In this respect the paranoiac-critical method continued to play a key role in his work but applied to new subjects; objective phenomena would be 'interpreted' irrationally. As Dali stated 'I applied my paranoiac-critical method to exploring the world'.

Geopoliticus Child Watching the Birth of the New Man manifests these new ideals. In particular it reflects the artist's observation that 'while the convulsions of childbirth of the biological belly of history squeezes out from the bottom of its entrails a bloody torrent of mechanical catastrophes, Dali isolates himself, in order to conceive his latest pictures which seem painted under the complacent gaze of Raphael, with a severity, a sureness, and a serenity almost inhuman. Behold the luck, the grace, and the miracle that in this year of Spiritual Sterility 1941, there can still exist a being such as Dali, capable of continuing the conquest of the irrational merely by becoming classic'.

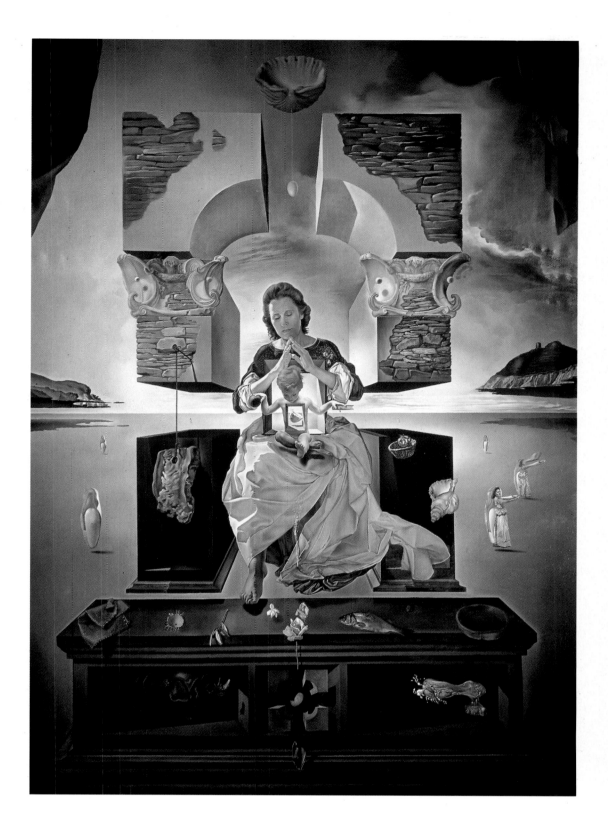

The Madonna of Port Lligat,
1950

Oil on canvas
144×96 inches (368.6×245.8 cm)
Minami Art Museum, Tokyo

The nature of the re-born Dali was re-vealed in his *Mystic Manifesto* of 1951, in which he outlined the theory of his new style of painting which he named 'nuclear mysticism'. This denotes an investigation of reality based on the synthesis of Dali's fascination with atomic theory, inspired by the explosion of the atomic bomb in 1945, with his faith in the 'supreme reality' of God.

This painting is the first expression of Dali's attempt to harness the discoveries of nuclear physics to religious subject-matter. Taking as his model Piero della Francesca's altarpiece, *Madonna and Child with Saints* 1492-94 (Brera Gallery, Milan), Dali depicted Gala as the Madonna. As in Piero's painting, an ostrich egg is suspended over the head of the Virgin. This is a medieval symbol of the Virgin Birth, for it was believed that the ostrich hatched its eggs by exposing them to sunlight and without the inter-vention of any other agency. Dali has ex-

tended the idea of Divine Motherhood by representing the body of the Madonna as a tabernacle for the infant Jesus, whose body in turn forms a space containing the holy bread. Dali described this image as '*The Weaning of Furniture-Nutrition* made sacred: instead of a hole in my nurse's back, a tabernacle'.

The elements within the painting are suspended in space like particles of atomic matter, reflecting Dali's 'nuclear' repre-sentation of reality. But many have a 'paranoiac' significance demonstrating the persistence of this ethos. The shape of a dove may be seen in the shell, and the angels at the right of the painting have

been formed from the cuttlefish bones on the opposite side. The elements contained in the predella are a similar mixture of paranoiac and Christian elements. The rhinoceros heralds Dali's fascination with its horn as the embodiment of formal per-fection. In the center, a sphere is enclosed by apsidal forms. This echoes the barrel vaulting above the Madonna and the arch of her hands above the infant's head, and it also forms the shape of a cross. Thus Dali's 'nuclear mysticism' was, he ex-plained, 'merely the fruit, inspired by the Holy Ghost, of the demoniacal and Sur-realist experiment of the first part of my life'.

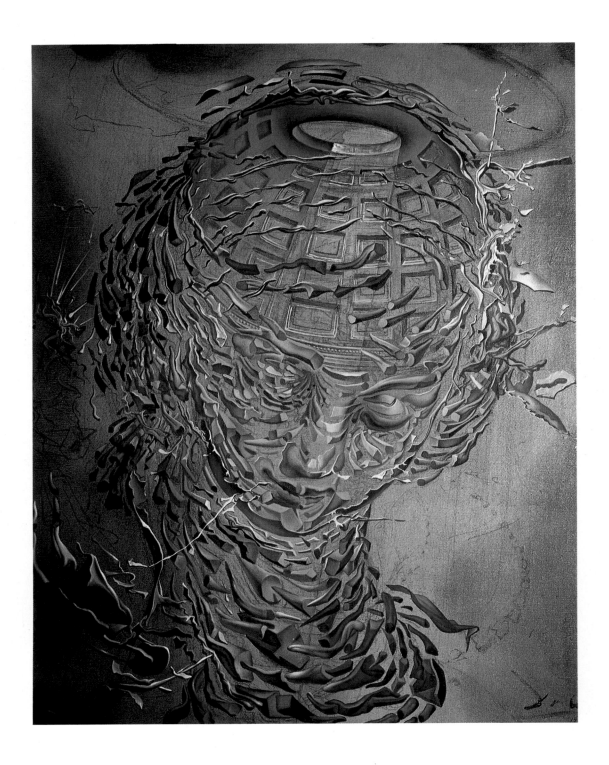

Raphaelesque Head
Exploding, 1951

Oil on canvas
16⅞×13 inches (43×33.3 cm)
Private Collection

In this painting a number of themes in Dali's work – his fascination with the atomic structure of matter, his religious beliefs, his admiration for the art of the Renaissance and his faith in his own paranoiac sensibility – find a synthesis. For Dali, the serene beauty of the Madonnas created by Raphael represented the peak of man-made perfection. In his 1955 lecture *Phenomenological Aspects of the Paranoiac-Critical Method*, which he delivered at the Sorbonne in Paris, Dali identified formal perfection in nature by a process of paranoiac reasoning. He claimed that the physical composition of sunflowers contain logarithmic spirals – perfect curves – which he then interpreted as rhinoceros horns, for Dali the embodi-

ment of natural beauty. In *Raphaelesque Head Exploding* these two ideals became linked. The idea of absolute perfection which this image seeks to convey is expressed as a head, whose downcast eyes and shapely mouth are reminiscent of Raphael's Madonna and Child, known as *The Madonna of the Grand Duke*, in the Pitti Palace, Florence. Dali depicted this in a state of nuclear fragmentation, each corpuscle being interpreted not as individual atoms, but as rhinoceros horns. The image has been subjected to further paranoiac interpretation in that some of the horns coalesce to assume the shape of a wheelbarrow: an old obsession of Dali's relating to Millet's *The Angelus*. They also form the dome of the Pantheon, the

circular temple in Rome and Raphael's burial place. As Dali explained: 'Artists, all through history, have been tormenting themselves to grasp form and reduce it to elementary geometrical volumes. Leonardo always tended to produce eggs, which were the most perfect form according to Euclid. Ingres preferred spheres, and Cézanne cubes and cylinders. But only Dali, by the convolutions of his paroxysmal hypocrisy, has found the truth. All curved surfaces of the human body have the same geometric point in common; the one found in this cone with the rounded tip curved toward heaven or toward the earth, and with the angelic inspiration of destruction in absolute perfection – the rhinoceros horn!'

Christic of St John of the Cross, 1951

Oil on canvas
80¾×45⅝ inches (206.7×116.7 cm)
Glasgow Art Gallery, Glasgow,
Scotland

During the first half of the 1950s Dali focused his nuclear mysticism upon the central icon of the Christian faith, the Crucifixion, and painted two versions of this subject, *Christ of St John of the Cross*, 1951, and *Corpus Hypercubicus*, 1954 (page 102). In the execution of both works he sought to recreate the style of the Spanish painter Francesco de Zurbarán (1598-1664), which is characterized by dramatic chiaroscuro and the use of distinctive golden tones in the modeling of human form.

Christ of St John of the Cross developed from the fusion of two separate sources of inspiration. The first, Dali explained, was a 'cosmic dream' in which he saw the image of a sphere encased in a triangle. He interpreted this as representing the 'NUCLEUS OF THE ATOM'. Some time later, Father Bruno de Jésus-Marie, the Director of Carmelite studies in Paris and author of a book on the life of St John of the Cross, drew Dali's attention to a drawing which the sixteenth-century friar had made following a vision of the crucified Christ. Lacking any art training and relying only on the image which appeared in his ecstasy, St John made a drawing which broke free from the conventional depiction of this subject. It depicted Christ hanging forward from the cross as if seen from above. When Dali saw this image he associated the triangular shape formed by the head and arms of Christ

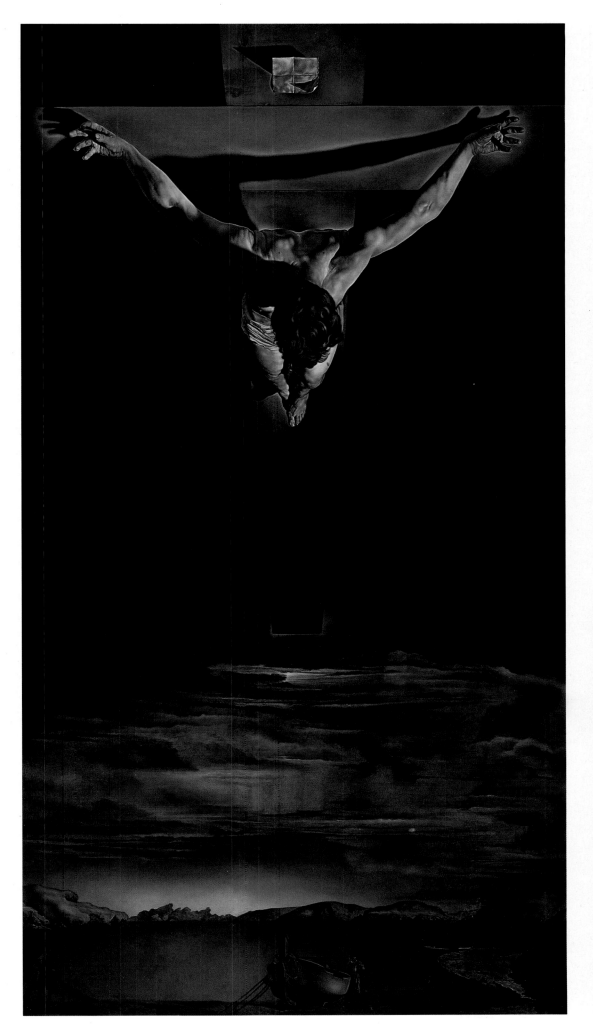

and the horizontal member of the cross with his own dream vision. He thus formed a 'nuclear' Christ whose head, in this sense, forms the nucleus of the atom.

Dali began making studies for the painting from life in Hollywood in 1950 using Russ Saunders, a film stuntman, as a model. Dali posed Saunders by having him lie on his back on the ground with his

arms outstretched behind him, in order to obtain the deep perspectival recession which is the characteristic feature of the painting. Although coolly received by the press upon its first exhibition in London, it has since become one of Dali's most celebrated works, not least for having survived (through restoration) an attack by a fanatic who slashed it.

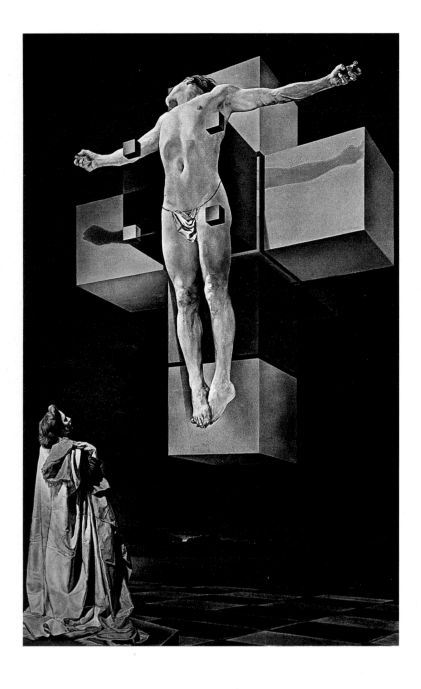

Corpus Hypercubicus, 1954

Oil on canvas
76⅜×48⅞ inches (195.6×125.2 cm)
Metropolitan Museum of Art, New
York

In the *Mystic Manifesto* (1951) Dali announced: 'I want my next Christ to be the painting containing the most beauty and joy that has ever been painted up to today ... Absolute monarchy, perfect aesthetic cupola of the soul, homogeneity, unity, and biological, hereditary, supreme continuity. All of the above will be suspended near the cupola of the sky. Below, crawling and supergelatinous anarchy, viscous heterogeneity ... This is the "(almost divine) harmony of opposites" proclaimed by Heraclitus, which only the incorruptible mold of ecstasy will one day form using new stones from the Escorial'.

In *Corpus Hypercubicus* the 'stones from the Escorial' are manifested as a large crucifix formed by eight cubic elements, an image inspired by Dali's reading of the *Treatise on Cubic Form* by Juan de Herrera, a contemporary of Zurbarán and architect of the Escorial Palace. As in *Christ of St John of the Cross,* (page 101)

the crucified Christ is suspended above the earth, as if already received into Heaven, the 'cupola of the soul'. In this painting, however, the unusual angle employed in Dali's first painting of the Crucifixion is inverted, and we see the body of Christ from below. The impression of monumentality which this creates is enhanced further by its enormous size in relation to the figure of Gala, who is again depicted as the Madonna. As in *Christ of St John of the Cross,* the body of Christ is a perfect incarnation, unblemished by wounds or bodily hair and removed from any suggestion of physical suffering. As Dali explained, his Christ is 'the absolute antithesis of the materialist and savagely anti-mystical Christ of Grunewald'. Although referring ostensibly to Herrera's treatise, the 'metaphysical transcendent Cubism' which Dali identified in this work also relates to the innovations of Picasso and Braque. In this way, *Corpus Hypercubicus* reflects Dali's claim that he was 'the savior of Modern Art, the only one capable of sublimating, integrating and rationalizing imperially and beautifully all the revolutionary experiments of modern times, in the great classical tradition of realism and mysticism'.

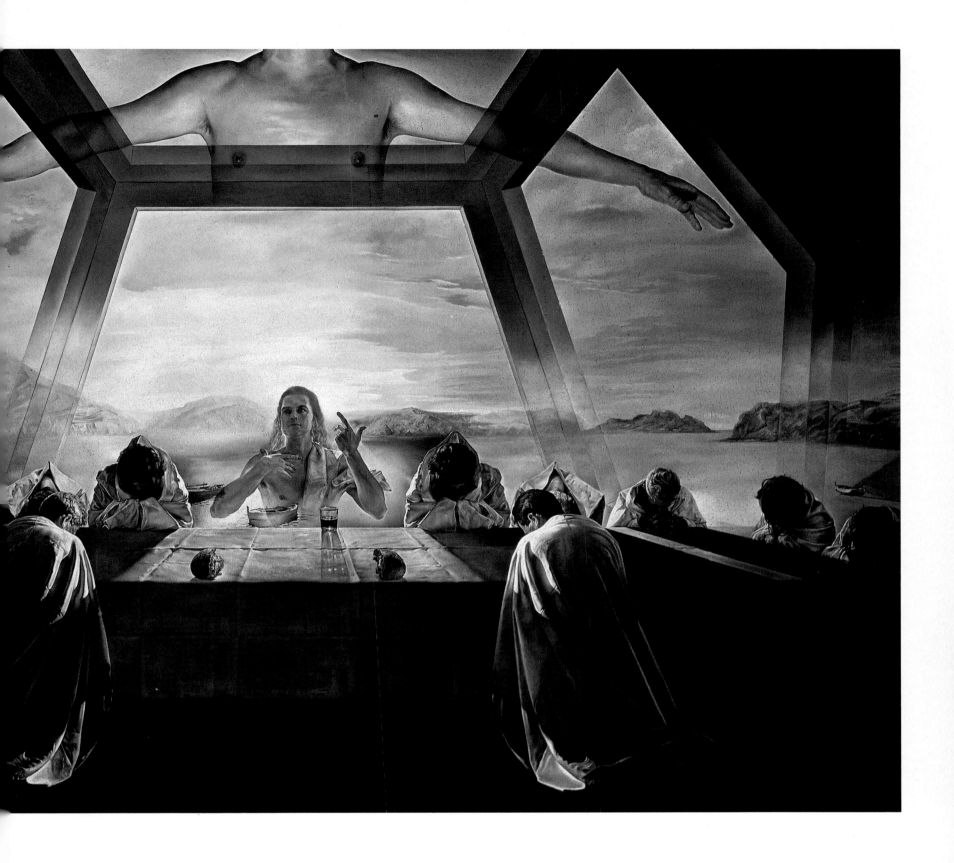

The Last Supper, 1955

Oil on canvas
65¾×105½ inches (168.3×270.1 cm)
National Gallery of Art, Washington
DC

The Last Supper reflects the fact that, for Dali, the return to classical ideals meant the pursuit of 'research in *Divina Proportione* interrupted since the Renaissance'. Dali's observation is an allusion to *De Divina Proportione* (Venice 1509), a treatise by the Renaissance mathematician Fra Luca Pacioli which argued that the principles governing pictorial composition were based on geometry and mathematical proportion. Leonardo da Vinci was influenced by Pacioli's ideas, as is evident in the composition of his fresco *The*

Last Supper, 1497. Dali followed Leonardo's lead in organizing the composition of this subject around a number of orthogonals radiating from the head of Christ to the sides and corners of the painting. In Dali's version the vanishing point is situated just below Christ's mouth and above his chin. The left side is a virtual mirror image of the right and the position of the pictorial elements is determined precisely by the system of radiating orthogonals. For example, a single diagonal connects the line of the left side of the table with the top of the head of the apostle in the foreground, the vanishing point in Christ's face, the top of the mountain on the right of the bay beyond, and the angle in the architectural frame at the extreme right of the picture. More

fundamental is the organization of the painting according to the theory of the 'Golden Section', the divine proportion originated by Euclid and thought of as aesthetically superior to all others. This held that, when a line is divided into two parts, the smaller segment should stand in the same relation to the larger segment as the larger segment does to the whole. In Dali's painting the line of the tabletop divides the painting in this way. The lower half of the painting is subdivided according to the Golden Section by the bottom edge of the cloth. The exact organization of the painting in this way reflects Dali's desire for perfection, but it was also used 'like a resplendent goddess at the temple gates of art, once more forbidding the unworthy to enter'.

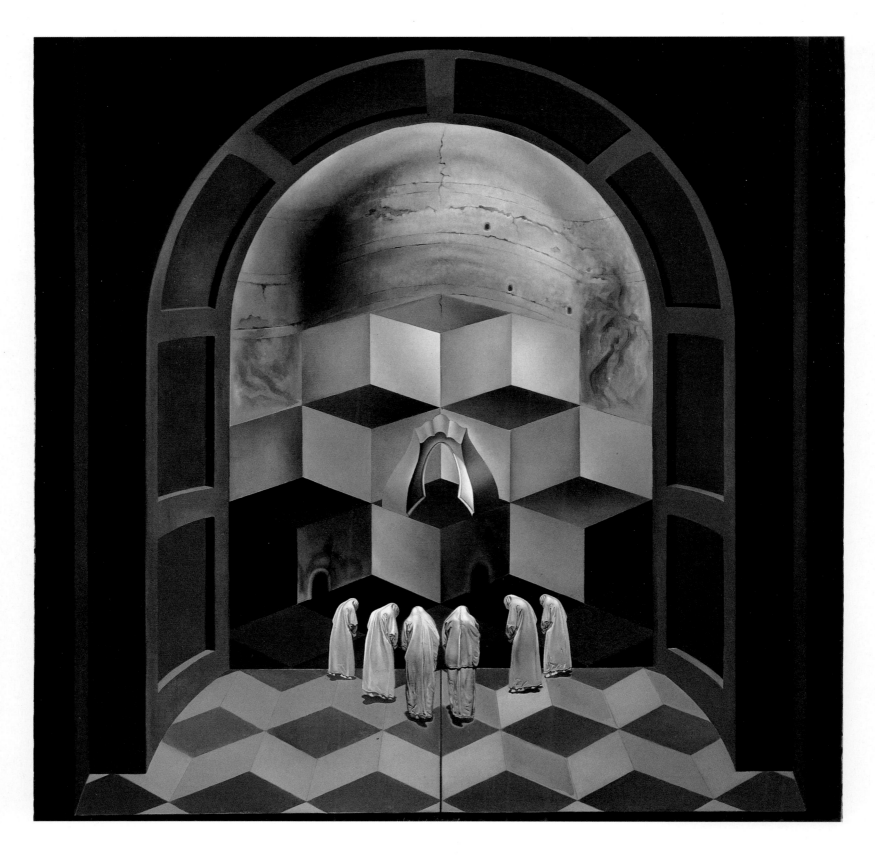

The Skull of Zurbarán, 1956

Oil on canvas
39¼×39¼ inches (100.5×100.5 cm)
Hirshhorn Museum and Sculpture
Garden, Smithsonian Institution,
Washington, DC

Dali's 1955 lecture *Phenomenological Aspects of the Paranoiac-Critical Method* attested the continuing importance of his Surrealist work as a keystone, although he had long ceased to be associated with the Surrealist movement. Double images evoking hidden correspondences and significances populate Dali's later work and manifest his perpetual fascination with this phenomenon.

The Skull of Zurbarán demonstrates Dali's fusion of paranoiac interpretation with the 'consubstantial' forces of realism and mysticism. Dali's admiration for Zur

barán's painting was, in part, due to the master's success in marrying deep spirituality with a love of realism. This achievement is reflected in Zurbarán's numerous cycles of paintings for monasteries and convents. In *The Skull of Zurbarán* Dali alludes to the monastic spirituality which characterizes Zurbarán's best work. A group of monks, bent in prayer, stand before an altar. Dali has depicted this as a series of ascending cubes, a further manifestation of the influence of Herrera's *Treatise on Cubic Form*. The arched form in the center of the painting, an echo of Dali's admiration for Art Nouveau, takes the place of a tabernacle. The cubic form of the altar is repeated in the floor patterning, creating a visual ambivalence; we read one area as three-dimensional, the other as flat, but their juxtaposition undermines this dis-

tinction. It is also possible to read the top surface of some of the cubes as the bottoms of others so that, instead of six cubes stacked in the form of a pyramid, the altar can also be read as seven cubes in a two-three-two configuration. Dali exploits this uncertainty and also the positions of the figures, the arch, the cubes and the shadow falling across the curved ceiling of the apse, in order to effect a remarkable visual 'switch'. These elements can be interpreted as a gigantic skull, the figures forming the teeth, the arch forming the nasal cavity, the dark surfaces of the central row of cubes forming the eye sockets and so on. In this way, by means of the paranoiac association of different forms, a subject characteristic of Zurbarán, painted in the style of the seventeenth-century master, is transformed into his deathly visage.

The Sistine Madonna, 1958

Oil on canvas
87¾×74¾ inches (224.6×191.3 cm)
The Museum of Modern Art, New
York

During the 1950s Dali's fascination with double images was extended by his interest in physics and, in particular, by his study of optical theory. *The Sistine Madonna* is a concentration of a range of ideas and influences, including his own 'nuclear mysticism', his admiration for Raphael, op art, abstract painting and a return to the notion that 'the double image may be extended to make a third image appear . . .'

The principle which Dali employed to unite these disparate elements is that of halftone photography. This is the method used in newspaper illustrations whereby the lights and shades of photographs are reproduced as dots, their variations in size being mixed optically and read as different forms. The starting point for this painting was one such illustration, a photograph of Pope John XXIII which appeared in *Paris Match*. Dali made a detail of the photograph, reproducing only the ear of the Pontiff, and then expanded and transcribed this halftone composition on to canvas. The dots produced in this way relate also to Dali's experiments with the description of matter in terms of its atomic structure, which he had been pursuing earlier in the decade in paintings such as *Galatea of the Spheres*, 1952. Seen at close range this dot-pattern produces a purely abstract effect. But by paranoiac association Dali recognized an alternative visual significance in the configuration of the dots. He enhanced this hallucination by painting further tones in the interstices between the dots. As a result, when seen further away the painting can be read as a detail of Raphael's painting *The Sistine Madonna*, 1513. Viewed from a greater distance still, this image is replaced by the representation of an ear, measuring five feet across at it greatest extremity, framing the Madonna and reflecting the formal structure of Raphael's painting. When *Raphaelesque Head Exploding* (page 100) took an image and shattered it, here a regular pattern of particles combine to create an image.

Dali completed this illusion with a virtuoso example of *trompe l'oeil* painting. Two pieces of folder paper, one supporting a cherry on the end of a piece of string, the other receiving its shadow, apparently float in front of the surface of the painting.

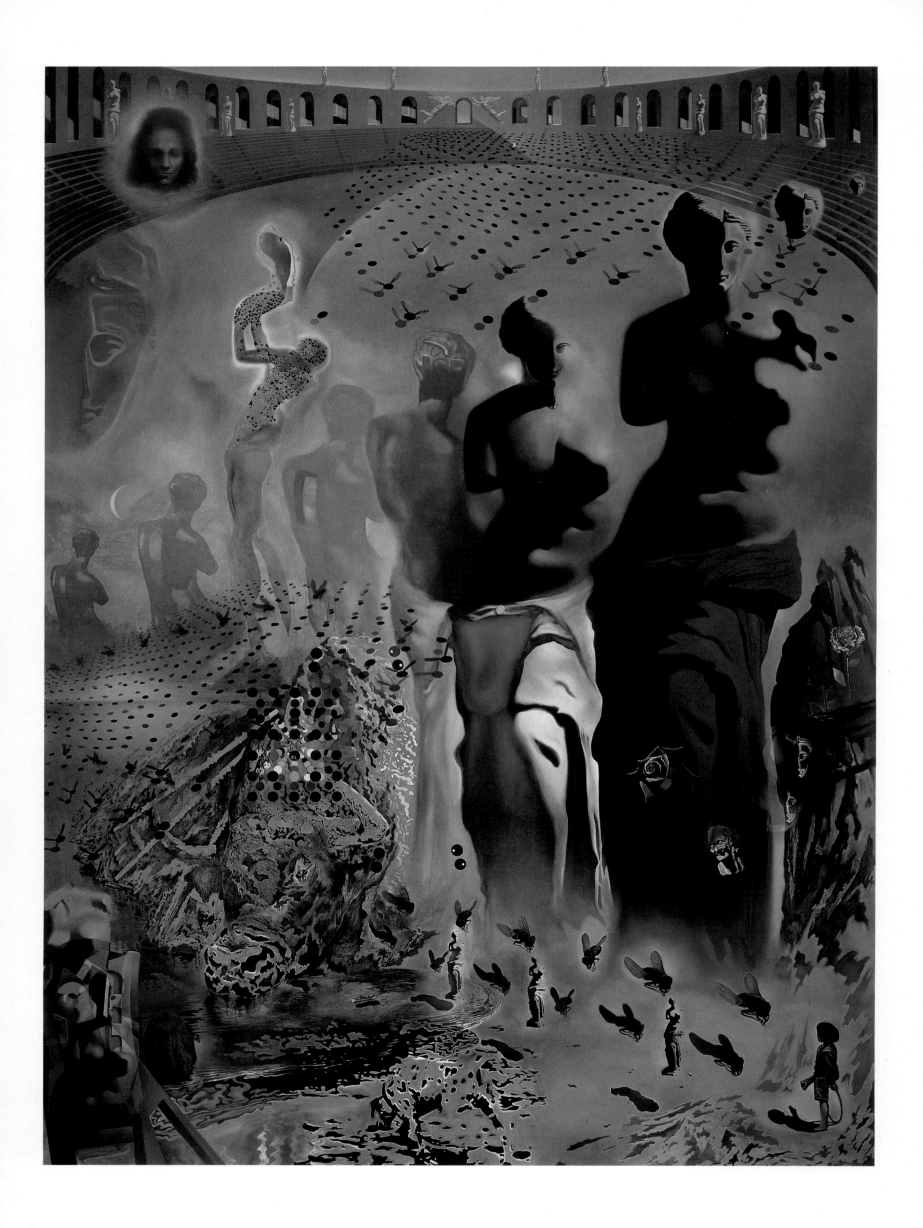

The Hallucinogenic Toreador,

1968-70

Oil on canvas
157×114 inches (402×292 cm)
Morse Charitable Trust, on loan to
Salvador Dali Museum, St. Petersburg,
Florida

During the 1960s Dali continued to paint
on a large scale but turned from religious
subject-matter to historical and allegor-
ical themes. *The Hallucinogenic Toreador*
brings together many preoccupations and
images from all phases of Dali's work; he
called it was 'All Dali in one Painting'.

Its inspiration derives from his recogni-
tion of the head of a toreador in a re-
production of the *Venus de Milo* on a box
of colored pencils, which forms the
central subject of this painting. The head

and shoulders of the toreador appear in
the configuration formed by repeating the
image of the *Venus de Milo*, the curve of
the bullring, and the drapery covering the
legs of the Venus. References to Dali's
past abound. The small boy at the bottom
right of the painting depicts Dali as a child
and refers to an image in an earlier paint-
ing, *The Specter of Sex Appeal*, 1934. In
the drapery of the largest Venus, the
double image in *The Slave Market with
the Disappearing Bust of Voltaire*, 1940
(page 96) reappears. The shadows formed
by the three small Venuses in front of the
child assume the shape of the female
peasant in Dali's interpretation of Millet's
Angelus. The surface of the lake forming a
veil beneath which is a dog was an image
which recurred in Dali's paintings during
the 1950s. The image of the dog is formed

by light passing through the water, a
double image which also makes a playful
allusion to the splatters of paint found in
Abstract Expressionist painting. A
further double image occurs in the image
of the dying bull, pierced by banderillas
formed by striations in the rock face. The
colored disks on the toreador's ornate
jacket relate to the corpuscular spheres of
Dali's 'atomic' paintings. Some disks
assume wings, metamorphosing into flies
and symbolizing the miracles of the Cata-
lonian saint, Narciso of Gerona. A swarm
of flies within the torso of one of the
Venuses outlines the shape of a toreador
tossing his cape into the air. The head of
this Venus relates to the influence of Juan
Gris in Dali's early painting.

Dali began *The Hallucinogenic Torea-
dor* in 1968 and completed it in 1970.

107

Gala Contemplating the Mediterranean Sea which at Twenty Meters Becomes The Portrait of Abraham Lincoln (Homage to Rothko), 1976

Oil on canvas
99¼×75½ inches (254.1×193.3 cm)
Minami Art Museum, Tokyo

Dali's recognition of a toreador's head in the image of the *Venus de Milo* on a box of pencils is a classic example of what he saw as the capacity of the paranoiac mind to perceive hidden, irrational significances in everyday experiences. The products of an abnormal sensibility, such perceptions were also, Dali explained, 'consubstantial with the human phenomenon of sight'. It was thus natural that Dali's later development of the paranoiac-critical method embraced an increasing fascination with the mechanics of perception: the ways in which the human brain decodes and interprets visual information. This development is evident in *Gala Contemplating the Mediterranean Sea*.

Gala is depicted nude, standing before a tiled window which is in the shape of a cross, an echo of Dali's religious phase. Through the window a burning sun can be seen lighting up a Mediterranean sky. It is also possible to read the sun as the head of the crucified Christ, an image taken from Dali's *Christ of St John of the Cross*, 1951 (page 101). A more fundamental transformation is latent in the patterning of the tiles around the cruciform window. This is based on a digital interpretation of a photograph of the face of Abraham Lincoln which Dali obtained and transcribed on to the canvas. The reduction of form to a regular arrangement of different colored squares relates in principle to halftone photography, which Dali had incorporated in his painting *The Sistine Madonna*, 1956 (page 105), although the digital encoding of images employs computer technology. From a distance, or through half-closed eyes, the organization of the tiles may be decoded and reinterpreted as the face of the President. This hallucination is reinforced by the integration of the tiles with the figure of Gala, whose bent arm forms the shape of Lincoln's nose, and with the head of Christ, which forms a highlight on his brow. Dali dedicated this work to Mark Rothko, the Abstract Expressionist painter who committed suicide in 1970.

Dali's Hand Drawing Back the Golden Fleece in the Form of a Cloud to Show Gala the Dawn, Completely Nude, Very, Very Far Away Behind the Sun, 1977

Oil on canvas
Stereoscopic work in two parts, each
23⅝×23⅝ inches (64.9×64.9 cm)
Spanish State Patrimony

From the early 1960s Dali carried out research into stereoscopy, the means of creating an illusion of three-dimensional depth by viewing two related but slightly different images through a lens which superimposed the two. The Victorians were familiar with this effect and postcard size images seen through a binocular viewer were a popular entertainment. During the 1970s Dali concentrated on this field of experimentation, producing a number of works comprising two near-identical canvases which, when seen through a stereoscopic viewer, appear to form a three-dimensional image. Dali bombastically dubbed this phase of his work 'metaphysical hyperrealism'.

Dali's Hand Drawing Back the Golden Fleece . . . reflects his desire to 'pierce the sky and start the picture in the luminous hole of the sky . . . a hole made possible by pure geometric positioning and thanks to the optical mathematics of binocular vision'. Dali based this work on Claude Lorraine's painting *Embarkation of St Ursula*, 1646. Claude's practice of basing the composition of his paintings on simple mathematical proportion and of painting his works in pairs, each painting illustrating the same theme but with a contrasting atmosphere or composition, was germane to Dali's own concerns. In this work the Dawn is personified as a female nude, her hair depicted as a cloud and also as the fabled golden fleece which Dali's hand draws aside. She stands on the horizon but appears situated *behind* the sun, an impression reinforced when the two images are seen stereoscopically superimposed. As such Dali's aim was to impregnate the picture with a sense of infinite depth.

Used in this way, Dali's final development of the double image manifested itself as a purely visual rather than as a paranoiac phenomenon; we read two related flat surfaces as deep space. Nevertheless, the nature of this illusion depends on the subversion of reality according to a subjective impression. This is the essence of the paranoiac-critical method. The underlying continuity of Dali's ethos was thus evident when he observed of his metaphysical hyperrealism: 'May our inner reality be so powerful that it corrects the exterior reality!'

Select Bibliography

PUBLICATIONS BY DALI

'L' Ane pourri' *Le Surréalisme au Service de la Révolution*, Paris, 1930, no. 1

La Femme visible, Editions Surréalistes, Paris, 1930

'Interprétation paranoïaque-critique de l'image obsédante *L' Angelus de Millet*', *Minotaure*, Paris, 1933, no. 1

Salvador Dali: 42 eaux-fortes et 30 dessins pour Les Chants de Maldoror. Exposition organisée par Les Editions Albert Skira aux Quatre Chemins, Paris, 1934 (includes Dali's essay *L'Angelus de Millet*)

La Conquête de l'irrationel, Paris, 1935 (English translation New York, Julien Levy, 1935)

Métamorphose de Narcisse; Poème paranoiaque, Editions Surréalistes, Paris, 1936 (English translation by Francis Scarpe, New York, Julien Levy, 1937)

Declaration of the Independence of the Imagination and the Rights of Man to His Own Madness, pamphlet, privately published, New York, 1939

The Secret Life of Salvador Dali, English translation by Haakon M Chevalier, New York, 1942

Le Mythe tragique de l'Angélus de Millet, Interprétation 'Paranoiaque-critique', Paris, 1963

Journal d'un genie, Paris, 1964 (English translation New York, 1965)

BOOKS ON DALI, EXHIBITION CATALOGUES AND OTHER PUBLICATIONS

Ades, Dawn *Dali*, London, 1982

Alexandrian, Sarane *Surrealist Art*, Paris, 1969 (English translation by Gordon Clough, London, 1970)

Alley, Ronald Entries on *Autumn Cannibalism* and *Mountain Lake* in *Catalogue of the Tate Gallery's Collection of Modern Art Other than Works by British Artists*, Tate Gallery, London, 1981

Dada and Surrealism Reviewed, Arts Council, Hayward Gallery, London 1978

Bailey, Martin 'Hiding behind the mask of a recluse' in *The Observer*, 10 May 1987

Breton, André *What is Surrealism*? ed. Franklin Rosemont, London, 1978 (includes Breton's catalogue introduction to Dali's exhibition, Goemans Gallery, Paris, 1929)

Le Surréalisme et la peinture, Paris, 1928 (English translation by Simon Watson Taylor, London and New York, 1972, also contains *Artistic Genesis and Perspective of Surrealism*, 1941)

Breton, André *Manifestoes of Surrealism* (English translation by R Seaver and H R Lane, University of Michigan Press, 1969)

Carrouges, Michel *André Breton and the Basic Concepts of Surrealism*, University of Alabama Press, 1974

Descharnes, Robert *Salvador Dali*, New York, 1976

Descharnes, Robert *Dali: The Work The Man*, New York, 1984

Sauré, Wolfgang, 'The Great Game of Paranoia' in Gómez de la Serna, Ramón *Dali*, New York, 1979

Freud, Sigmund *The Interpretation of Dreams*, Germany, 1900, London, 1953

Haslam, Malcolm *The Real World of the Surrealists*, London, 1978

Krafft-Ebing, Richard von *Psychopathia Sexualis, With Special Reference to Antipathic Sexual Instinct: a Medico-forensic Study*, London 1899, Chicago, 1901

Lacan, Jacques *De la psychose paranoïaque dans ses rapports avec la personnalité (1932) suivi de Premiers écrits sur la paranoïa*, Paris, 1975

Gómez de Liaño, Ignacio *Dali*, 1982 (English translation by Kenneth Lyons, London, 1987)

Nadeau, Maurice *The History of Surrealism*, 1944 (English translation by Richard Howard, London, 1987)

Reynolds Morse Foundation *A Guide to Works by Salvador Dali in Public Museum Collections*, privately published by Salvador Dali Museum, Ohio, 1973

Reynolds Morse Foundation, *Salvador Dali: A Collection*, Salvador Dali Museum, Ohio, 1972

Rubin, William *Dada and Surrealist Art*, London, 1969

Short, Robert *Dada and Surrealism*, London, 1980

Soby, James Thrall *Salvador Dali*, Museum of Modern Art, New York, 1946

Wilson, Simon *Salvador Dali*, Tate Gallery, London, 1980

Index

Acknowledgments

The publisher would like to thank Mike Rose, the designer; Mandy Little, the picture researcher; Jessica Orebi Gann, the editor; Pat Coward, who prepared the index; and the museums, agencies and individuals listed below for supplying the illustrations.

Bridgeman Art Library/Private Collection, page 1/Louvre, Paris, page 20/Galerie Beyeler, page 21(top)/Private Collection, pages 38, 44-45, 54-55/Ex-Edward James Foundation, pages 80-81/National Gallery of Art, Washington, page 103
British Film Institute, London, page 8(bottom)
Christie's Colour Library, London, pages 60, 76-77
Salvador Dali Museum, St Petersburg, Florida, pages 2-3, 30-31, 33, 34-35, 36-37, 46-47, 56-57, 59, 64, 65, 68-69, 71-72, 73, 96-97, 98, 106, 107
Robert Descharnes, Paris, page 27/Private Collection, page 86-87/Private Collection, page 99/Private Collection
Glasgow Art Gallery and Museum, page 101
Hirshhorn Museum and Sculpture Garden, Smithsonian Institute, Gift of Joseph H Hirshhorn Foundation, 1966, page 104
Hulton-Deutsch Collection, pages 6, 9(top), 11(bottom)
Kunstmuseum, Bern, page 63
MAS/Museo Español de Arte Contemporaneo, Madrid, page 8(top)/Private Collection, page 13(bottom)/Museo Dali, Figueras, page 14(top)/Museum of Modern Art, New York, page 18(bottom)/Private Collection, Lugano, page 22(top)/Palacio Zarzuela, Madrid, page 23/Private Collection, page 24(top), 25/Museo Contemporaneo, Madrid, page 28/Private Collection, page 42-43/Private Collection, page 52/Minami Art Museum, Tokyo page 108/Private Collection, page 105
Metropolitan Museum of Art, New York, Gift of the Chester Dale Collection, 1955, page 102
Musée D'Orsay, © Photo Réunion des Musées Nationaux, page 21(bottom)
Photograph Courtesy of Musée National d'Art Moderne,

Centre Georges Pompidou/photograph: Jacques Faujour, page 50
Pictorial Press, page 7
Museum Boymans-van Beuningen, Rotterdam, pages 79, 90, 91
Museum of Modern Art, New York, page 48-49/Abby Alrich Rockefeller, page 74/The Sidney and Harriet Janis Collection, page 39
Museo Español de Arte Contemporaneo/photo: Courtesy of Perls Gallery, New York, page 66
National Gallery of Canada, Ottawa, page 61
Perls Gallery, New York, page 62
Popperfoto, pages 17, 22(bottom), 24(bottom)
Private Collection on loan to the Scottish National Gallery of Modern Art, Edinburgh, page 100
Philadelphia Museum of Art/The Louis and Walter Arensberg Collection, pages 82, 83
Spanish State Patrimony/photo: MAS, Barcelona, page 26, 27, 93/Photo: Courtesy of Sotheby, Parke and Bernet, New York, page 40-41/Photo: Courtesy of Musée National d'Art Moderne, Centre Georges Pompidou/Beatrice Hata, page 109
Statens Konstmuseer Moderna Museet, Stockholm, page 57
Tate Gallery, London, pages 84, 88-89, 94-95
Copyright, 1936, Time Inc. page 11(top)
Courtesy of the Trustees of the Victoria and Albert Museum, London page 19
Wadsworth Atheneum, Hartford/Ella Gallup Sumner and Mary Catlin Sumner Collection, page 92
Weidenfeld Archive/Museum of Art and History of Saint-Denis, page 9 (bottom)/Museum of Modern Art, New York, page 10(bottom)/Courtesy Wadsworth Atheneum, page 15

All Dali images © DEMART PRO ARTE B.V./DACS London 1990
Page 21(top) © ADAGP, Paris and DACS London 1990